FACING THE MODERN
THE PORTRAIT IN VIENNA 1900

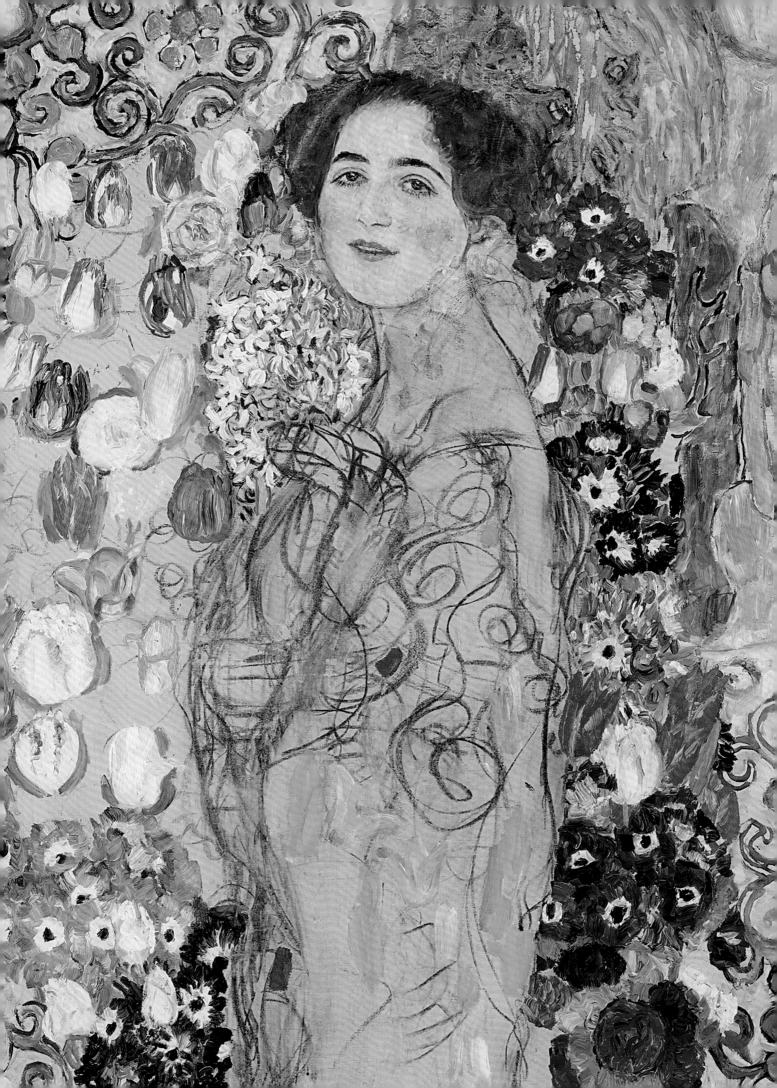

FACING THE MODERN
THE PORTRAIT IN VIENNA 1900

GEMMA BLACKSHAW

WITH AN
INTRODUCTION BY
EDMUND DE WAAL

WITH CONTRIBUTIONS FROM
Tag Gronberg, Julie M. Johnson,
Doris H. Lehmann,
Elana Shapira and Sabine Wieber

National Gallery Company, London
DISTRIBUTED BY YALE UNIVERSITY PRESS

This book was published to mark the exhibition

FACING THE MODERN
THE PORTRAIT IN VIENNA 1900

Held at the National Gallery, London
9 October 2013 – 12 January 2014

Sponsored by Credit Suisse

Gemma Blackshaw is Reader in Art History
at Plymouth University. She is co-author
of *Madness and Modernity: Mental Illness
and the Visual Arts in Vienna 1900* (2009).

Edmund de Waal is an artist, curator,
art critic and writer, and the author of
The Hare with Amber Eyes (2010).

First published in Great Britain in 2013 by
National Gallery Company Limited
St Vincent House, 30 Orange Street
London WC2H 7HH
www.nationalgallery.co.uk

HB ISBN 978 1 85709 561 6
1034208

PB ISBN 978 1 85709 546 3
1034207

British Library Cataloguing-in-Publication Data
A catalogue record is available from
the British Library
Library of Congress Control Number
2013941700

Portraying Viennese Beauty: Makart and Klimt
translated by Edward Neather

PUBLISHER Jan Green
PROJECT EDITOR Rachel Giles
EDITOR Caroline Bugler
PICTURE RESEARCHER Suzanne Bosman
PRODUCTION Jane Hyne and Penny Le Tissier
DESIGNER Philip Lewis

Designed and set in Nexus Mix Pro and Delvard

Origination by AltaImage, London
Printed in Italy by Conti Tipocolor

This exhibition has been made possible by the
provision of insurance through the Government
Indemnity Scheme. The National Gallery would
like to thank HM Government for providing
Government Indemnity and the Department
for Culture, Media and Sport and Arts Council
England for arranging the indemnity.

All measurements give height before width.
Comparative illustrations are denoted as figures.
All other numbered illustrations denote works
in the exhibition.

FRONT COVER Egon Schiele, *Self Portrait with
Raised Bare Shoulder*, 1912 (detail of 36; see p. 117)
BACK COVER Gustav Klimt, *Portrait of a Lady in
Black*, about 1894 (detail of 30; see p. 102)
FRONTISPIECE Gustav Klimt, *Posthumous Portrait
of Ria Munk III*, 1917–18 (detail of 63; see p. 183)
PAGE 8 Carl Moll, *Self Portrait in his Study*, 1906,
(detail of 10; see p. 45)

Contents

Sponsor's Foreword

As partner of the National Gallery, Credit Suisse is delighted to support *Facing the Modern: The Portrait in Vienna 1900*. This exhibition allows visitors to observe the development of portraiture during one of the most formative periods in Vienna's history: from the early nineteenth century to the end of the First World War in 1918. As the capital city and seat of the Austro-Hungarian Empire, Vienna was the centre of Austria's political, commercial and cultural landscape, and during this time the city saw a spectacular burgeoning of its *Bürgertum* or upper middle classes, reflecting the empire's new multiculturalism. They turned to portraiture as a means of representing themselves and making their mark on Viennese society.

In the narrative of the city's art history, this period is widely regarded as the time when the avant-garde redefined portrait painting traditions and styles. The exhibition explores the complexities of this story by considering both the changes and the surprising continuities in portrait production and consumption across the era.

Visitors have the opportunity to view a varied range of works of art including paintings, drawings and death masks, many of them on loan from public and private collections in Austria. The exhibition provides a chance to see significant paintings such as Gustav Klimt's *Portrait of Amalie Zuckerkandl* (Belvedere, Vienna) Richard Gerstl's *Nude Self Portrait with Palette* (Leopold Museum Private Foundation, Vienna); Egon Schiele's *Portrait of Erich Lederer* (Kunstmuseum, Basel) and Oskar Kokoschka's *Portrait of Lotte Franzos* (The Phillips Collection, Washington, DC).

We are very pleased to collaborate with the National Gallery in bringing this thought-provoking exhibition to London.

GAËL DE BOISSARD
CEO, Europe, Middle East and Africa
Credit Suisse

Partner of the National Gallery

Director's Foreword

It is hardly controversial to claim that 1900 represented a decisive change in European life and thought. It did so partly because so many people believed that things were changing, or were about to do so, or should do so, all of which licensed and drove forward radical ideas. Nowhere was this more the case than in Vienna.

The modernity of Viennese art has come to be associated with Gustav Klimt, Egon Schiele and Oskar Kokoschka. Their paintings are included in this exhibition and are illustrated in this book, but they are considered alongside work by other artists who have been largely forgotten even in their native city – in some cases never well known, there or elsewhere. The modernity of Vienna, usually defined in opposition to historicism, is also shown to have risen out of it. And some anticipation of the self-consciously unorthodox art of the new century is detected in portraiture over half a century earlier.

What is attempted here is indeed not a survey of art in Vienna, but a portrait of Vienna itself. Much that is included in this exhibition and discussed in this book – from fancy dress inspired by Renaissance art, to the elegiac sentiments provoked by demolition, to the paintings, photographs and plaster casts of the dead – has its parallel elsewhere in Europe and in North America. But in Vienna the ideological collisions between family values and sexual identity, imperial service and the ostentation of new wealth – along with the anxieties about social status, the support for experiment and the revulsion from its results – were most dramatic.

Gemma Blackshaw has brought great energy and commitment to curating the exhibition and, with her co-authors, to this book. Throughout the planning of the exhibition we have received sympathetic support as well as very generous loans from Viennese institutions: in particular, the Belvedere, the Wien Museum, the Gemäldegalerie der Akademie der bildenden Künste Wien, the Leopold Museum Private Foundation and the Arnold Schönberg Center. We are also most grateful to Credit Suisse for their support of this unique exhibition. Finally, we would like to express our special gratitude to Dr Evelyn Benesch, Deputy Director of the Bank Austria Kunstforum, who has acted as a special curatorial adviser.

NICHOLAS PENNY

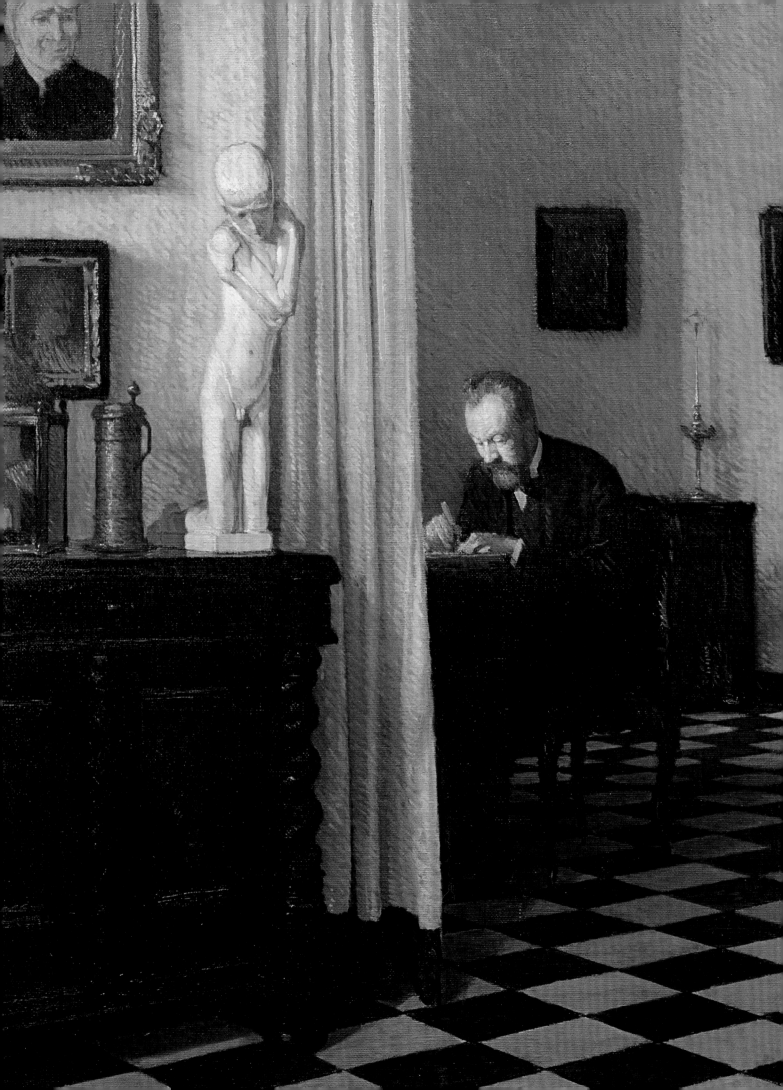

Introduction

EDMUND DE WAAL

Wherever you go in Vienna in 1900 you see the Emperor. His image is on every coin and every stamp, on every certificate. His portrait stands in shop windows, above the desk where the maître d' greets you in the restaurant, in the foyer of the Opera, in the waiting room at the station. And sometimes he is there in his carriage on the Ringstrasse, with a few outriders from a Balkan regiment in glorious uniforms, 'the best-dressed army in the world' according to the acidic Karl Kraus, off to open a building or a ball with his companion Mrs Schratt. This is a city clogged with decorations, insignia and titles, and the Emperor of Austria, King of Hungary and Bohemia, King of Lombardy-Venetia, of Dalmatia, Croatia, Slavonia, Galicia and Illyria, Grand Duke of Tuscany, King of Jerusalem and Duke of Auschwitz, with his chestful of medals and ribbons, is the index. He spans a geography and an era.

Vienna is a city of microscopic attention to details. In this year Adolf Loos is agonising over the design of a salt cellar, Kraus anatomising the wording of an advert in *Die Neue Freie Presse* and Freud focusing on the slip of the tongue. Condensing and editing down the world into the essential is a common discussion. For the poet Altenberg it is a passion: 'I would like to describe a person in one sentence – the experience of a person's soul on one page, a landscape with one word.' How are you going to represent yourself when every choice of medium, of scale, of dress and posture, of background and foreground, of how you hold yourself in the world, is going to be noticed? Portrait is revelation and this city is unforgiving in its analysis, its obsessive decoding of what is being revealed and what withheld. Where are you placed in Klimt's portrait of the closing of the Burgtheater, or Theodore Zasche's portrait of the Corso, the ritualised stroll along the Ring to scrutinise who is who and who they know? Writers, artists, the Mayor, courtesans in full flow. Everyone knows who Freud's patients are, who the characters in Strauss and Hofmannsthal's *Der Rosenkavalier* are based upon. And every single day the *feuilleton* printed in the papers contains some baroque riff

on Viennese characters – the seller of fruit in the market or a coffee-house bore expounding on the political situation, some portrait of a passionate young man and his love affairs. If you live in Vienna in 1900 you see, read and hear the portrait.

If you haven't inherited a corridor of ancestral portraits what do you do to show Viennese society who you are? The possession of all those ancestors indicates belonging, a trajectory that demonstrates that you know this city is yours. But what if you are newly rich, newly arrived, Jewish, a woman? One simple strategy adopted by my own newly rich, newly arrived Jewish family, the Ephrussi from Odessa – deeply anxious to be seen as Viennese as quickly as possible – was to commission portraits from the two principal portraitists to the establishment. They built a Palais by the right architect, furnished it in the French manner, gilded and painted the ceilings – and then bought the portraits. Hans Makart was the theatrical showman of Viennese art, the stager of the spectacular procession to celebrate the opening of the Ringstrasse, an artist who understood how to deploy the full panoply of Renaissance references to elevate arriviste Viennese to the heights of the Medicis. And Heinrich von Angeli, it is said, was possessed of such charm that he could be found in the corridors of Windsor or the Schönbrunn. These ennobled artists were calling cards. I look at the picture of my great-great grandmother by Angeli (fig. 27; see p. 97) and realise that his facility with a rope of pearls – like his ease with the Emperor's uniforms – was central to his success. He made the details work hard, knowing how much the fur stole, the tiara, the chivalric order of some Balkan kingdom would matter.

Though it is possible to regard Vienna as a series of polarised camps – Kraus's famous 'testing-station for the end of the world' – this is too easy a way of understanding this complex city. Of course there are the households where everything starts again, like that of the Gallias, with their portrait of Hermine by Klimt and their fierce white furniture to perch on by the fashionable Josef Hoffmann. But even in these households of self-conscious modernity, old family portraits might be hung nearby, radical drama playing out under the whiskers of the *Gründerzeit* Viennese. Tumult happens, the exhibitions at the Secession are denounced, reviews of poetry are visceral, and there are riots at the premières of music at the Musikverein, but proper meals are still on the table, served by maids at the correct time. Everything is a matter of life or death, but this is Vienna.

For there is a theatricality about how you represent yourself in Vienna. When researching a book about my family in Vienna I was fascinated to discover that alongside the grandeur of their image-making, there was

a more complex story. There were photographs of dressing-up – the handsome young poet Hofmannsthal and my great-grandmother Emmy as a teenager dressed up as Renaissance Venetians at a wedding masque. And a series of photographs of a weekend party around 1904 where all the girls, all Jewish cousins, had been photographed dressed up as characters from Old Master paintings. Emmy is Titian's Isabella d'Este, while other cousins are pretty Chardin and Pieter de Hooch servant girls. This is young girls choosing how they want to be portrayed, playing as in a masquerade with their own self-image, refracting themselves into pictures on their own terms. And there is a series of 12 portraits of family and friends – more enigmatic but with a similar energy – contained in a very soft white suede folio with silk ribbon ties. The cover bears the dates 1878 and 1903 in Secessionist type, and each card is illuminated in pen and ink, edged with silver, each with its own carefully designed frame in a Secessionist pattern, each with a cryptic quatrain in German, Latin or English, part of a poem or a snatch of song. One drawing shows an uncle reading *Die Neue Freie Presse*, another a cousin on the skating rink, another of Emmy dancing at a ball. These are Viennese portraits that stage moments of life and character as a game of charades, a private staging for a family of jokes and anecdote rather than public role-playing.

This book explores the ways in which the creation of images in Vienna intertwines with patronage, politics and the creation of taste. Spending time with these pictures, of artists' friends or their families, of themselves, of young couples and of lovers and rivals on their deathbeds, I think of this fissile city in 1900. So many of these new portraits take away the props and backgrounds that so exactly indicated the societal position of the previous generation. There is a bareness to the way in which these Viennese people stand and sit against nothing that reminds me of how Loos described autopsy – 'the evisceration of flesh to see what is beneath'. And in this moment when there is a radical unwrapping of clothes, an unpinning of hair, a casting aside of jewellery and insignia to reveal the new and the modern and the honest man and woman of the present day, I see a delight in theatre that is thoroughly old-fashioned and one that the old Emperor would understand.

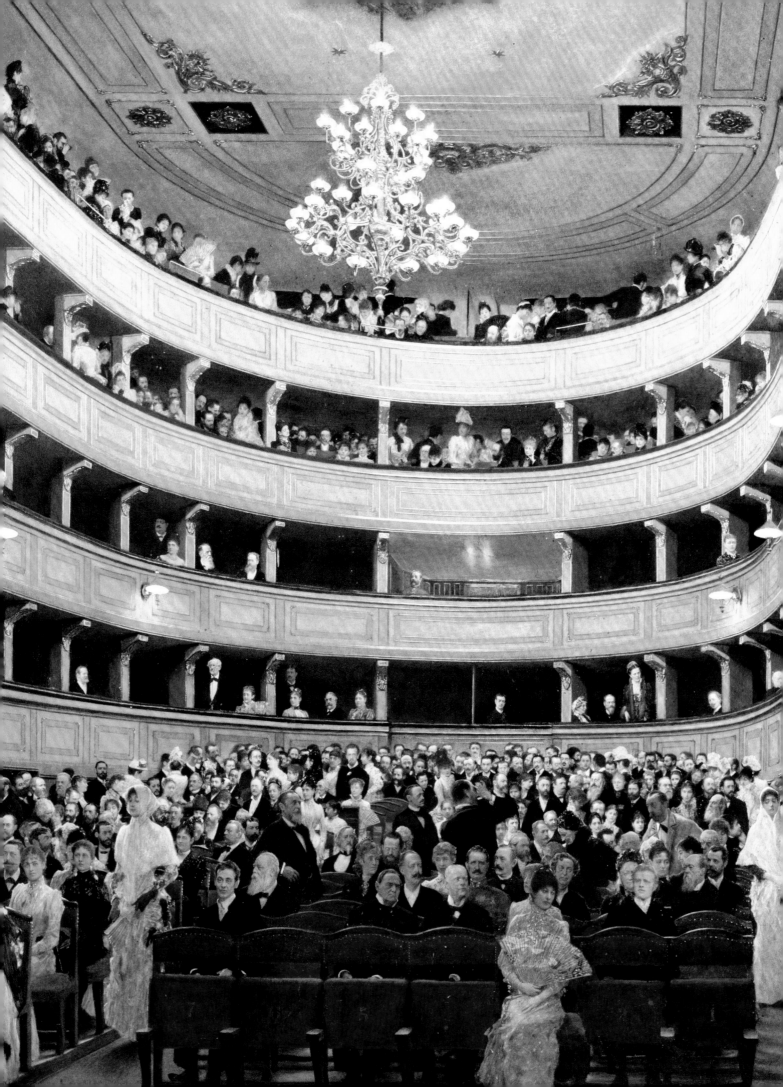

ON STAGE THE NEW VIENNESE

Gemma Blackshaw

When the 'old' Burgtheater, in which Mozart's *Marriage of Figaro*
was first given, was torn down, all of Vienna's society was formally
and sorrowfully assembled there; the curtain had hardly fallen
when everybody leapt upon the stage, to bring home at least
a splinter as a relic of the boards which the beloved artists had
trod; and for decades after, in dozens of bourgeois homes, these
insignificant splinters could be seen preserved in costly caskets,
as fragments of the Holy Cross are kept in Churches.[1]

In 1887, the artist who would become Vienna's most famous modern
portraitist – Gustav Klimt – was commissioned to paint a picture
showing the interior of the city's legendary court theatre, the 'Burg'
(fig. 1).[2] The Burgtheater, which adjoined the imperial palace on
Michaelerplatz in Vienna's First District, was due to be demolished.
For the Viennese, gathering in the theatre for the last performance in
October 1888, it was the end of an era; according to the papers, everyone
with a claim to social rank turned up to say goodbye. Demolition – of
old or precarious or unsuitable buildings, of values, traditions and
schools of thought – is one of the leitmotifs of the time and place that
has become mythically known as fin-de-siècle Vienna. Portraits played
a central role in the quintessentially Viennese staging of this 'end of the
century', so it is fitting that Klimt's commemoration of the 'Burg' took
the form of a group portrait. One hundred and thirty-one minutely
realised faces provided a 'Who's Who' of the upper echelons of Viennese
society, from aristocrats to the far more numerous politicians, bankers,
industrialists, journalists, surgeons, celebrities and others.[3] The *Auditorium
in the Old Burgtheater* has been interpreted as a portrait of the late
nineteenth century,[4] but it is also an image of the sector of society that
most defined this century: the middle classes. The patronage of this
diverse, dynamic and increasingly threatened social group was to
determine the course of Klimt's career, and to ensure the ineffaceable
association of portraiture with the flourishing of modern art in
Vienna around 1900.

FIG. 1
GUSTAV KLIMT (1862–1918)
Auditorium in the Old Burgtheater,
1888–9
Gouache and watercolour,
with gold highlights
Wien Museum, Vienna

Sigmund Freud was not included in the 'Who's Who' of Klimt's painting, but he has since become synonymous with the middle-class world it represented. Freud's pioneering map of the mind has indelibly informed our interpretation of the anxious faces and nervous hands of those portrayed by Vienna's modern artists. Psychoanalysis had but the faintest of effects on painting in the city around the 1900 moment, but in our attempts to discern the 'truth' in an image of a society woman by Klimt – of their relationship, for example, or her neurosis – we assume a position rather like Freud, sat behind the headrest of that infamous couch.[5] From this position, we are less likely to ask why an artist like Klimt would have been commissioned to paint her portrait. What would it say about her politics and religion, her wealth and tastes, her heritage and ambitions? How, in other words, would it work to define her? The Freudian lens through which we view subjects such as this, living in their 'city of dreams', provides us with only one perspective on the modern Viennese portrait. The aim of this book is to peer through another lens, and in doing so, to discern in the development of this genre the highly self-conscious staging of middle-class identity across a wholly formative period in the city's history.

This period encompassed Vienna's reign as the Habsburg Empire's 'capital of culture' and the life of its most successful painter, Klimt. It opened with the establishment of Austria-Hungary as a dual monarchy in the *Ausgleich* (Compromise) of 1867,[6] and closed with its dissolution following defeat in the First World War in 1918. Geographically, Austria-Hungary was one of the largest countries in Europe, comprising 11 national groups. Under the terms of the *Ausgleich*, the State acknowledged the equality of the languages spoken by these groups, though this did not extend to Yiddish. Freedom of worship was also recognised, with the Empire supporting the religious cultures of Catholics, Protestants, Orthodox Christians, Jews and Muslims following the annexation of Bosnia and Herzegovina in 1908. The rapid development of the Austro-Hungarian rail network ensured that this multi-national, multi-faith population was mobile, moving to newly accessible urban centres for employment. As the capital city and imperial seat, Vienna was the centre of Austria's political, commercial and cultural landscape, and the focal point of the Empire's tremendous diversity. The population in the city virtually doubled between 1880 and 1890, passing the two million mark in 1910, making it the fourth largest city in Europe after London, Paris and Berlin. This was primarily the result of migration: Magyars, Slovaks, Serbs, Ruthenians, Romanians, Croats, Slovenes, Czechs and Poles, along with Germans and Italians, made Vienna one of the most heterogeneous urban populations of the day.

Vienna around 1900 has been described as a city with two obsessions: the stultifying life of the court on the one hand, and the vibrant existence of the theatre on the other.[7] The site of the old Burgtheater painted by Klimt was so revered because it physically connected the two, providing the imperial family with direct access from their apartments in the Hofburg to the stage. Participation in the world of the 'Burg' was the means by which the Viennese expressed their sense of belonging to the city and declared their 'cultural capital' – the symbolic as opposed to economic assets that would enable them to move up through society.[8] Participation extended from attending performances to collecting the photographs and autographs of the theatre's leading actors and actresses (fig. 2) and following their star-studded lives as described in Vienna's newspapers. The importance of this socio-cultural function of the 'Burg' to the city's aspiring immigrant population cannot be overstated. But theatre was not the only form of cultural capital on offer: the visual arts of the present day and, as we will go on to see, of the *Alt-Wiener*

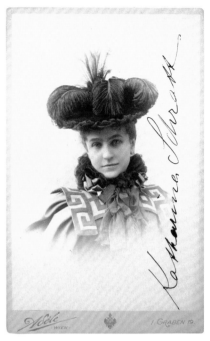

FIG. 2
Carte de visite photograph of the Burgtheater actress Katharina Schratt signed with her autograph, about 1890.
Österreichische Nationalbibliothek, Vienna

(Old Viennese) past, were also to play a vital role in the cultivation of *Neu-Wiener* (New Viennese) middle-class identity.

Vienna was the hub of the Empire's art world. Despite sharing capital status with Budapest, and despite the importance of other artistic centres under imperial rule, such as Prague, Vienna was the city with the most developed infrastructure for the production and consumption of art.[9] Geographically, its close proximity to Munich established it on the Western European map of the modern art market, though this position was a peripheral one until the founding of the Vienna Secession in 1897. Secessions were a Central European phenomenon of the late nineteenth century. Taking their name from the verb 'to secede' (to withdraw), they defined themselves in opposition to the academies, providing their avant-garde members with professional representation and, through this, middle-class status. The Vienna Secession, to which Klimt was elected president, set a particularly important example (fig. 3). It was created in order to bring the most progressive European painting to the city through a vibrant temporary exhibition programme that quickly became central to the city's cultural calendar. The artists Josef Hoffmann and Koloman Moser produced bespoke architectural, interior and graphic design schemes for shows that attracted record-breaking numbers of visitors. Conceived in the manner of the *Gesamtkunstwerk* (total art work) and photographed accordingly for publication in luxury journals, these ever-changing Secessionist rooms created the culture of the exhibition that is so familiar to audiences today.

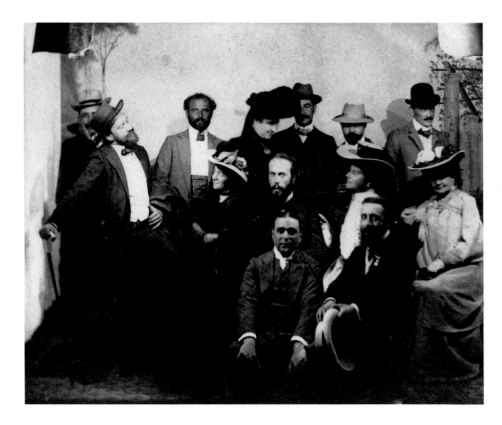

FIG. 3
Group photograph taken during the early days of the Vienna Secession. Josef Hoffmann (far left, standing); Carl Moll (second from left, standing, with walking stick); Gustav Klimt (third from left, standing); Koloman Moser (far right, standing, in bowler hat). About 1898

The Vienna Secession was also significant for the way it filtered Eastern Europe's first responses to modern art produced in the West, providing truly foundational retrospectives of movements such as Impressionism.[10] The fact that this encounter with Western European art happened so late in Vienna's history goes a long way towards explaining the distinctiveness of modern Viennese art. Klimt's painting of the old Burgtheater was produced almost a decade before the founding of the Secession. It might seem stilted when compared to contemporaneous images of theatres by the French Impressionists, but seeds of modernity lay in this bed of formality. The commission to commemorate the old theatre through an image of its audience was a herculean task. No preparatory drawings of the highly differentiated faces exist and this suggests that Klimt worked from photographs, relocating each face into the theatre space once it was drawn. This accounts for the figures appearing so lost in their thoughts, despite being clustered in groups – an alienation that Klimt did not attempt to disguise. The resulting disjuncture between social cohesion and psychological estrangement recalled the paintings of Edouard Manet, but this was not the only innovative aspect of Klimt's painting. In depicting the theatre from the stage, Klimt represented Viennese society as an audience of actors, observed and observing one another in their costumes and roles. Such a viewpoint was typical of progressive Western European painting, brilliantly evoking the tensions between reality and fantasy, 'truth' and deceit, that defined the experience of the theatre and that of modern middle-class life.

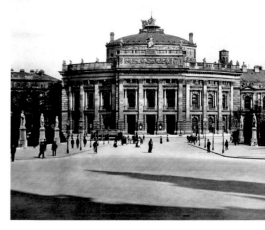

FIG. 4
Exterior view of the New Burgtheater, Vienna, built by Gottfried Semper and Karl, Baron of Hasenauer, 1874–88. Photograph, 1904

FROM THE PRIVATE TO THE PUBLIC SPHERE

The audience of the old Burgtheater consisted primarily of the city's middle classes, and this sector of society was to experience dramatic changes during the nineteenth century. The period covered by this book begins in 1867 with the *Ausgleich*, which gave all citizens of Austria-Hungary equal rights. To understand the significance of this legislation to the middle classes, we need to look back further into the nineteenth century, to the neo-absolutist regime of Klemens von Metternich, Austria's first State Chancellor, who was in power from 1821 to 1848. Responding to Europe-wide anxieties about liberal power following the rise and fall of Napoleon Bonaparte, Metternich founded a repressive political system based on monarchical legitimacy and authority. Living in a police state that suppressed democracy, censored the press and restricted rights of assembly, Vienna's middle classes retreated to the

home. The vibrant cultural life of the home typified the period known as the Biedermeier era, a term that described the apparent contentedness of the middle classes in this private sphere.[11] But in the March revolutions of 1848, Austria's liberal middle classes broke into the public sphere, rising up against Metternich and forcing him to resign. Conservative power was restored within a matter of months, but from 1859 to 1869, under the reign of Franz Joseph I (1848–1916), constitutional government replaced the Metternich regime, and parliamentary liberalism oversaw an era defined by democratic reform and economic boom.

This 'golden age' in Vienna's nineteenth-century history was characterised by three inextricably linked phenomena.[12] The first was the spectacular rise of the city's *Bürgertum* or upper middle classes – as represented by Klimt in his painting of the old Burgtheater. The second was the taste of this sector of society for historicism: the replication of historical styles in architecture; the representation of historical events and costumes in art; and the recreation of historical pageantry in festivals and masked balls. And the third was the demolition of the medieval fortifications that surrounded Vienna's old town centre to create the Ringstrasse – a circular boulevard edged with bombastic public buildings and private palaces built and decorated in the historicist style. The 'Ring' was an architectural declaration of the political, cultural and commercial might of the *Bürgertum*. Fittingly, it was the location for the new 'Burg' (fig. 4), which was constructed in the Baroque style and celebrated for its wholly modern use of electric lighting to illuminate the stage. But the Ringstrasse itself was as much a site for performance and display as the new theatre (fig. 5). The 'Ringstrasse Corso' described the self-conscious perambulations of the moneyed and fashionable Viennese around this avenue; the *Ringstrassenzeit* denoted the era in which they came to power.[13]

Vienna's upper middle classes were the part of society most altered by
the liberal heyday of the 1860s and 1870s. They comprised those families
who had been awarded titles for recent service to the Emperor, who
had amassed considerable fortunes, and who mingled with the old yet
minor aristocracy who recognised their importance in establishing the
supremacy of the dual monarchy. New opportunities for political activity
and social mobility, and new emphases on the conferring of status
through the accumulation of cultural capital as opposed to the privilege
of birthright, made the *Bürgertum* one of the most dynamic sectors of
Viennese society. The 1867 constitution of the *Ausgleich* was of particular
importance to Europe's Jewish community, radically transforming the
composition and confidence of the Empire's *Bürgertum*. Many of Vienna's
most powerful upper-middle-class families had Jewish immigrant back-
grounds and connections. As the Jewish writer Stefan Zweig observed, it
was through culture that such families claimed Viennese citizenship and
went on to define it at its most discerning: 'They were the real audience,
they filled the theatres and the concerts, they bought the books and
the pictures, they visited the exhibitions, and with their more mobile
understanding, little hampered by tradition, they were the exponents
and champions of all that was new.'[14]

The 'new' described by Zweig was modernism, a pan-European
movement in the arts of the mid-to-late nineteenth century that was
identified by its avant-garde call for artistic experimentation and moral
emancipation. In Vienna, modernism was identified with liberal politics
and Jewish audiences, and this made it increasingly vulnerable to attacks
from the city's burgeoning right wing. The stock market crash of 1873
turned many working- and lower-middle-class Viennese citizens against
the Liberal Party as that of 'Jewish speculators'. Conservative, nationalist
and anti-Semitic mass movements developed in the city in its aftermath.
Modernism itself – in theatre, music, literature and the visual arts –
became a target of right-wing attack, with commentators moving
effortlessly from discussions of form and aesthetics to discourses on
disease and degeneration. By 1889, the year of the completion of Klimt's
painting of the old Burgtheater, the Christian Social Party leader Karl
Lueger was a significant enough political figure to be included in the
audience, albeit as a last-minute addition, seated close to Katharina
Schratt, one of the theatre's leading actresses and the Emperor's
companion (fig. 6, detail of fig. 1).[15] By the early 1890s Lueger's party was
in the ascendant and in 1895 it defeated the Liberal Party in the City

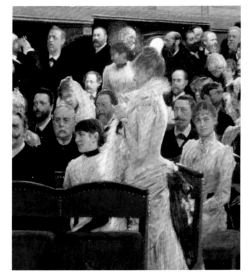

FIG. 6
GUSTAV KLIMT (1862–1918)
Auditorium in the Old Burgtheater,
1888–9, detail. Lueger has a full
beard and is seated to the far left;
Schratt is seated to the far right.

Council elections.[16] Lueger's populist, anti-Semitic rhetoric raised fraught questions about the constellation of Jewish, liberal, modernist and upper-middle-class identities. His infamous justification for having Jewish friends – '*I decide who is a Jew*' – reveals much about the uncertainties that faced many members of Vienna's *Bürgertum*.

'WHO'S WHO?': THE MIDDLE CLASSES

What did it mean to be middle class in Vienna around 1900? Individuals identified as middle class could have diametrically opposed views on trade, education, religion and the political liberation of women, to give but a few examples. The plural form adopted throughout this essay, and the distinguishing of the *Bürgertum*, the upper middle classes, from the *Mittelstand*, the lower middle classes, goes only some way towards conveying the intricate hierarchies that defined and divided this sector of society. The question of what constituted middle-class identity in the political climate of Christian Social Vienna was posed through portraiture. Portraits could take many forms in the city's rich visual and material culture, from drawings and photographs, to postcards and death masks, but the painted work on canvas was of particular importance. As the most expensive mode of portrait production, which was identified with the aristocracy up until the early nineteenth century, it revealed the city's middle classes at their most aspirational.

The investment of the middle classes in their painted representation accounts for the sheer size of portraiture as an industry in the city and the number of styles it was able to support. Responding to Vienna's ideological tensions, sitters selected their artists with care. Their status as emergent or established practitioners, their professional affiliations (to the Künstlerhaus for example – home to Austria's oldest artists' society – or the Secession, identified with the new), their influences and traditions, and their reputations and fees signified as much if not more than their skill in the depiction of their subject. The variety of artists that sitters were able to choose from, and the patterns of preference we can discern in the history of their commissions, show how attuned the city's portrait industry was to their differing tastes. The proliferation of portraiture across both conservative and more progressive modes of painting registered and elaborated on the political and cultural diversity of the middle classes.

Two examples of portraits from either end of this deeply divided sector of society illustrate this diversity. When the young Lueger commissioned Hermann Nigg to paint his portrait (fig. 7), he turned to the popular historicist style of the 1870s and 1880s, as exemplified by

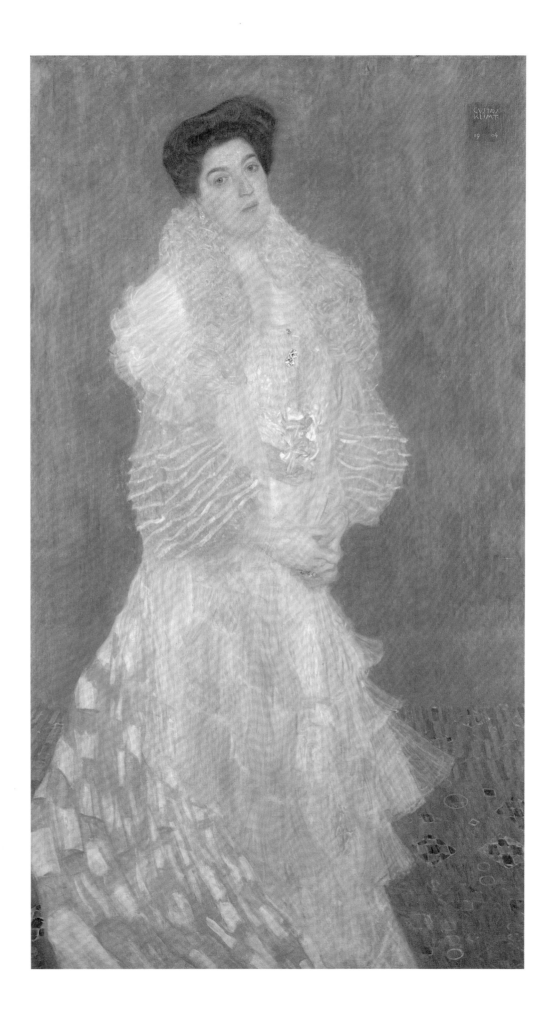

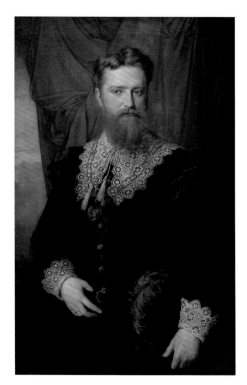

Hans Makart – the self-styled 'Prince of Painters' so sought-after
that only the upper middle classes and aristocracy could afford to sit
for him. As a fledgling artist, aged just 27 at the time of the commission,
Nigg's prices were within Lueger's reach. Moreover, as an artist with
ambitions to paint the highest echelons of Viennese society – the imperial
family – which he went on to realise in the 1880s, Nigg was a decidedly
less flamboyant painter than Makart, working in a style more suited to
Lueger's conservative position; the aspirations of both artist and sitter
thus mutually reinforced one another. Lueger's portrait was painted
in 1876, one year after his election as deputy of the city's municipal
assembly – a position that provided him with the platform to agitate
against the city's Liberal mayor, Cajetan von Felder.[17] Dressed as a
Renaissance courtier, with velvet coat, lace collar and plumed hat,
Lueger revealed in this early portrait his ambition to become a leading
politician – able to rub shoulders with imperial and government
officials, while concealing his modest past as the son of a caretaker.
The aristocratic mode of dress and presentation also obscured Lueger's
political sympathies as a social conservative who championed the
cause of the working and lower middle classes.

Lueger's rise to power forms the political backdrop to a portrait from
the opposite end of Vienna's middle-class spectrum: Klimt's image
of Hermine Gallia of 1904 (1). The industrialist Moriz Gallia and his wife
Hermine were Jewish-born and wed, and had moved from the Empire's
northern reaches of Moravia and Silesia respectively to Vienna in the
late nineteenth century.[18] Their four children were baptised as Catholics,
though Moriz and Hermine were to remain members of Vienna's Jewish
community until 1910, when they formally withdrew. Their support of
the Secession was another means by which they declared their Viennese
citizenship and, in the process, redefined what this citizenship signified
at its most urbane and worldly. When they commissioned Klimt to paint
this portrait, the Gallias made a very particular statement about their
cultured identity and class. Klimt was Vienna's most progressive and
expensive artist – identified, as Zweig described it, with the 'new' – and
a portrait by him served to position Moriz and Hermine as one of the
leading couples of the *Bürgertum*. Such a commission declared their ability
to not only appreciate but also cultivate avant-garde forms of portraiture.
Aristocracy in this context was not a matter of birth, but of taste.[19] The
pleasure Hermine took in Klimt's image of her as the new aristocracy of
Vienna is revealed in a family biography that describes a photograph taken
over a decade later. It shows her in the same pose, with her head similarly
tilted and hair arranged, 'trying to live up to Klimt's picture'.[20]

Klimt's *Damenporträts*, or portraits of society women, are central to a
highly influential study of the artist and the world of Vienna 1900 by the
cultural historian Carl E. Schorske.[21] The majority of these portraits were
completed in the first two decades of the twentieth century, in the midst
and aftermath of the outcry over Klimt's paintings for the University of
Vienna.[22] The University paintings were a crossroads, taking the artist
from the historicism of his early years to the modernism of his last two
decades – a direction that horrified many Viennese. In his cornerstone
book, Schorske interprets the *Damenporträts* as agents of Klimt's
retreat from the public sphere that had turned so suddenly against
him. Describing the shift from the University paintings to these portraits
and evoking their display in the sitters' private palaces, Schorske writes:
'The painter of psychological frustration and metaphysical malaise
became the painter of an upper-class life beautiful, removed and
insulated from the common lot in a geometric house beautiful.'[23] The
flight to the private sphere – to the interior of the home but also of the
mind – is identified by Schorske as one of the leitmotifs of Viennese
modernity. The hostilities of Christian Social Vienna, he argues, placed
the city's *Bürgertum* under a metaphorical house arrest, and the only
compensation was to fill their homes and minds with art.

Schorske describes these homes as the 'fragile shelters' of the *haut
monde*, and in this context it is interesting to consider the display of the
portrait of Hermine in an early interior. In a photograph of 1916 of the
Gallia residence on Wohllebengasse (Good Living Street), which was
situated close to the imperial palace and gardens of the Belvedere, we
see the portrait installed in the lady's salon on the first floor, to the left
of an elegant column (fig. 8). This salon, along with four other rooms
along this floor devoted to leisure and entertaining, was designed by
Hoffmann in 1913. Klimt's portrait of Hermine was an integral part of
this *Gesamtkunstwerk*: her white, pleated dress, contained within a long,
rectangular frame, found its architectural equivalent in the white fluted
columns of the new salon. Was this home and this art a 'fragile shelter'
for the Gallias and for Klimt? Klimt's *Damenporträts* are described by
Schorske as 'a-social portraits', representing the disillusionment and
detachment of the artist and his sitters. But these works of art were
as public as they were private. Displayed in exhibitions, described
in newspapers and reproduced in journals, they were more socially
engaged than Schorske would lead us to believe.

Hermine's portrait was seen in public before being displayed at home –
despite being unfinished – in Klimt's sensational one-man show at the

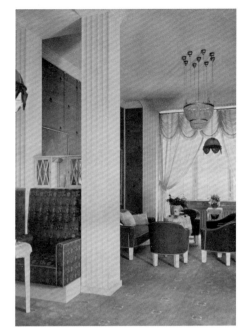

FIG. 8
Photograph of the Gallia apartment
decorated by Hoffmann, in
Deutsche Kunst und Dekoration,
volume 37, 1915–16, p. 407.

FIG. 9
Photograph of the Gallia portrait
installed at the *Klimt Kollektive*
of 1903, in *Die Kunst*, volume 10,
1904, p. 355.

Secession in 1903. Photographs of this exhibition, designed by Hoffmann and Moser, were published in journals devoted to the fine and decorative arts. Readers of *Die Kunst*, for example, could see the portrait of Hermine *in situ* in a quintessentially Secessionist arrangement of furniture and soft furnishings, decoration and painting, placed symmetrically between two of Moser's cubic chairs (fig. 9). The *Klimt Kollektive* exhibition included all three of the University paintings, which were exhibited alongside one another for the first time, and a further five *Damenporträts*. Despite competing with what proved to be the most provocative paintings in the history of early twentieth-century Viennese art, the *Damenporträts* more than held their own in the reception of the exhibition. For the critics, these women represented Viennese society at its most elegant and refined. Descriptions of their sensitivity and sensuality, their finely modelled faces and 'filmy *toilettes*', proliferated in the press.[24] Conservatives were appalled by Klimt's University paintings but the embrace of the *Damenporträts* in the city's centre to right-wing press pointed to how these works of art might 're-socialise' him. In this context, 'Klimt's women' were not the faces of his retreat from the public sphere but the hands that would lead him back to favour.

BODIES, SCREENS

The same conservatives who embraced Klimt's *Damenporträts* were to turn aggressively against the younger artist Oskar Kokoschka when he exhibited a series of 23 portraits at the city's Hagenbund in 1911, which included an image of Lotte Franzos, the young wife of a Viennese lawyer (2). The society women represented by Klimt were not named in the Secession's catalogue or exhibition reviews, but in the Hagenbund guide

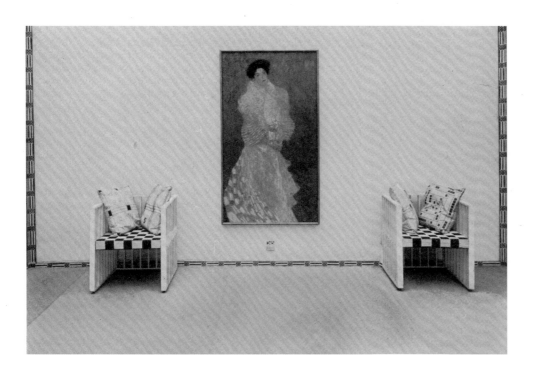

2
OSKAR KOKOSCHKA (1886–1980)
Portrait of Lotte Franzos, 1909
Oil on canvas, 114.9 × 79.4 cm
The Phillips Collection,
Washington, DC

3
HANS CANON (1829–1885)
Girl with Parrot, 1876
Oil on canvas, 126 × 84.6 cm
Belvedere, Vienna

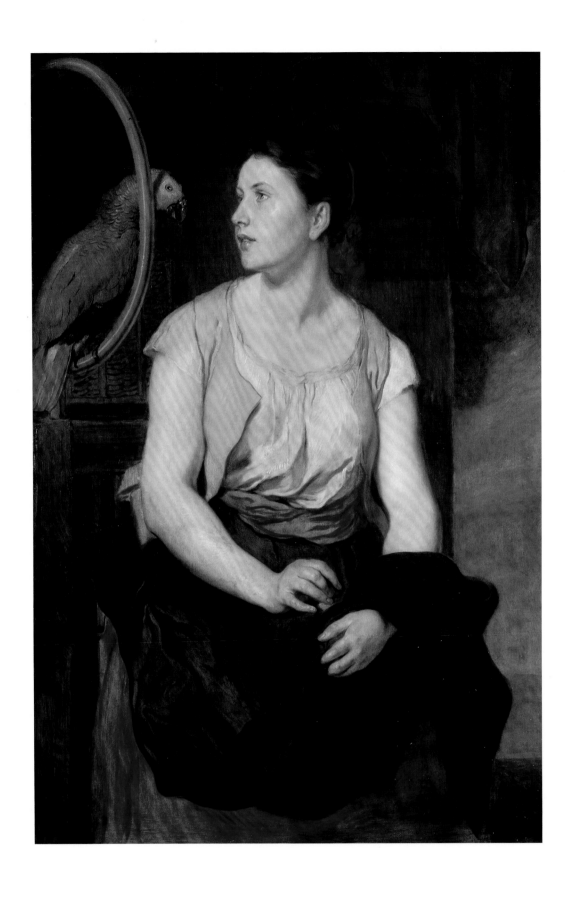

Lotte was identified by her initials, and in the press she was named directly. Josef Strzygowski, writing for *Die Zeit*, exclaimed in horror: 'What a foul smell emanates from the picture of Frau Dr Franzos!'[25] Alarmed by the representation of Lotte's fetid body, Strzygowski's accusation – this portrait *smells* – highlighted the direction avant-garde painting had taken in the work of a new generation of Viennese artists. Responding to the seemingly insatiable demands of the city's middle classes for portraits, and encouraged by discerning patrons keen to move on from *Secessionstil*, Kokoschka and his artist contemporaries were to become even more fixated than Klimt on the image of the individual, producing hundreds of works on canvas and paper between them. We see in Hans Canon's 1876 image of his wife (3) – with her flexed arms and splayed fingers – that the expressive depiction of the body was already a feature of Viennese portraiture, but artists working in the early years of the twentieth century took this further in their embrace of the contorted and corrupted body. Irrespective of their gender and age, or the attractiveness of their frames and features, sitters portrayed by these artists were all depicted as painfully thin and unnaturally tense.

Hermine was so pleased by Klimt's portrait of her that she would take up the same pose for photographs later in life; Lotte was not so enamoured with her portrait by Kokoschka. In a letter sent soon after its completion, Kokoschka wrote to thank her for the photographic portrait she had sent him in order to remind him of her beauty. He gently informed her in return that he was not an 'anatomy-still-life-painter' (meaning an Academy portraitist) or a 'cosmopolitan-stylist' (meaning Klimt). This was a different form of portraiture: 'Your portrait shocked you, I saw that. Do you think that the human being stops at the neck in the effect it has on me? Hair, hands, dress, movements, are all at least equally important.'[26]

Klimt was as interested as this younger generation in the expressive qualities of hair, hands, dress and movements, but the representation of the body in his portraits was concentrated increasingly in the face and hands. Brightly coloured and richly decorated fabrics gradually encroached on Klimt's bodies, encasing them in flat panels of pattern to the neck and wrist. Schorske describes one of the aims of the Vienna Secession as 'a critical assault on the screen of historicism and inherited culture with which bourgeois man concealed his modern, practical identity'.[27] Klimt, along with his fellow artists Hoffmann and Moser, left the Secession in 1905, in order in part to concentrate on their project to draw the fine and decorative arts together in an ever-closer embrace. But in doing so, the screen of historicism was replaced with the screen of

FIG. 10
GUSTAV KLIMT (1862–1918)
Auditorium in the Old Burgtheater,
1888–9, detail. Serena Lederer is
wearing a black hat.

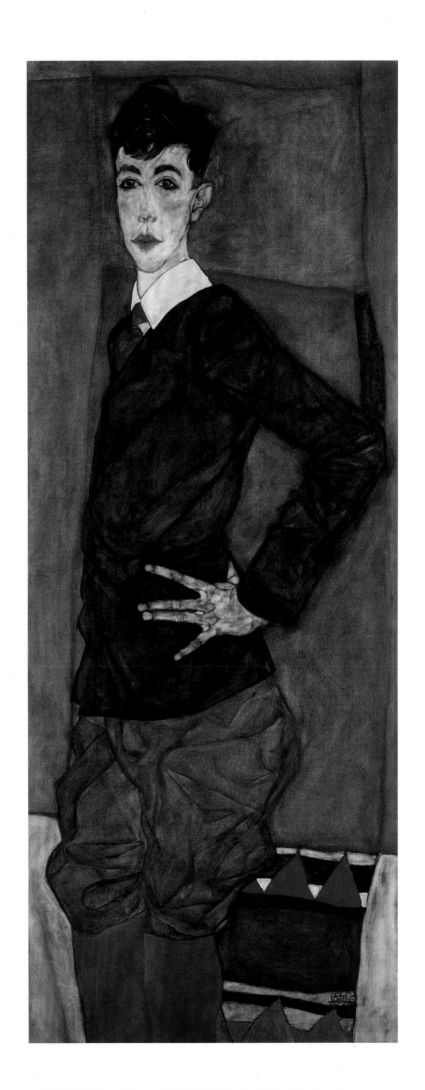

4
EGON SCHIELE (1890–1918)
Portrait of Erich Lederer, 1912
Oil and gouache on canvas,
140 × 55.4 cm
Kunstmuseum Basel
Gift of Frau Erich Lederer-von
Jacobs, in memory of her
late husband

ornamentation. The dresses that Klimt's sitters appeared in were resolutely contemporary, but they were no less a disguise than the historicist costumes concocted by his predecessor Hans Makart. Kokoschka's description of the importance of the effects of the human body from the neck down exemplifies how this new generation of painters differentiated their work from Makart and Klimt, removing the screen to reveal the modern body that lay behind it in all its shocking physicality.

We see from Lotte's dismay at her portrait that to be represented in such a way was an acquired taste, and one that few female patrons developed. Hardly any of Klimt's clients posed for this new generation of artists, and this shows a considerable degree of anxiety about what such portraits, in the new style, might say about upper-middle-class identity. Was it disease-ridden, for example, and therefore degenerate? The rise of anti-Semitism in Vienna, which equated Judaism with theories of racial impurity and decline, alerted would-be patrons to such questions. In this context, the Jewish industrialist August Lederer, who was born in Bohemia in the north-west of the Empire, and his wife Serena, who was included in Klimt's painting of the old Burgtheater (fig. 10, detail of fig. 1), were exceptions to the rule. In 1912 they commissioned the

5
OSKAR KOKOSCHKA (1886–1980)
Portrait of Hugo Schmidt, 1911
Oil on canvas, 72.5 × 54 cm
Private collection

6
OSKAR KOKOSCHKA (1886–1980)
Portrait of Max Schmidt, 1914
Oil on canvas, 90 × 57.7 cm
Museo Thyssen-Bornemisza, Madrid

young Schiele to paint the portrait of their teenage son, Erich (4). In his depiction of Erich's long, pale face – the dark eyebrows and full, red lips – and most especially in the thin hand with elongated fingers splayed against the hip, Schiele created a picture of awkward adolescence that spoke to his own image as an emergent artist. Portraiture and self portraiture, as we will go on to see, were to become mutually defining practices, with sitters increasingly opting to pose for artists who would portray them in their own damaged image. Most members of the *Bürgertum* were apprehensive of such developments and this is indicative of the socio-political crises that defined the city in the years leading up to the First World War; in such a context, the new aristocrats required an image as stable as the old.

The generation of artists working after Klimt appealed, then, to a different sector of middle-class society: educated, cultured and liberal, but with considerably less wealth and power than his clients from the *Bürgertum*. Able by virtue of their lower-class status to engage both critically and visibly with concepts of identity, and the political climate that made them so contested a matter, the intellectuals and professionals painted by these artists were willing to take risks with their representation for the sake of what was considered 'authentic'. In their revealing of experimental painting processes, unfinished works show the gambles such sitters took, and we see this in Kokoschka's portraits of the Schmidt brothers Hugo, Max and Carl Leo (5, 6, 7) who ran the highly successful furniture and fittings company F.O. Schmidt. But was the body that signified this authenticity any less of a screen? In its function, was it any different to the historicist costumes and contemporary fashions worn by the previous generation of portrait-sitters, was it any less theatrical? By looking at the development of the portrait across a formative period in the history of the city's middle classes this book aims to challenge some of the long-held beliefs we share on portraiture and the advent of Viennese modernism at the turn of the twentieth century.

THE FREUDIAN SCRIPT

In his autobiography *The World of Yesterday*, Stefan Zweig reflected on the importance of the relationship between theatre and society in Vienna: 'The Burgtheater was for the Viennese and for the Austrian more than a stage upon which actors enacted parts; it was the microcosm that mirrored the macrocosm, the brightly coloured reflection in which the city saw itself'.[28] In purchasing an autographed photographic print of the theatre's leading lady, Katharina Schratt (fig. 2, see p. 16), Burgtheater

devotees declared their investment in this Viennese institution and the city that had enabled such a woman to rise so meteorically through Austro-Hungarian society. Schratt was from the lower middle class, but through her roles on stage she became the 'uncrowned Empress' – lifelong confidante to the Emperor Franz Joseph and chatelaine of a palace opposite the magnificent *Hofoper* (court opera house) on the Ringstrasse. The print of Schratt thus also functioned as a mirror, reflecting back the image of the city's aspiring middle classes. The cult of the theatre and its celebrities was, as Zweig described, quintessentially Viennese, and it shows how attuned the city was to what we might think of as the theatricality of modern life. Identity, in this very particular socio-cultural context, was understood in terms of re-invention, drama and disguise. The middle classes were the most altered and ambitious sectors of Viennese society and this made them especially receptive to the different ways in which identity could be staged. As a representation of a single and by implication singular individual, the portrait was of central importance, becoming the means by which members of this class could direct themselves in their own starring roles.

To consider portraiture in 'Freud's city' as a conscious act as opposed to an unconscious impulse is to depart from the script we usually turn to in order to understand its art and culture. Freud's concept of the human subject as one ruled by instinctual drives and traumatic memories, destined to play out an Oedipal drama of oppression and revolt, has become utterly central to our notion of the modern in Vienna around 1900, and as images of human subjects, portraits have been especially implicated.[29] The Freudian script stresses the private over the public, the young over the old, the unmediated over the deliberated and the authentic over the artful. In doing so, it privileges the generation of artists working after Klimt, the *Jung-Wiener* (Young Viennese), accepting their highly charged rhetoric of firstness and truthfulness. This book takes, by contrast, the *Neu-Wiener* (New Viennese) as its subject, considering the twists and turns in the history of this class throughout the long nineteenth and early twentieth centuries. It thus expands the time frame usually covered in such studies of modern Viennese art – tracing lines of continuity between Biedermeier, historicism and modernism – and introduces unfamiliar paintings, including those by women artists and Jewish artists, as well as less well-known forms of portraiture, such as death masks. Our own celebrity culture is such that we are drawn to the idea of the remarkable artist, the psychoanalytic interpreter of his age; this book offers a new approach, re-scripting the story of the modern portrait as that of the city's middle classes: the New Viennese.

7
OSKAR KOKOSCHKA (1886–1980)
Portrait of Carl Leo Schmidt, 1911
Oil on canvas, 97.2 × 67.8 cm
Carmen Thyssen-Bornemisza
Collection, on loan at the
Museo Thyssen-Bornemisza,
Madrid

ON STAGE: THE NEW VIENNESE

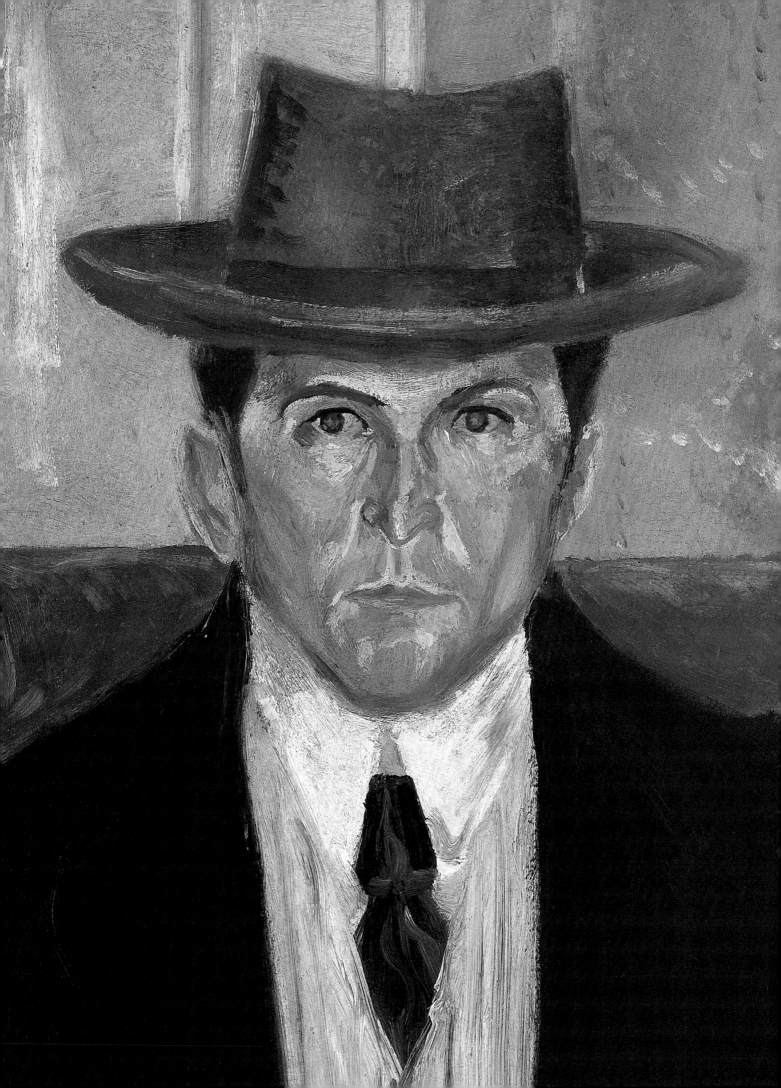

PAST TIMES AND PRESENT ANXIETIES
AT THE GALERIE MIETHKE

Gemma Blackshaw

The year 1905 was an eventful one in Vienna's cultural calendar. On 25 January, the composer Arnold Schönberg conducted the premiere of his scandalous fifth opus *Pelleas und Melisande*.[1] The subject was the forbidden love of the two title characters, but it was the discordant form of the composition that outraged the audience. Reflecting on the controversy, Schönberg recalled: 'One of the critics recommended sticking me in an insane asylum and storing all music paper well out of my reach.'[2] A few months later, the psychoanalyst Sigmund Freud published his *Three Essays on the Theory of Sexuality*, which explored the sexual instincts of 'inverts', 'neurotics' and – most explosively – children.[3] Widely regarded as his most significant contribution to the theory of sexual development, this slim publication – 'as tightly packed as a hand grenade'[4] – shattered nineteenth-century ideas about the family, childhood, marriage and morality. The artist Gustav Klimt was also in the news. On 3 April he wrote a letter to the Ministry of Culture and Education withdrawing from the commission to decorate the ceiling of the Great Hall of the University of Vienna with three paintings celebrating the faculties of Philosophy, Medicine and Law – works he had already completed and exhibited. Klimt's unflinching representation of the naked body and bleak interpretation of the human condition was too private a matter for the censorious public sphere; professors and politicians were horrified. Highlighting the embarrassment he had caused the Ministry, Klimt broke the terms of the contract and turned his back on the State.

Such events were typical of the cultural and intellectual tumult that was Vienna 1900. They show the wholly conflicted nature of the city's middle-class attitudes to public and private lives, to gender and sexuality, and to tradition and innovation. This milieu and these attitudes informed another event in 1905: a portraiture exhibition, which opened at the Galerie Miethke in Vienna's old town centre on 28 April. The Miethke was one of the city's most progressive galleries, but the exhibition was

8

FRIEDRICH VON AMERLING
(1803–1887)
Emperor Franz I of Austria, Study
for the Official Portrait of 1832, 1832
Oil on canvas, 29.9 × 21.8 cm
Cartin Collection USA, courtesy of
Daxer & Marschall, Munich

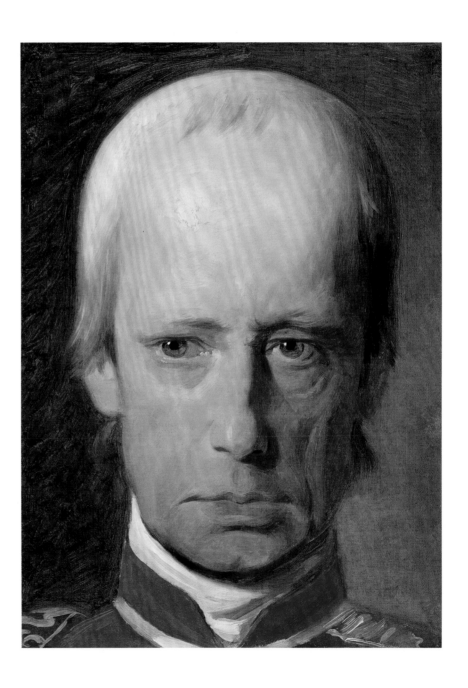

not concerned with the art of the day; rather, it looked to the art of the past, to a period that was regarded by many as being somewhat outmoded: the *Biedermeierzeit* of the early nineteenth century. The show was devoted to what was described in the press as the *Alt-Wiener* (Old Viennese) portrait. One hundred and forty-six portraits by a wealth of artists working in the city from 1800 to 1850 were brought together to offer a survey of a genre that was considered quintessentially Viennese. Subjects included the Emperor Franz I, who founded the Austrian Empire in 1804 (8),[5] and Ludwig van Beethoven on his deathbed, but such aristocratic and heroic figures were in the minority. Most of the faces on display were those of Vienna's *Bürgertum* or upper middle classes. Visitors to the exhibition – the vast majority of whom were also middle class – felt a warm glow of familial connection as they walked around the gallery space. As one reviewer commented:

> The faded picture of the artistic culture of our grandfathers and great-grandfathers, which can now only be comprehended in occasional features and which, the more it disappears, seems all the more delicious and endearing, has been held fast for a fleeting moment by a careful selection in the current exhibition at Miethke's. Here is a most delightful proof of the pleasures inherent in getting to know a piece of home-grown art and culture.[6]

The connoisseur and gallerist Hugo Haberfeld wrote the catalogue that accompanied this 'careful selection' of works. Haberfeld – like Schönberg, Freud and Klimt – was one of Vienna's moderns, and although the exhibition did not contain any modern portraits, they were very much in his mind. For him the exhibition was exciting precisely because it expressed 'the links of our modern painters with the masters of Old Vienna'.[7] One of the defining features of modernism is its call for a break with the recent past. In the Viennese context, the historicism of the 1860s, which attained such dizzy heights in the 1880s, was rejected, and the art of a more distant, less spectacular past revived. Haberfeld was one of many in the city at this time who turned to the traditions of the early nineteenth century in order to legitimise the innovations of the early twentieth century. What prompted the taking of such protective steps? To answer this we should return to the milieu and attitudes of Vienna 1900 – to the critic who told Schönberg he belonged in an asylum, to the professional frustrations of Freud seeking recognition for his pioneering work on the mind, and to the attacks on Klimt's ceiling paintings as the work of a madman.[8] The city's avant-garde, and the sector of society that supported it both intellectually and financially, was under

threat around the 1900 moment. In looking to the Biedermeier era, in 'holding fast for a fleeting moment' the rose-tinted features of the Old Viennese, the Miethke exhibition assuaged the anxieties of the New Viennese – the city's modern, and by now much-altered, middle classes.

A PROFOUND GAZE

One of the most popular Biedermeier paintings exhibited at the Miethke was Ferdinand Georg Waldmüller's *Portrait of a Young Man in Black* of 1842 (fig. 11). Posed dynamically, as if about to rise from his chair, the sitter stretches his hand out to the viewer, appearing to engage them in animated conversation. This work was continually singled out in the reviews for its sparkling sense of subjectivity, and in this, its proto-modernity. For the art critic Berta Zuckerkandl, it was the most precious period portrait of all those on display in that it communicated across time so consummately, providing her contemporaries with a 'profound gaze into the soul of the individual'.[9] Zuckerkandl was one of the city's most ardent voices in support of modern art, professing to speak for Klimt – her friend and a reticent public speaker – from her column in the left-wing Viennese daily, the *Wiener Allgemeine Zeitung*. Her response to what she described as Waldmüller's 'profoundly penetrating' mode of depicting individuals reveals a great deal about the development of the portrait in her own lifetime. For Zuckerkandl and her contemporaries, the pictorial languages of the Biedermeier and the Modern spoke to one another. To consider how, we should put Waldmüller's young man in black into dialogue with a quintessentially *Neu-Wiener* (New Viennese) painting – an image widely regarded as Vienna's first truly modern portrait.

In 1898 Klimt painted the young Sonia Knips, a member of the minor aristocracy who had recently married an upper-middle-class iron magnate. In her portrait (fig. 12), Knips sits on the edge of a snow-white garden chair amid a tangle of orchids. It is night-time and the surrounding darkness, shot through with 'restlessly weaving open air lights'[10], envelops the pale pink tulle of her evening dress. Klimt's brushwork is as restless as these lights: thin, agitated lines convey the rustle of her dress with its many folds, frills and fastenings. This impressionistic way of painting then changes, unexpectedly, at the face. Knips's delicate features – the flushed cheeks, the sheen on the top of her lip, the swell of her rounded chin – are depicted in exquisite, fine detail.

Such detail looked back to the traditions of the Biedermeier period, to the painting of an artist like Waldmüller; painting which was made

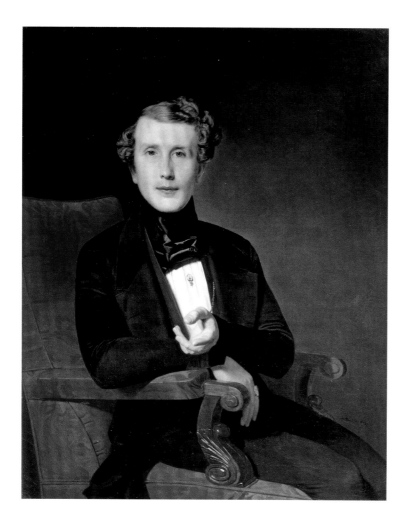

FIG. 11

**FERDINAND GEORG
WALDMÜLLER** (1793–1865)
Portrait of a Young Man in Black,
1842
Oil on canvas
Belvedere, Vienna
Loan from the Association of
Friends of the Österreichische
Galerie Belvedere

modern by Klimt by being confined, as here, to this single area of the
canvas – the face. This face is turned directly towards us; Knips holds our
attention with the directness of her gaze and the questioning arch of her
eyebrow. She grips the arm of the chair with such force that our encounter
with her seems charged with tension. This tension – which is both
psychological and painterly – is what makes the portrait so thoroughly
of its time, and also of its place. On seeing it at the Secession in 1903,
one critic remarked: 'It takes a lot of daring for a lady to sit for Klimt;
he places frightful things in their eyes. It's lucky that most people see
far too inaccurately to recognise the "fleurs du mal" [flowers of evil]
that he allows to bloom on their cheeks'.[11] Such a response shows how
the conflict between propriety and impropriety that defined Viennese
middle-class experience was very much a part of the city's public
discourse; portraits articulated it like no other cultural form.

FIG. 12
GUSTAV KLIMT (1862–1918)
Portrait of Sonia Knips, 1898
Oil on canvas
Belvedere, Vienna

It was works like this that Berta Zuckerkandl had in mind when she looked at Waldmüller's painting of a young man in black. She did not know the name of the sitter, but he was painted with such startling immediacy that she felt able to reach him nevertheless. Perched, like Knips, on the edge of his seat, he is so present, so engaged, that he appears poised to speak to us. This portrait by Waldmüller was as lifelike and as modern as that by Klimt. It produced in Zuckerkandl what she described as a comparable 'psychological thrill'. Such a response to the porcelain-like perfection of a Biedermeier painting might strike us as strange. We are more attuned to the psychological thrill of a modern painting, like Klimt's portrait of Knips, with her tight collar and her clenched hand. But the naturalism of Biedermeier portraiture – the gleam of the skin, the hint of the tear in the eye – was considered as psychologically compelling as what would become known as the expressionism of modern portraiture. For Zuckerkandl, the 'total veracity' of Waldmüller's painting – its absolute adherence to the natural, the particular, and even the peculiar – was the precedent for the work of an

artist like Klimt. And it wasn't just Waldmüller's portraiture that so captured her attention. The work of his contemporaries, such as Friedrich von Amerling, who painted the fretful face of the engraver Franz Xaver Stöber in 1837 (9), was also cast in what Zuckerkandl described as a 'wholly new light'.[12]

This dialogue between portraits from the Biedermeier and Modern periods is rarely discussed in presentations of the work of Klimt and his contemporaries, but it provides us with a real insight into the Viennese middle-class mind around the 1900 moment. In his foreword to the catalogue accompanying the exhibition, and in an echo of the critic who remarked that not all would recognise the 'fleurs du mal' on Knips's cheeks, Hugo Haberfeld wrote: 'He who has eyes to see can read a portrait gallery as one reads a history of culture.'[13] But whose culture was actually on display: that of the Old or the New Viennese?

OLD MASTERS, NEW CONTEXTS

The Miethke exhibition was organised by the artist and curator Carl Moll, a great friend of Klimt's and one of the founding members of the Vienna Secession. In his self portrait of 1906 (10), we glimpse him at work in his villa-retreat on the Hohe Warte in Vienna's fashionable and leafy nineteenth district. He is contained within the perfect square (the canvas measures 100 × 100 cm) of Secessionist design; a format first used by Klimt in his portrait of Knips. The diagonal position of the early nineteenth-century mahogany sideboard, placed on the diagonal pattern of the tiled floor, invites the eye to travel along other such lines. Van Gogh's mother, in the painting at the top left, turns her head towards George Minne's sculpture of a kneeling naked boy, his head tilted in the same direction as Moll, absorbed in contemplative work at the absolute centre of the composition. The arrangement of these three heads – tilted in sympathy – expresses at a formal level Moll's relationship with the Secession and commitment to its interest in the art of Western Europe: Minne's sculpture was exhibited in the eighth Secession exhibition of 1900; the Van Gogh portrait was included in the sixteenth in 1903.

The self portrait also, however, represented Moll's break with the Secession. In November 1904, while still a Secession member, he was appointed creative director of the Miethke. As a rival commercial gallery, this presented a professionally awkward situation, and in June 1905 – ten days after the *Alt-Wiener* portrait exhibition had closed – Moll, Klimt and their closest colleagues left the Secession to work exclusively through the Miethke.[14] Moll went on to curate major and formative exhibitions

9
FRIEDRICH VON AMERLING
(1803–1887)
Portrait of Franz Xaver Stöber, 1837
Oil on canvas, 41 × 33 cm
Liechtenstein. The Princely
Collections, Vaduz-Vienna

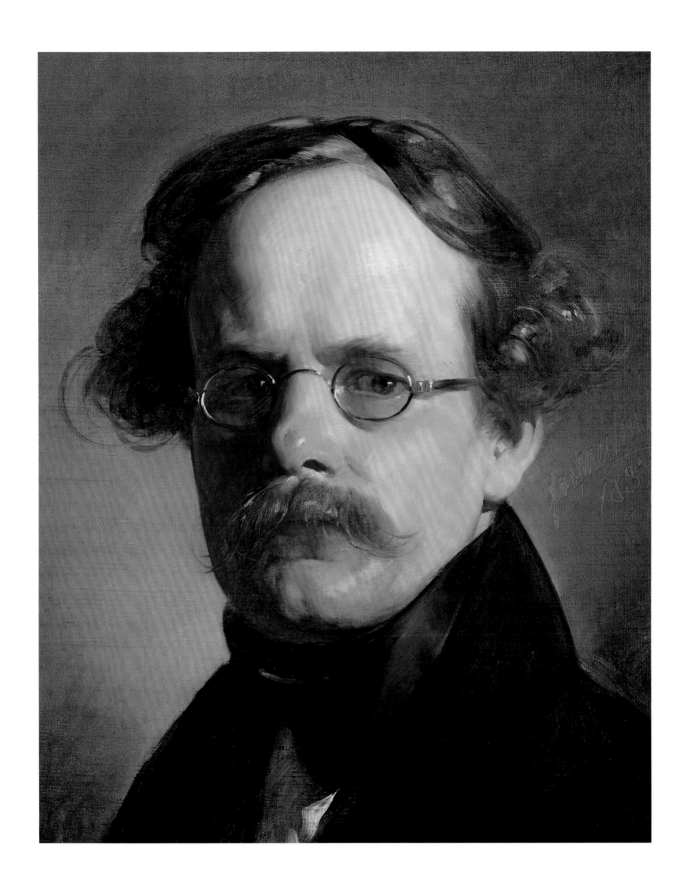

at the Miethke devoted to the work of Van Gogh in 1906, and Minne in 1910, among many others, bringing the most progressive art from abroad to Austria. But he chose to inaugurate his new role with an exhibition devoted to Ferdinand Georg Waldmüller (November–December 1904) – the painter of the young man in black – which was followed by his survey of the *Alt-Wiener* portrait (April–May 1905). The invitation card to the Waldmüller exhibition announced that the aim of this programme was to nurture Biedermeier painting, and in the accompanying catalogue essay Hugo Haberfeld proclaimed that this would connect Vienna's Old Masters with its new moderns. With this distinctive curatorial agenda – identified by one conservative art critic as 'the new regime'[15] – Moll tied the city's moderns into a history of the *Biedermeierzeit* as it was being written through the Miethke exhibitions. For Moll and those associated with him – poised to make the avant-garde move of seceding from the Secession – being modern at this particular moment in time was as much about looking back to the Austrian past as it was about looking out to the painting of Western Europe.

This was expressed through Moll's self portrait, painted a matter of months after the *Alt-Wiener* portrait exhibition had closed. The artworks that surround Moll – by Van Gogh and Minne – were stridently of the day, but Moll also represents himself as of the past by posing as the Biedermeier professional, working from home. Moll might have had Friedrich von Amerling's portrait of Rudolf von Arthaber and his three children of 1837 in mind, since he selected this work for the Miethke exhibition, displaying it at the centre of a room devoted to the artist (figs 13; 14). Amerling's chequered floor, silk curtain and glimpse of a wall-hung painting were absorbed and adapted by Moll in ways that – though subtle and suggestive – would not have been lost on his contemporaries, who had so recently seen this work at the Miethke. But Moll's interest in Amerling's portrait was about more than the painting itself – its setting, structure and style – it was also about class, and in particular the identification of one *bürgerlich* man with another, across the tumultuous nineteenth century.[16] Moll lived in the same rural nineteenth district of Döbling that Rudolf von Arthaber had chosen as the location for his villa, the Tullner Hof, over 70 years earlier. Moll collected art, albeit on a less ambitious scale than Arthaber, who amassed a collection of over 100 works, which were displayed in his own picture gallery in this villa. And both men were middle class. As an industrialist, Arthaber was considerably richer than Moll, but in turning back to this Biedermeier portrait for his own representation, Moll – working from *his* villa,

10

CARL MOLL (1861–1945)
Self Portrait in his Study, 1906
Oil on canvas, 100 × 100 cm
Gemäldegalerie der Akademie der bildenden Künste Wien, Vienna

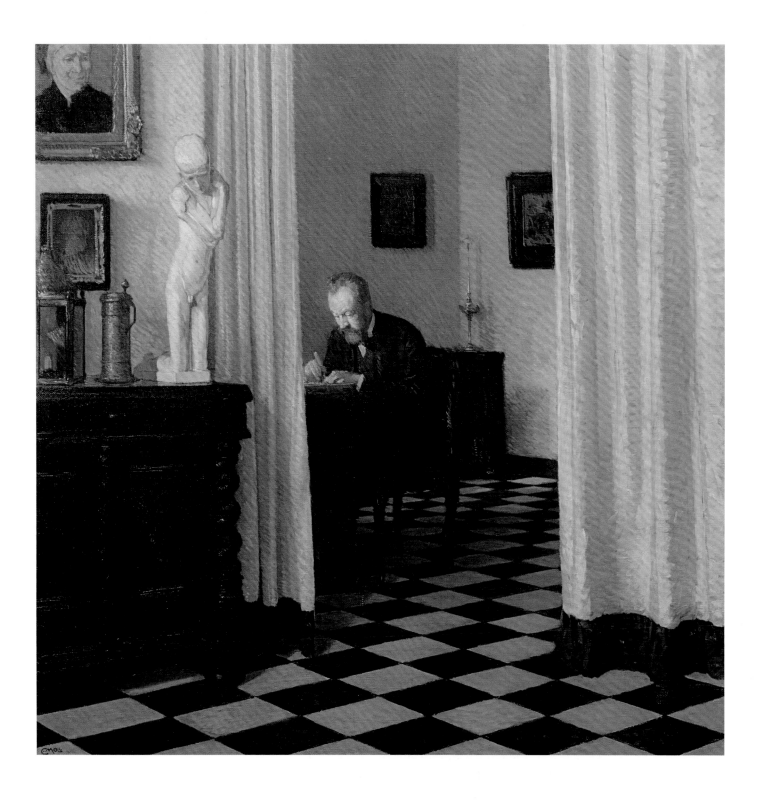

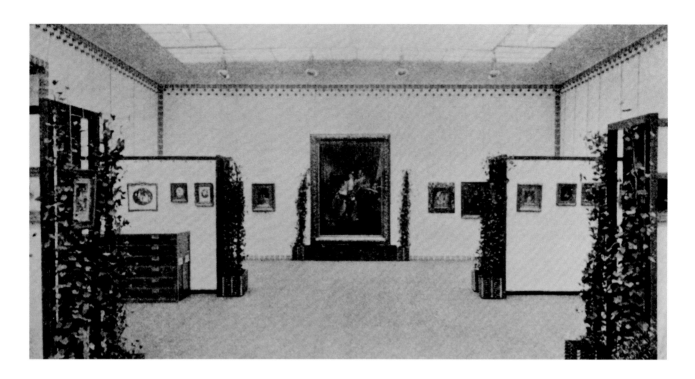

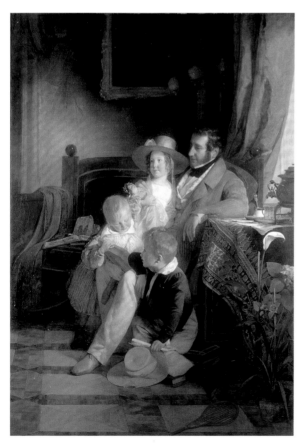

FIG. 13
Installation photograph of the
Alt-Wiener exhibition at the
Miethke Gallery in 1905.

FIG. 14
FRIEDRICH VON AMERLING
(1803–1887)
*Portrait of Rudolf von Arthaber
with his Children Rudolf, Emilie
and Gustav, 1837*
Oil on canvas
Belvedere, Vienna

surrounded by *his* art collection – made an aspirational claim for
the comparable significance of his own life, work and legacy.

Interestingly, this framing of the modern with the Biedermeier
also worked in reverse. In the photograph of the *Alt-Wiener* portrait
exhibition we see that Amerling's portrait of Arthaber took centre stage
in a minimalist space that offered the very latest in exhibition design.
The portrait was framed by verdant climbers in square planters, reminis-
cent of those that decorated the terraces of Moll's villa on the Hohe
Warte,[17] and set against a plain white wall, the strict linearity of which
was emphasised by decorative borders. Such an installation consciously
evoked the exhibitions at the Secession designed by Josef Hoffmann
and Koloman Moser, who were soon to work with Moll and Klimt at
the Miethke. Their work, which was described as *Raumkunst* – the art of
space – elevated exhibition design into an art form. The documentation
of these spaces through photographs such as this, which were published
in lavish design journals, shows how important these installations were
to the narratives of art being written through the exhibition. Through
its display in this new context, this modern frame, Amerling's *Alt-Wiener*
portrait became a *Neu-Wiener* painting, an image of the day that spoke
to Moll and his contemporaries in particularly resonant ways.

MODERN INTERPRETATIONS

Vienna's moderns were as interested in the social history of *Alt-Wiener*
portraiture as they were in the work itself, and they offered a very
distinctive interpretation of it. In the catalogue that accompanied
Moll's exhibition, Hugo Haberfeld proposed that the development of
the Viennese portrait in the early nineteenth century was due to the
effects of political alienation on the city's middle classes. Newly wealthy
yet politically disenfranchised during the Age of Metternich, which saw
the First State Chancellor of Austria suppress democracy, this sector
of society turned to portraiture for representation. Haberfeld claimed:

> The *Alt-Wiener Bürgertum* were kept away from public business
> dealings and were externally constrained by the prescriptions of
> the police state, so they developed the pleasures of domestic and
> social life to an unimagined extent.[18]

Haberfeld felt that men such as Rudolf von Arthaber, who was a liberal
agitator petitioning for concessions at court and from the government,
were forced to turn to the home for self-definition. Portraiture captured
this change in their circumstances. Ultimately, it became the means of

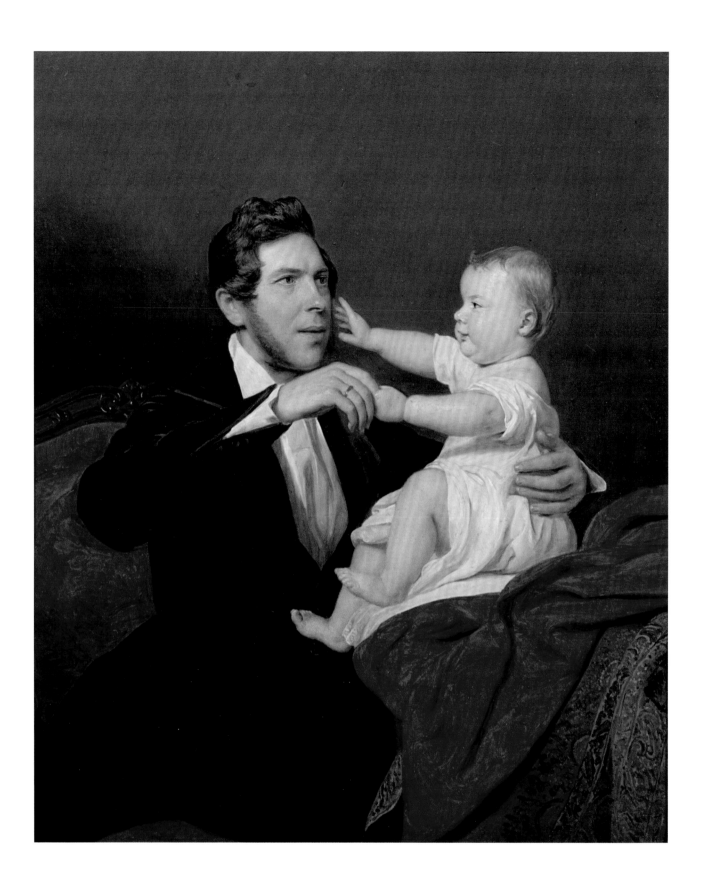

11
FERDINAND GEORG WALDMÜLLER
(1793–1865)
Portrait of Militia Company Commander
Schaumberg and his Child, 1846
Oil on oak, 31.8 × 26.2 cm
Gemäldegalerie der Akademie der
bildenden Künste Wien, Vienna

12
FERDINAND GEORG WALDMÜLLER
(1793–1865)
Portrait of Schaumberg's Wife, 1846
Oil on oak, 31 × 25.6 cm
Gemäldegalerie der Akademie der
bildenden Künste Wien, Vienna

a representation that could not otherwise be achieved under a political regime which utilised espionage to monitor liberal dissent, removed university professors and newspaper editors with liberal sympathies from post, and passed legislation to limit the freedom of the press.[19] *Bürgerlich* men compensated for their lack of political power by finding agency in the home, through the roles of husband, lover, father and provider. The commissioning, collecting, displaying and exchanging of portraits both realised and – as they were looked at – perpetually reproduced the soothing assurances of their domestic relationships and paternal authority. As Haberfeld explained:

> The patriarchal communications within the family and the sentimental contacts between friends and lovers often meant that a picture was proof of affection which was often given and gladly received.[20]

As 'proofs of affection', portraits were the source of pleasure. They enabled middle-class men to experience many times over the confirmation of an identity that was under threat outside the home in the suspicious atmosphere of the Metternich state.

This interpretation casts Waldmüller's portrait of Militia Company Commander Schaumberg and his child (1846) in an interesting light. The portrait was one of a pair that included an image of the Commander's wife (11, 12). Unusually, their child was depicted alongside the Commander. In a remarkably dynamic pose for a painting of this size (31.8 × 26.2 cm), Schaumberg encircles his almost-upright infant as it extends its arms to touch his cheek and grasp his fingertips. Unsteady, yet balanced by its father's responsive body, the child situates Schaumberg's masculinity within the family home – an unexpected location, we might think, considering Schaumberg's role within Austria's local militia.[21] Haberfeld's interpretation of Vienna's politically alienated *Bürgertum* provides us with a context for this location, and leads us to consider how the portrait might have expressed the Commander's resistance to being confined to the home – Schaumberg holds his child, but looks beyond it with a frown. In characterising the Viennese middle-class experience as that of liberal repression and dissension, Haberfeld alerts us to the complexities of Waldmüller's modest pair of paintings. But what was it that motivated Haberfeld's reading of such work? What might his approach to the *Alt-Wiener* portrait of the early nineteenth century reveal about the political and cultural outlook of the early twentieth century?

By 1905, the year of Moll and Haberfeld's exhibition, Vienna's middle classes were very different in their composition to the *Alt-Wiener Bürgertum* on display in the gallery space. This was now a multi-national, multi-ethnic and multi-faith sector of society, comprising many families with Jewish immigrant backgrounds and connections; Haberfeld himself, as the son of a Jewish industrialist, was typical. The *Ausgleich* of 1867, which gave all citizens of the Empire equal rights, reversing the values of the Age of Metternich, enabled the *Bürgertum* to grow in size and in confidence. But from the 1890s onwards, with the re-establishment of a politically conservative regime that institutionalised anti-Semitism, this group found itself under threat once more. In his landmark study *Fin-de-Siècle Vienna: Politics and Culture*, Carl E. Schorske argued that the Christian Social Party's landslide victory in the City Council elections of 1895 signalled the decline of liberalism as a political and cultural force in the city. With their values increasingly under attack, this sector of society retreated from the public world of politics to the private world of art, substituting aesthetic contemplation for civic action. The cultural ferment of Vienna 1900, of the work of Freud, Schönberg and Klimt, was the expression of their alienation.

Schorske's model has been heavily critiqued in recent years. For some, the political defeat of the Liberal Party did not mean the destruction of liberal values in politics or culture; for others, Schorske's characterisation of the *Bürgertum* as simply 'liberal' is not sufficiently specific. This sector of society was also, and to a very great extent, Jewish, and as such its increasingly contested religious and ethnic identity needs further thought. But what remains very convincing, nevertheless, is the chiming of Schorske's interpretation of the *Neu-Wiener* with Haberfeld's interpretation of the *Alt-Wiener*. Haberfeld, writing in 1905, explained the proliferation of Viennese portraiture in the early nineteenth century in almost exactly the same terms as Schorske writing about the early twentieth century. The similarity suggests that in interpreting Biedermeier portraiture as the anxious retreat of the *Bürgertum* from the hostile advance of the public sphere, Haberfeld was revealing as much about Vienna's present as its past.

The rediscovery of Biedermeier painting could only be made in this modern context of political uncertainty and social unrest. The troubled milieu and conservative attitudes of Vienna 1900 were an unwelcome reminder of the Age of Metternich and the adage that 'history will repeat itself'. This made the Biedermeier notion of the domestic life as one of

retreat and refuge – of mental freedom – all the more compelling. But given the radically altered composition of Vienna's *Bürgertum*, it was also all the more complex. Interiors of the private sphere – of the home and of the mind – were to become crucial to the modern transformation of Biedermeier portraiture, from the social to the psychological.

13

LEOPOLD CARL MÜLLER
(1834–1892)
Portrait of Victor Tilgner, about 1899
Oil on canvas, 95 × 68 cm
Gemäldegalerie der Akademie der
bildenden Künste Wien, Vienna

PSYCHOLOGICAL PORTRAITS

One of Schorske's most powerful and pervasive ideas on Vienna 1900 is that the political crises of the fin-de-siècle provided the push towards the birth of psychological man – 'a creature of feeling and instinct'.[22] In Klimt's portrait of Sonia Knips, and in other less well-known works such as Leopold Carl Müller's portrait of the sculptor Victor Tilgner (13), we see how Vienna's moderns embraced this creature. Portraits of the past and present day were valued according to how vividly they brought the sitter 'to life'. This led not only to the modern interest in the Biedermeier but also to the rediscovery of an Austrian artist who had died only recently, in 1889: Anton Romako.

Romako's work was reappraised by Carl Moll directly after the Waldmüller and *Alt-Wiener* portrait exhibitions in a posthumous one-man show, also at the Miethke.[23] In the eyes of the moderns, Romako connected the psychological naturalism of the Biedermeier with the psychological expressionism that typified the early years of the twentieth century. His mode of depicting Vienna's middle classes in their highly self-conscious states, standing in empty spaces that seem charged with the energy of their discomfort and agitation, was to set an important precedent for later artists, such as Oskar Kokoschka and Max Oppenheimer. In his 1909 painting of the art historians Hans Tietze and Erica Tietze-Conrat, Kokoschka was also concerned to convey the intensity of his sitters' inner worlds through expressive mark-making – such as the frenetic scratching of the painted surface with the wooden tip of a brush (55; see p. 168). And in his 1910 portrait of Heinrich Mann, Oppenheimer depicted the novelist with eyelids half shut against the light that emanates from his head (14). But this modern interest in Romako's work was not simply a matter of painting – of how he realised a 'psychological portrait' with palette and brush. It was also a matter of class – an acknowledgement of the beginnings of the conflicts that characterised Vienna's modern *Bürgertum*, the first stirrings of those creatures of feeling and instinct.

MAX OPPENHEIMER (1885–1954)
Portrait of Heinrich Mann, 1910
Oil on canvas, 91 × 81 cm
Wien Museum, Vienna

In 1884 Romako was commissioned to paint the portrait of Christoph Reisser (16), the technical director of Vienna's leading liberal newspaper, *Die Neue Freie Presse* – a publication widely associated with the city's Jewish intelligentsia. Reisser holds a crumpled edition of this paper in his hand, its pages separated to suggest recent avid reading. A medal hangs from a bright red ribbon pinned to his jacket lapel. This medal was awarded to Reisser in recognition of his work towards the third World Exhibition that was hosted by Vienna in 1873, the motto of which was the liberal maxim 'Culture and Education'. Such values were to be irrevocably challenged just one week into the World Exhibition with the stock market crash. Reisser's portrait was painted by Romako some 12 years later, in the same year that Karl Lueger gained significant political ground by winning a seat in the Austrian parliament. In wearing his medal from the Liberal Party heyday at a time of extreme anti-liberal agitation, and in commissioning an artist widely regarded as the city's most radical portrait painter, Reisser made a very particular statement about his political and cultural identity – an identity that by 1885 was beginning to be undermined.

In this context, it is interesting to note that Reisser's portrait was not only an image of the man of business and enterprise looking back at his past achievements as a decorated Liberal; it was also an image that commemorated Reisser as a husband. Romako was commissioned to paint both Reisser's portrait and that of his wife, Isabella (15). The dimensions of the two works are identical, which suggests they were to be displayed side by side, to be enjoyed in the privacy of the Reisser home. Dressed in the opulent, corseted eveningwear of the late nineteenth century, with a golden bracelet in the form of a serpent snaking around her wrist, Isabella stands alone and alert in the same somewhat ominous space as her husband. The pairing of these two marriage portraits recalls the *Alt-Wiener* tradition as exemplified by Waldmüller in his depiction of Schaumberg and his wife – figures also removed from any pictorial context except that of a black and rather forbidding background. But in their painterly experimentation – the unfinished, agitated brushwork, the flickering, hallucinatory space – the portraits of the Reissers are at the same time *Neu-Wiener* paintings, pointing forward to developments in portraiture in the first decades of the twentieth century. In their innovation and their strangeness they show how the hostilities of the political sphere could generate highly progressive painting practices – portraiture at its most anxious.

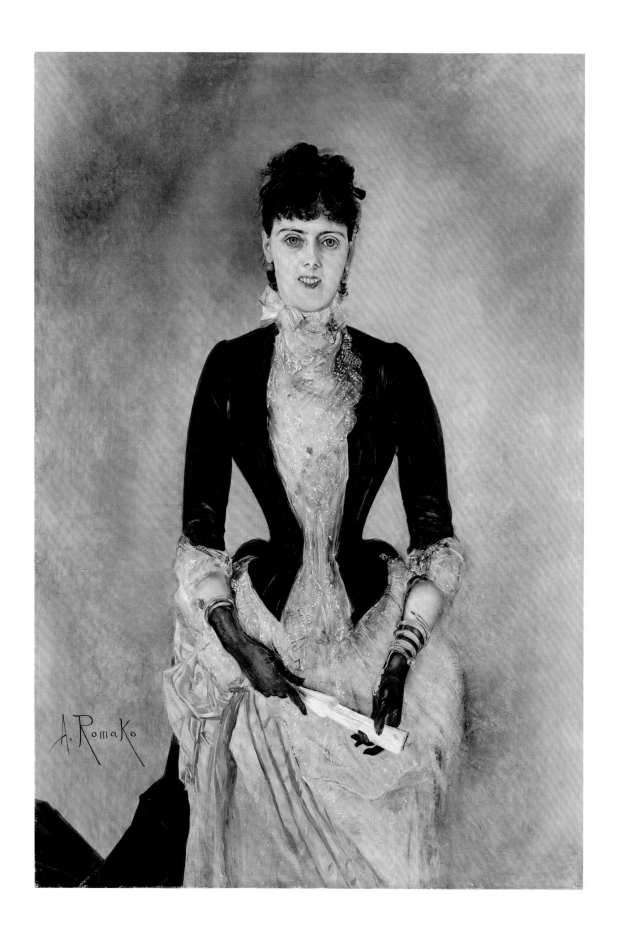

15
ANTON ROMAKO (1832–1889)
Portrait of Isabella Reisser, 1885
Oil on canvas, 130.5 × 90 cm
Leopold Museum Private Foundation,
Vienna

16
ANTON ROMAKO (1832–1889)
Portrait of Christoph Reisser, 1885
Oil on canvas, 130.5 × 90.5 cm
Leopold Museum Private Foundation,
Vienna

The interior played an important role in the creation of the psychological portrait. During the late nineteenth century, interiors were conceived as subjective, sensation-rich environments that conveyed not only the aesthetic tastes but also the psychic sensitivities of those who inhabited them. This notion of the interior as a cult of self was not specific to Vienna.[24] However, the turn of the moderns to the Biedermeier period – celebrated for its own embrace of the interior as a site of familial ritual and domestic intimacy – shows a very particular Viennese approach to a Europe-wide phenomenon. In characterising *Alt-Wiener* portraiture as the self-protective retreat of the upper middle classes to the family home, Hugo Haberfeld was also describing the project of *Neu-Wiener* portraiture. By 1905 families from Vienna's *Bürgertum* were, however, more loosely defined – encompassing friends and intellectual allies as well as kin – and homes could be sites of tension as well as safe havens. Artists with Jewish histories and connections are particularly interesting to consider in terms of this notion of the modern flight to the interior: Vienna's growing anti-Semitism was the cause of much concern, and such individuals felt themselves increasingly visible to the scrutinising public eye of Christian Social politics.

The artist Richard Gerstl was born into a typically mixed marriage, to an immigrant Jewish father who had prospered in Vienna and married a Roman Catholic, bringing up their family in comfort in the city's newly affluent ninth district of Alsergrund. The family's first-floor apartment on Nussdorferstrasse was the location for Gerstl's portrait of his brother Alois, standing to attention in his lieutenant's uniform (17). Alois claimed the portrait was the result of at least ten sittings, and even then it was left unfinished: the bottom right corner of the canvas, below his hands, is a later addition. The pointillist style of the portrait, with its shimmering surface, endows the interior scene with a nervous energy. Walled in by tables and chairs, a rise-and-fall pendant light, a window and a mirror that reflects the back of another, unidentified person, the representation of Alois standing in the dining room doorway is wholly claustrophobic. Research on the painting has revealed that it was divided up by the gallerist Otto Kallir ahead of the first exhibition devoted to Gerstl, which he curated at the Neue Galerie in Vienna in 1931.[25] The canvas was cut vertically to the left of Alois's right arm, and the two halves were exhibited separately as an interior and a portrait. In removing the figure from the interior he inhabited, Kallir failed to recognise the significance

of the apartment, the family home, to the Viennese image of the individual. The touches of violet paint across Alois's collar and cuffs, the mahogany furniture and edges of the window panes, are used to pictorially unify figure with setting. Here there is no distinction between interior painting and portrait painting – both speak of the modern psyche.

Gerstl's friend Arnold Schönberg placed his sitters in his more modest apartment rooms in Vienna's ninth and thirteenth districts. Schönberg's apartments served a number of different yet intrinsically related functions: home, study, rehearsal room, teaching space, exhibiting space and studio. His first, on Liechtensteinstrasse, where he lived with his wife and two children from 1903 to 1910, was memorably described by a visiting writer as a 'small yet deeply emotive world'[26], a place of respite, reflection and regeneration where the controversial composer – subject to vicious public attacks on his music – could protectively gather his friends, pupils and admirers around him. Schönberg depicted members of this extended family against the decorated walls of these apartments, perched uncomfortably on chairs and pressed up close to the picture plane. In the 1910 portrait of Hugo Botstiber (18) – a fellow Jewish musicologist who fled Nazi Austria in 1938, dying in England in 1942 – the proximity of the sitter and the intensity of his suspicious gaze make for decidedly uneasy viewing.

For the writer who visited Schönberg's apartment, the furnishing and decoration of the simple rooms mirrored the composer's 'peculiar and intriguing personality', his 'artistic nature and manner'; they reflected his 'voluntary loneliness' and 'artistic calling'. We see here how the interior functioned as both a physical place and a mental space, flickering with Schönberg's psychic and creative energy. In placing his sitters within this apartment, Schönberg subverted established conventions of the portrait as an image of an individual sat among the signs of the world he or she had created and belonged to. These were not portraits, but self portraits, speaking only of Schönberg, his instincts and emotions. For the musicologist Elsa Bienenfeld, who reviewed Schönberg's work in 1910, his paintings appealed not to the painter or the connoisseur of art, but to the psychologist, because they were 'no longer paintings, but wild confessions of a tormented, afflicted human soul'.[27]

RETROSPECTION, INTROSPECTION

At the end of his catalogue essay accompanying the exhibition of *Alt-Wiener* portraiture at the Miethke, Hugo Haberfeld reflected on the comforts of looking back at the art of early nineteenth-century Vienna, with its scenes of middle-class domesticity and material comfort, of music and play: 'And we, the heirs to that time ... would gladly surrender all the greatness of our isolating times for the smiling charm of those days of joyful dancing.'[28] The 'isolating times' that so defined Vienna 1900 and the work of artists such as Schönberg made the promises this art gave — of familial connection, socio-cultural belonging and economic security *despite* the political uncertainties of the world outside the home — all the sweeter. In highlighting the centrality of the *Bürgertum* to the development of Viennese art, the exhibition provided its *Neu-Wiener* visitors with a sense not only of heritage, but also of future longevity, that was all the more potent for being so fictitious. One critic of the exhibition discussed its appeal in terms of a family history, but this was a generation of grandparents imagined and claimed, rather than known: '... a warm breath of life still streams from these old pictures, and a gentle admonition that in these dated and forgotten examples there is a good spirit which might make the grandchildren inwardly wish that it might come back to life and work'.[29] The exhibition generated such nostalgia precisely because it simplified the complexities of the social group it was meant to represent: Vienna's modern middle-class history of immigration, intermarriage and assimilation was reassuringly smoothed over, as impenetrable as the varnished perfection of the Biedermeier painted face.

The Miethke exhibition exemplifies how ideas of the past are motivated (invisibly, as far as their authors are concerned) by socio-political anxieties of the present. Carl Moll's 'careful selection' of portraits, and Haberfeld's interpretation of them as images of a middle-class identity crisis, was in many ways a means of looking at their own fraught lives and times. The political alienation of Vienna's middle classes during the Age of Metternich, and their attendant turn to portraiture for compensation, was historicised as such because of the socio-political problems facing the city's *Bürgertum* at the opposite end of the century. If we accept that the idea of the *Alt-Wiener* was to a great extent driven by the desires and fears of the *Neu-Wiener*, then we must also acknowledge how this process of historicisation is ongoing, implicating us still. It will be for future generations to decide how this book's presentation of the portrait in Vienna 1900 speaks as much of our present as it does of the Austrian past.

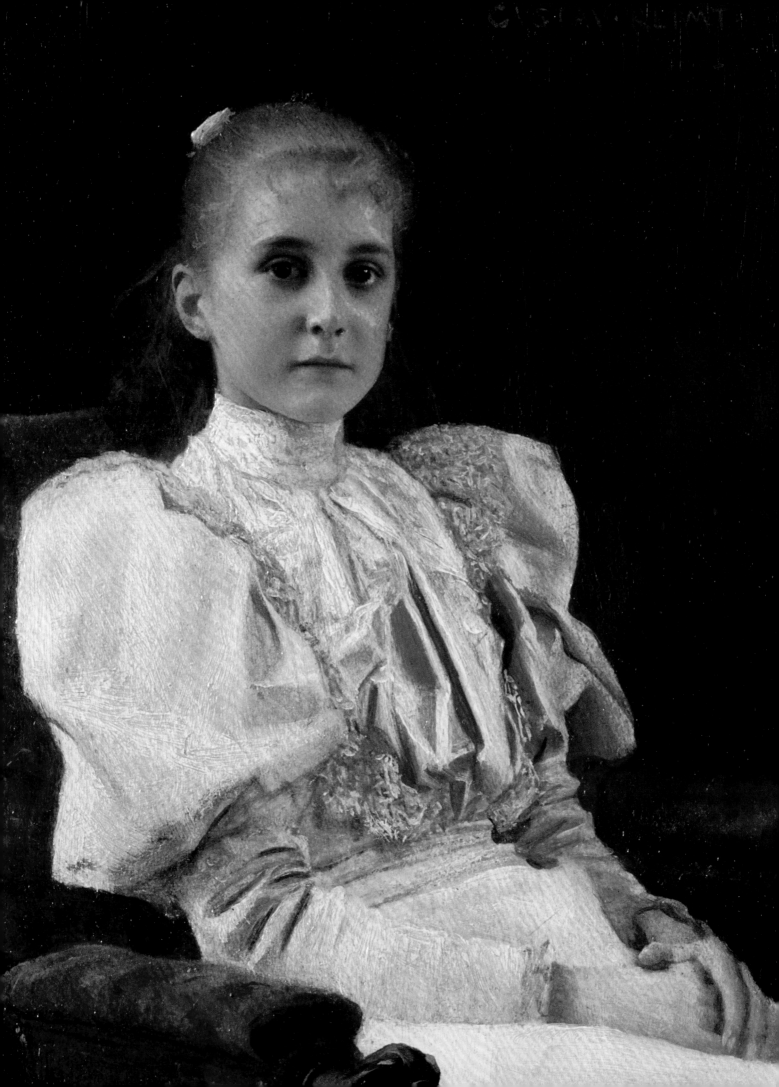

BIEDERMEIER MODERN
REPRESENTING FAMILY VALUES

Tag Gronberg

On 17 March 1899, Alma Schindler recorded her visit to the fourth Vienna Secession exhibition: 'Klimt took me personally to look at his *Schubert*. It's indisputedly the best picture at the exhibition … Schubert sits at the piano, surrounded by ultra-modern young ladies singing'[1] (fig. 15). Klimt's painting took the form of an imaginative portrait of the early nineteenth-century composer, who had achieved cult status. Franz Schubert (1797–1828), who was born and died in Vienna, was lauded as an indigenous cultural icon, and by 1899 tributes to him were a popular way of asserting Austrian prestige and identity. The Emperor Franz Joseph himself had opened the large centennial exhibition of Schubertiana at the Künstlerhaus in 1897.[2] In the context of the avant-garde around 1900, Klimt's conjunction of venerable tradition (Schubert) and the new (the 'ultra-modern') was characteristic of the Viennese strategy of defining modern art through reference to an earlier period, specifically the Biedermeier culture of the early nineteenth century. In 1899, when the architect Adolf Loos unveiled his strikingly austere redesigns for the Café Museum in the heart of Vienna, he explicitly cited the inspiration of coffeehouses of 'a hundred years ago'.[3] According to Loos, his bold modernisation of the Café Museum was not the result of innovation, but rather based on the famous Viennese *Kaffeehäuser* of the Biedermeier era (fig. 16).

'Biedermeier,' usually identified with the period extending from the Congress of Vienna (1814–15) to the revolutionary year of 1848, was more than a simple stylistic label.[4] It signified the early stages of a modernity characterised by urban growth and the concomitant rise of the middle classes.[5] In the case of Vienna, the term 'modernity' is often related to the later nineteenth century, particularly to the years around 1900, which saw momentous developments in art and intellectual life. The innovations of Vienna 1900 – in the arts, music, philosophy and psychoanalysis – would have (and continue to have) a profound international impact. But this 'golden age' of Viennese culture resonated all the more powerfully

against an awareness of Biedermeier as an earlier manifestation of modernity, during those first decades of the century in which not only the boundaries between European nations but also those between classes had been contested, negotiated and redrawn.

Such preoccupations with Biedermeier culture involved more than acknowledgements of past artistic achievements, whether in music or in architecture. By the late nineteenth century Biedermeier had come to signify a way of life and a means of ordering society. It is in this respect that images of Schubert are particularly telling. One of the most popular exhibits at the 1897 Schubert show, for example, was Julius Schmid's

painting *A Schubert Evening in a Middle-Class Viennese House*[6] (fig. 17).
The picture showed the Viennese as they liked to be seen – convivial and
cultured. Even more important, however, was the idea of the *bürgerlich*
(middle-class) home as the site of high culture. This surely appealed
to the Viennese *Bürgertum* (upper middle classes), for many of whom
a devotion to *Wohnkultur* (interior design) and patronage of the fine and
decorative arts was an important indicator of social status.[7] From this
perspective, Biedermeier society and culture could function not only
as a precedent, but also as a validation, of late nineteenth-century
middle-class aspirations.

FIG. 17

JULIUS SCHMID (1854–1935)
*A Schubert Evening in a Middle-Class
Viennese House*, 1897
Oil on canvas
Gesellschaft der Musikfreunde,
Vienna

FAMILY VALUES

Biedermeier visual culture was strongly identified with family values.
Indeed, 'Biedermeier', when used as a stylistic label for the decorative
and fine arts of the first half of the nineteenth century, has always evoked
associations with the domestic terrain of family life.[8] In the realm of
painting, depictions of the family were a key theme of Biedermeier
portraiture. These portraits provide interesting insights into the changes
and tensions in Austrian society of the time, but their value far transcends
that of simple descriptive documents. Aesthetically, these are subtle and
nuanced pictures, sensitive depictions of sitters and landscapes, arising
from new ideas about art and the artist. At the same time, such portraits

played a vital role in establishing the identity and status of both individuals and families. In its own period, Biedermeier imagery of *bürgerlich* domesticity was important in the complex renegotiations of class identity across the social spectrum, for the aristocracy and the royal family as well as for the *Bürgertum* itself. However, the significance of Biedermeier art did not cease with the liberal revolutions of 1848. As the century drew to a close, artists (such as Klimt and Loos in 1899) variously referred to 'Biedermeier' in order to legitimise what they claimed as distinctively modern – and Austrian – in their own practice.[9] Indeed, Biedermeier culture remained a crucial point of artistic reference throughout the years covered by this book. In this sense, therefore, Viennese portraiture can usefully be addressed in terms of a 'long nineteenth century', extending from the early 1800s to the First World War.

Many of the characteristics that are recognised as quintessentially Biedermeier today are displayed in Ferdinand Georg Waldmüller's portrait of the Eltz family, painted in 1835 (fig. 18). Waldmüller was one of the most successful artists of his day, and the magnificent Eltz picture is testament to his prowess as a painter of both portraits and landscapes.[10] The Eltz family are shown on summer holiday in Bad Ischl, a spa town in western Austria, where they owned a villa. Ischl became increasingly fashionable over the course of the nineteenth century, and by 1835 it was already equipped with the accoutrements of a desirable continental spa: a hotel, a theatre and (perhaps somewhat counter-intuitively from the

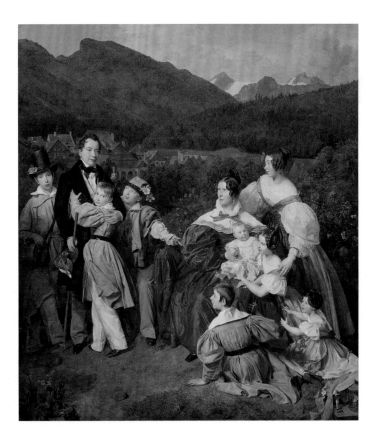

point of view of today's health regimes) a renowned *Konditorei* (cake shop). In its choice of prestigious artist and stylish location, this portrait commission made an evident claim for the social status of its sitters. Dr Eltz worked in the legal profession, and today's official title of the picture *The Notary Dr Josef August Eltz (1788–1860) with his Wife Caroline, born Schaumburg, and their eight Children in Ischl* reads almost like a legal document. We are given Eltz's dates and, in accord with German-language conventions, also his profession and title; Mrs Eltz is identified by her first and maiden names. The title's emphasis on the number of children is telling too: clearly this is an affluent professional middle-class family, whose size is on an almost dynastic scale.[11]

However, the full significance of the conventions of Biedermeier family portraiture is most evident in the painting and composition of the picture. Waldmüller's lyrical depiction of the wooded landscape setting, with the snow-capped Dachstein mountain towering in the background, may at first glance seem to align this picture with the tradition of English eighteenth-century conversation pieces – paintings in which aristocratic and wealthy owners were depicted in the context of their family estates. Certainly the aesthetic conceit of a 'conversation' seems to operate as a narrative device linking the figures in the Eltz portrait. We are shown the moment when the notary returns from a country walk with his two elder sons, and is warmly greeted by the rest of the family. Although the Eltzes owned a country villa, they are not depicted as landowners. They enact the rituals of the evocatively named *Sommerfrische*, the summer holidays during which a whole household would move from town or city to the countryside. Such sojourns were clearly the prerogative of the well-to-do, in themselves a further indication of status and wealth. As a favourite destination of the Eltzes, Ischl represents a kind of personalised land-scape setting, the site of happy family memories. The summer might in certain respects represent a break from the routines of urban life, but a family portrait such as this functioned as more than a souvenir. It had to manifest not only the personal aspirations of its owner, but also the wider cultural values of the *Bürgertum* with which the depicted family identified.

The family values embodied in Waldmüller's Eltz portrait involve an intricate blend of elements: the private and the public, nature and artifice, the fashionable and the timeless. The painting's theatrical staging, with its declamatory gestures and poses, indicates an address to a wider audience than that of the family circle. At the same time, this tableau aims to convey a domestic scene of affectionate intimacy. Eltz's return is clearly an occasion of delight. The *Notar* gazes benignly at his

large family and embraces one of the younger sons, who has rushed up to grasp his father in fond greeting. In the midst of this excitement, Mrs Eltz is a calm smiling presence, anchoring the pictorial composition. She forms the stabilising element of a family circle, which is emphatically gendered: husband and older boys on the left, women and young children on the right. The men have enjoyed the adventure of a walk and nature study – Eltz carries a walking stick, wildflowers are pinned to the older boys' hats and one of them carries a satchel. In the far right corner we glimpse some toys scattered on the ground, entertainment for the younger children and girls who have stayed quietly at home. The eye is drawn to Mrs Eltz's magnificent russet gown with its rich folds. A fashionable paisley shawl (its pattern echoed in Mr Eltz's kerchief) is casually draped over Mrs Eltz's seat. As the *Notar's* wife, she presents a seemly appearance: clad in attire appropriate for the country, but at the same time elegant. The opulent drapery of dress and shawl are indicative of the Biedermeier penchant for a lavish use of textiles in interior decoration as well as in dress. Here in the Eltz portrait the effect is to present the family matriarch in a monumental guise, enthroned almost. (We are reminded of another type of pictorial conversation, the *sacra conversazione*, in which Madonna and Child are surrounded by – in 'conversation with' – a group of saints.) Femininity plays a double role – fashionable but also eternal.

There are also other respects in which the Eltz portrait involves a range of rich allusions, a balancing act between change and permanence, innovation and stability. The mountain landscape, which forms the backdrop, may suggest timeless nature, but like the up-and-coming spa town of Ischl, this was a country terrain, which had specific cultural resonances. As a region, the Salzkammergut was newly in vogue, rediscovered by both tourists and artists, and increasingly the destination for sketching and painting excursions. With its unspoiled mountains, lakes and spas, the area provided an attractive repertoire of images, not only for the localities in question, but also for Austria more generally. (It is no coincidence that a more recent popular portrayal of Austrian-ness, *The Sound of Music*, was set in Salzburg.) For early nineteenth-century contemporaries, the Dachstein mountain carried exciting connotations of adventure and achievement: its summit had only recently been scaled for the first time, in 1832. In its setting and composition, then, the Eltz portrait confronts us with a *bürgerlich* family identified with innovation and change while at the same time stressing the delights of a stable domestic life. Waldmüller's painting reveals the complex ways in which Biedermeier portraiture conveyed the status and class of a particular family. We see, too, how the family unit formed an effective means of

articulating values, which are rendered simultaneously vital in their dynamism and reassuring in their ostensible stability.

Like a number of other art-historical style labels, 'Biedermeier' was a retrospective and (initially) disparaging term. As a general description of the arts before the 1848 Revolution, it was only put into extensive use from around 1900. But it was first used earlier in the century in the realm of literature, where it conveyed derogatory connotations about certain aspects of the middle classes. The pseudonym Weiland Gottlieb Biedermaier was fabricated by two writers, a country doctor Adolf Kussmaul and a lawyer Ludwig Eichrodt, for poems they jointly published 1855–7 in the Munich journal *Fliegende Blätter* (Flying Sheets). The mocking nom-de-plume was derived from titles of poems published throughout in 1848 by Joseph Victor von Scheffel, *Biedermanns Abendgemütlichkeit* (Biedermann's Evening Comfort), and *Bummelmaiers Klage* (Bummelmaier's Lament). 'Biedermaier's' poems were a parody of poetry which the authors perceived as *klein bürgerlich* (petit-bourgeois), a mocking critique of the middle classes in the growing urban centres of German-speaking countries. 'Biedermaier' might loosely be translated as 'everyman', but a very specific kind of everyman: a figure whose horizons were severely restricted, both by class and by the growing political oppression and official censorship of the Metternich regime, following the Napoleonic Wars. Whether due to political caution or to limited intellectual aspirations, the Biedermaier everyman confined his action primarily to the privacy of the home.

Historically, such caricatures may be of limited value, but it is true to say that growing middle-class patronage of the arts during the first half of the nineteenth century contributed to a flourishing decorative arts industry, along with a proliferation of portrait commissions – such as that by *Notar* Eltz. By the end of the century, when Vienna experienced a renewed vogue for all things Biedermeier, the term had come to signify a dignified middle-class sobriety and simplicity, as well as an authentic indigenous Austrian culture. The definition had evolved from mocking stereotype back to an emphasis on the German connotations of the word *bieder*: upright and honest.

IMPERIAL AUTHORITY

Waldmüller's Eltz portrait, as we have seen, offers a revealing instance of how Biedermeier portraiture played its part in a professional middle-class family's negotiation of social position and status. But the celebration of Biedermeier family values was by no means restricted

FIG. 19
LEOPOLD FERTBAUER
(1802–1875)
Emperor Franz I and Family, 1826
Oil on canvas
Wien Museum, Vienna

to middle-class interests. Leopold Fertbauer's oil painting *Emperor Franz I and Family* (fig. 19), painted almost ten years before the Eltz portrait, forms an interesting comparison with Waldmüller's painting. This is an imperial dynastic representation, showing Franz I (1768–1835, Emperor from 1804) with his wife Caroline Augusta on the left, Napoleon's son in the centre of the composition, and Napoleon's widow Marie Louise along with the archdukes Leopold and Franz Karl, as well as the latter's wife Sophie. (Franz Karl and Sophie were the parents of the future Emperor Franz Joseph.) The poses here, as well as the style of painting, are more formal and stiff than Waldmüller's animated depiction, but both pictures carefully establish a 'natural' *mise-en-scène* in order to define the family's position. In its own terms, this is an informal setting: we are shown neither a palace nor grand country retreat, but rather a garden pavilion or hut (no doubt a tribute to Franz I's well-known interest in botany and gardening). The men are not depicted in uniform or court regalia; they stand clad in the dark, unostentatious modern garments more usually identified with the *Bürgertum*. The women sitters are allowed a somewhat greater sense of informality. Two of them appear in simple, flowing white dresses accessorised with summer straw hats and loosely draped shawls. The Emperor's identity as a keen horticulturalist facilitated a neat twist on the imagery of a 'family tree.'[12] The framing tree stumps left and right are connected by clambering vines to the rustic logs forming the pavilion, the artifice of dynastic claim and succession in effect legitimised as 'natural' right and evolution.

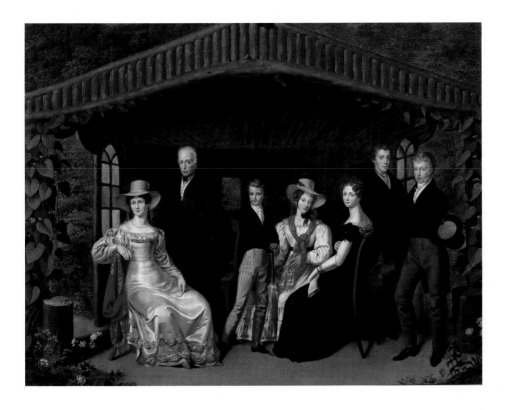

But the middle-class suits make a rather different statement, an implication of imperial duty as a kind of bureaucratic administration, where the desk replaces the imperial throne.[13] Later in the nineteenth century, Emperor Franz Joseph continued this more modern conceit; like Franz I he liked to represent himself as the diligent administrator, seated at his desk (fig. 20). During the early nineteenth century, while the map of Europe was being renegotiated in the wake of the Napoleonic Wars, imperial authority was also redefined in fundamental ways. Franz (under the title of Franz II) ruled as last Emperor of the Holy Roman Empire of the German nations. After Napoleon proclaimed the French Empire, Franz established the hereditary Empire of Austria in 1804, with himself as its first Emperor, Franz I. (In 1806 he abdicated as Emperor of the Holy Roman Empire, which was then dissolved after a period of over 800 years.) In this context it was important for visual representations of imperial reign to allude to timeless paternalism (the Emperor as father of nations) while at the same time acknowledging, and indeed appropriating, the innovative dynamism of the growing middle classes. However much it may have been prudent to formulate new images of imperial family life based on notions of 'ordinary' domestic idylls, there should never be any doubt about the special nature of imperial power. But here, too, an emperor's omnipotence could be recast in terms of patriarchal beneficence.

On the death of Franz I, his widow commissioned three paintings aimed at demonstrating the Emperor's paternalistic concern for his subjects. One of these, Johann Peter Krafft's (1780–1856) *Emperor Franz I giving a Public Audience* shows Franz in uniform, at one of his Wednesday morning audiences for members of the public, consoling a kneeling widow and her three children. In the realm of updated self-presentation,

FIG. 20
JOHANN STEPHAN DECKER
(1783–1844)
The Emperor at his Desk, 1826
Watercolour
Wien Museum, Vienna

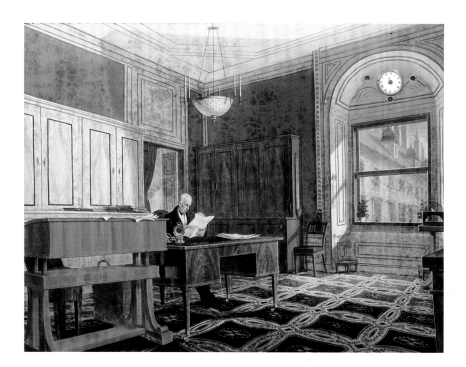

interior design also played an important role in imperial assertions of modernity. Around 1822, when Archduke Karl (the imperial heir) took charge of redecorating the interiors of the Albertina palace, he commissioned the workshop of the cabinetmaker Joseph Ulrich Danhauser. The ensuing designs for interiors, furniture, silver and porcelain, based on simple geometric forms, came to be seen as defining characteristics of Biedermeier style. This delicate balancing act between tradition and innovation was to remain a challenge for the aristocracy until the dissolution of empire in 1918.

Successive emperors were keenly aware of the importance of visual representation in asserting their authority and their role as unifying ruler over the newly formed Austrian Empire. At a symbolic level, the emperor as benign patriarch needed to be shown as all-powerful but also as all-seeing. Baroque architecture, painting and garden design had relied on magnificent centralised compositions in order to convey dramatic images of absolute power. In Vienna, for example, the Schönbrunn Zoo – opened as imperial menagerie in 1752 by Franz I, Holy Roman Emperor and husband of Maria Theresia – was constructed on a circular plan. Thirteen animal enclosures were laid out radially (like slices of a cake) around a domed pavilion. The central pavilion, with its four entrances corresponding to the four points of the globe, afforded a privileged vantage point to survey the exotic creatures in the menagerie. Symbolically, as a kind of precursor to Bentham's later eighteenth-century centralised panopticon designs for buildings that allowed surveillance and therefore control in public institutions, the Schönbrunn Zoo pavilion established its inhabitant as lord of all he surveyed.[14] Here the imperial family met for breakfast, perhaps the most intimate repast of the day.

By the first decades of the nineteenth century, such allusions to the divine, godlike nature of imperial power needed to be tempered by more modern manifestations of the Emperor's gaze. A telling example can be found in the commission by Archduke Ferdinand (Emperor from 1835) of a series depicting the most beautiful sites of the Empire.[15] The project ran from 1833 to 1849, involving a number of the period's most accomplished artists. As an imperial commission, these vistas perpetuated the symbolic remit of the royal menagerie, where the world was brought to the ruler. The original intention was for the landscapes (watercolour on paper) to be viewed either in the context of an album, or through the Emperor's peepbox, an optical device where pictures were viewed through a small hole.[16] But the series also fulfilled another function: several of the images depicted official visits by the Emperor, verification of his presence – and authority – throughout the Empire.

One of the best-known pictures from the collection is Jacob Alt's *View from the Artist's Studio in the Alservorstadt toward Dornbach* (1836, fig. 21). Jacob and his son Rudolf contributed 170 of the roughly 300 works in the imperial commission. According to an apocryphal account, Emperor Ferdinand I specifically requested this particular scene, having learned that the artist's studio afforded such beautiful views towards the hills of the Vienna Woods. Alt not only worked, but also lived with his wife and seven children, in the suburb of Alservorstadt (now in the city's ninth district). A cosy domesticity is conveyed by the informality of the studio, and particularly by the lovingly portrayed plants in their terracotta pots – one containing pinks, the other a geranium, perched on the windowsill.[17] The interior seems to function almost as a portrait by proxy. There is a vivid sense of the artist, as though he has only just vacated his chair, which is pushed back from the table on which we see a glass of water and various papers. Indeed, this was a period in which the *Zimmerbild*, the depiction of a particular interior, was considered to be a form of extended portrait, a means of proclaiming individual identity. The artist's presence is discernible, too, in the skill with which he has represented this view as a *Fensterbild* (literally 'window picture',

FIG. 21
JACOB ALT (1789–1872)
View from the Artist's Studio in the Alservorstadt toward Dornbach, 1836
Watercolour and pencil
Albertina, Vienna

a popular early nineteenth-century pictorial format). A limpid light bathes the landscape; it filters in through the studio window, conjuring up gleaming reflections on the chair and work surface of the table. Commissioned for the gaze of the Emperor, Alt's picture forms a profound contrast with the centralised geometry of Baroque sightlines. Here it is no longer the imperial pavilion, which forms the vantage point on the outside world; rather, we are presented with a view of the newly expanding Viennese suburbs. The carefully staged vista, explicitly identified with the modest environment of the painter's studio and home, produces another kind of image of Empire and Austrian-ness. Imperial magnificence is not so much rendered redundant as updated, redefined through the validation of simplicity over pomp.

DOMESTIC SCENES

In more modest, non-aristocratic circles, images of benign patriarchy were also crucial to representations of domestic harmony. Friedrich von Amerling's *Rudolf von Arthaber with his Children Rudolf, Emilie and Gustav* (1837; fig. 14; see page 46) shows a typical Biedermeier domestic interior. A golden light streams through the window to reveal a pleasingly informal sitting room. Arthaber rests his arm on a table, where papers and teacups perhaps suggest that he has interrupted his own preoccupations to enjoy time with his three children. Two of these have straw hats, indicating outdoor activities (as does the tennis racket, tossed on the parquet floor). A lushly flowering pot plant – that favourite Biedermeier motif – forms a further link between domestic interior and exterior nature. The scene is affectionate and relaxed, but Arthaber's wistful facial expression hints at a poignant sense of loss. It is likely that the family are gathered around a picture of the recently deceased Mrs Arthaber, which rests between the widower's knees. The device of a picture-within-a-picture was popular in painting of this period, whether to suggest a wider extended family than that actually portrayed, or, as in the Arthaber portrait, to convey intimations of bereavement. Such painterly acts of commemoration recognised the continuity of individual middle-class families as much as that of imperial dynasties.

The family values associated with Biedermeier often involve assertions of continuity in the face of modernisation. But ideas concerning fatherhood, and parenthood more generally, were themselves subject to modernity and change. Shifting conceptions of masculinity are strikingly evident in portrayals of the modern artist. In his influential later nineteenth-century writings on modernity, Charles Baudelaire

19

JOSEF MARIA AUCHENTALLER
(1865–1949)
'Bunte Bände' (Portrait of Maria), 1912
Oil on canvas, 120 × 110.5 cm
Archivio Auchentaller, Italy

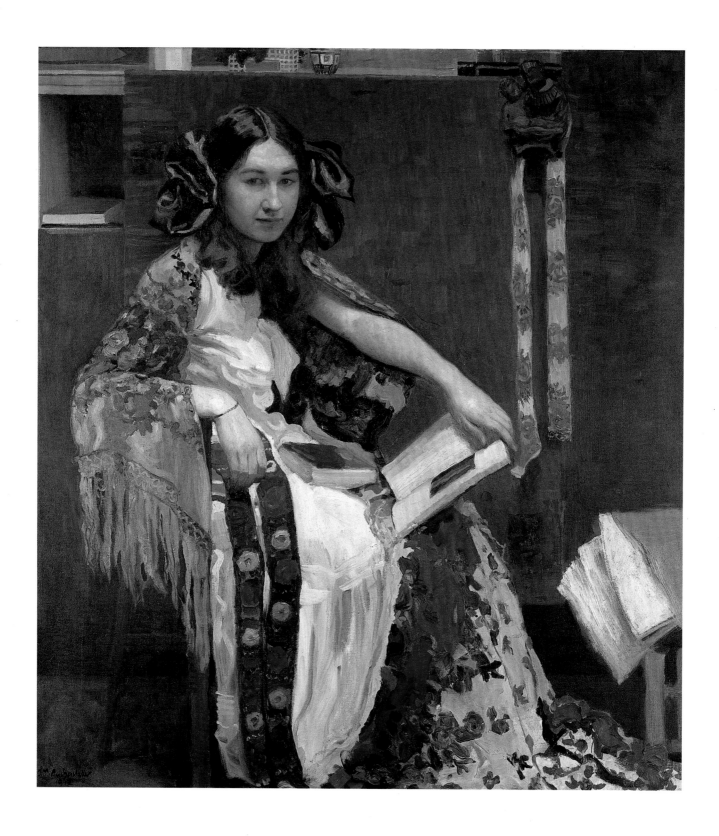

formulated the figure of the *flâneur* (the male urban stroller) to elaborate his idea of the modern poet and artist. For the *flâneur*, unfettered by the constraints of bourgeois responsibility (those of family as well as of a nine-to-five job), it was the passion of erotic love rather than affectionate parenthood that constituted the prerequisite for artistic inspiration.[18] Such allusions to the excitement of the modern city street have tended to overshadow a Biedermeier emphasis on domesticity as the context for artistic and intellectual life. As we have seen, its very viewpoint the evidence of expanding cities and urban populations, Alt's studio *Fensterbild* clearly incorporates references to modernity.[19] The lovingly delineated interior, however, with its domestic setting and furniture, suggests that this is an artistic modernity sustained by the home.

Allusions to home and parenthood remained important for Viennese portrait practice well into the twentieth century. Like Alt's depiction of his studio, Carl Moll's 1906 *Self Portrait in his Study* represents a work-space in the context of the home (10; see p. 45). In Moll's case, this was the house recently commissioned from the Secessionist architect Josef Hoffmann in the newly fashionable Viennese suburb of the Hohe Warte. Here in a kind of updated *Zimmerbild*, both the design of the interior and the location of Moll's stylish home define his identity as an artist and impresario of modern art.

Josef Auchentaller's 1912 portrait of his daughter Maria wearing coloured ribbons similarly deploys a domestic setting to make an artistic statement (19). The composition echoes paintings by Whistler (much admired by Secessionist artists), and a small metal Hoffmann vase is just visible at the top of the picture. Maria's meditative expression and artfully contrived pose (her outstretched left arm reminiscent of Michelangelo's Sistine sibyls), present the painter's daughter as muse, a point reinforced by the books she holds and the artist's portfolio at her feet.

For women artists, references to the domestic environment were no less important, but they had a somewhat different significance. Recalling the popular Biedermeier subject of children at play, Broncia Koller's portrait of her daughter with a caged bird (1907–8) implies artistic practice as an extension of the domestic sphere, painting as an aspect of maternal vigilance and care (46; see p. 137). In the case of women artists, identification with motherhood could function as a re-assertion of femininity, allaying contemporary anxieties about the potentially 'de-sexing' effects of their art practice. Adopting a somewhat different strategy, Elena Luksch-Makowsky in her *Self Portrait with her Son Peter* (1901, 50; see p. 151) shows the two figures in a Madonna and Child format – another instance of modernity (the woman artist) tempered by continuity (the sanctity of motherhood).

As part of a domestic ethos of familial affection and informality, the representation of children in Biedermeier painting owes something to Romantic ideas about childhood innocence. However, an emphasis on youth, whether in the case of infants or adults, was also an aesthetic preoccupation. Waldmüller's *Portrait of an Unidentified Seated Girl in a White Satin Dress* (1839; 20) depicts a young woman clad in a more formal version of the classicising white dresses worn by the aristocratic women in the garden portrait of Emperor Franz I and family (fig. 19; see p. 71). Here the gown is tightly cinched at the waist, with artfully ruched sleeves and pleated bodice. The props (the red upholstered armchair) and the figure's pose, head resting on her left hand, are portrait conventions, but the sitter's calm steady gaze directed at the viewer lends immediacy to the image. The subtle slant of the seated position is balanced by the formal symmetry of the face and the centre-parting of the sitter's hair. Gleaming skin and eyes are enhanced by the sheen of the silk dress; this is an image of glowing young womanhood. The flower pinned to the waist of the dress is a telling detail. A camellia's red and white petals unfurl, echoing the folds of the fabric. By analogy, it is almost as if the painting itself has unfolded for us that transient, all-too-brief-bloom of fresh youthfulness – the springtime of life.

The portrait stands in a long line of later depictions of 'women in white', including works by Manet, Whistler and Klimt. An early such work by Klimt, *Young Girl, Seated* of 1894 (21), shows a pensive young woman in a high-necked dress, her hands demurely folded in her lap. Painted a decade later, the painter's *Portrait of Hermine Gallia* (1904, 1; see p. 22), its full-length subject clad in a stylish white ensemble, conveys its modernity through a more febrile painterly execution of figure and clothing. These two women in white reveal something of Klimt's stylistic evolution as a portraitist. In both these turn-of-the-century pictures, portraiture's subtle powers of psychological penetration stand in vivid contrast to the limpid serenity of Waldmüller's portrayal. Portraits composed as paired figures form an interesting permutation on the theme of young women in white. The dreamy, wistful tenor of Anton Romako's *The Artist's Nieces, Elisabeth and Maja* (1873; 23), in which one of the girls clutches a posy of wildflowers, forms a variation on the theme of the springtime of youth. The feminine pairing is conceived very differently in Richard Gerstl's *The Sisters Karoline and Pauline Fey* (1905, 24; see p. 83), where the two women appear as shimmering apparitions. The picture creates a haunting, uncanny impression as the siblings emerge almost ghostlike from a dark background.

20
FERDINAND GEORG
WALDMÜLLER (1793–1865)
Portrait of an Unidentified Seated
Girl in a White Satin Dress, 1839
Oil on canvas, 32 × 26.5 cm
Wien Museum, Vienna

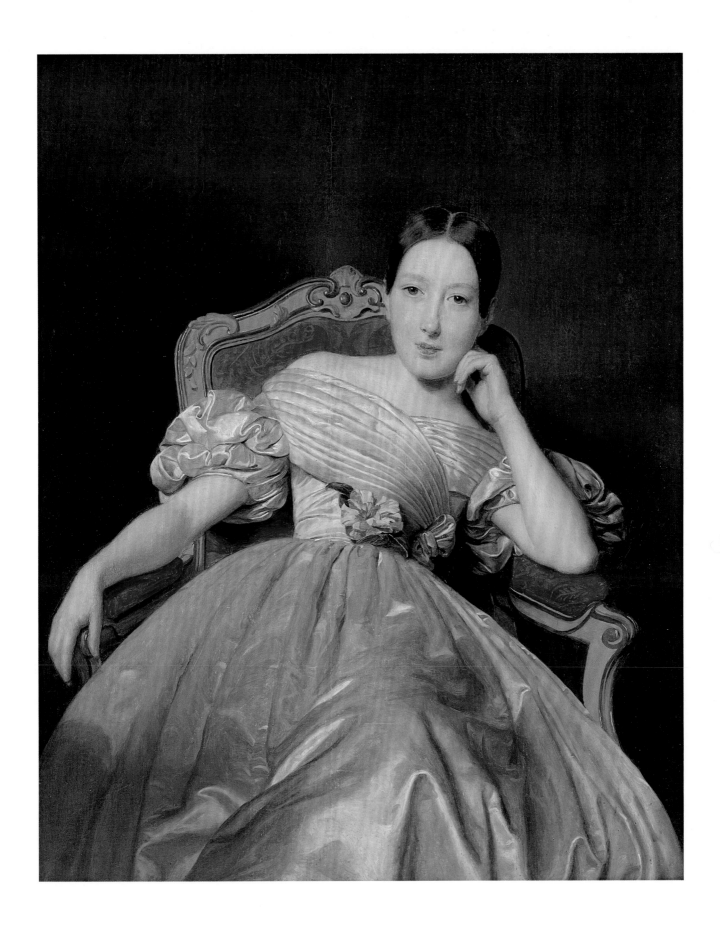

21

GUSTAV KLIMT (1862–1918)
Young Girl, Seated, 1894
Oil on wood, 14 × 9.6 cm
Leopold Museum Private
Foundation,Vienna

22

JOSEF MARIA AUCHENTALLER
(1865–1949)
Portrait of Maria, 1896
Oil on canvas, 30.5 × 25.5 cm
Archivio Auchentaller, Italy

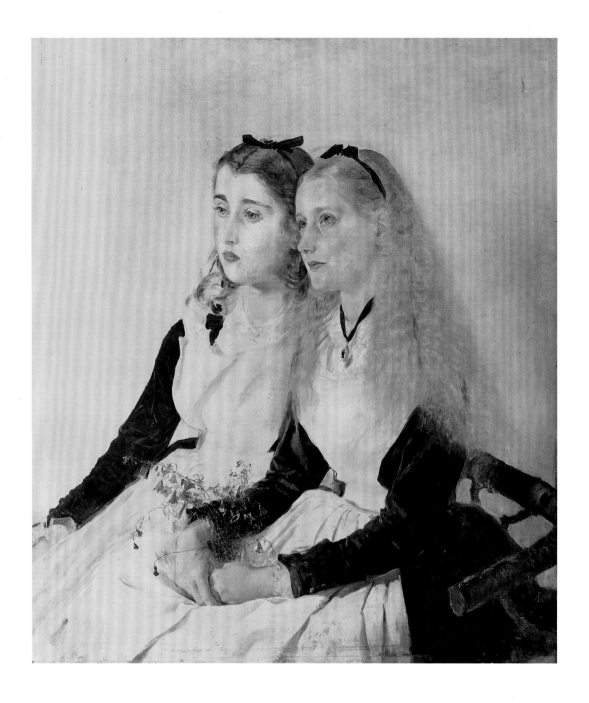

23
ANTON ROMAKO (1832–1889)
*The Artist's Nieces, Elisabeth
and Maja*, 1873
Oil on canvas, 93.2 × 79.6 cm
Belvedere, Vienna
Donated by Dr Imre von Satzger,
grandson of Elisabeth von Satzger,
née Romako

24
RICHARD GERSTL (1883–1908)
The Sisters Karoline and Pauline Fey,
1905
Oil on canvas, 175 × 150 cm
Belvedere, Vienna

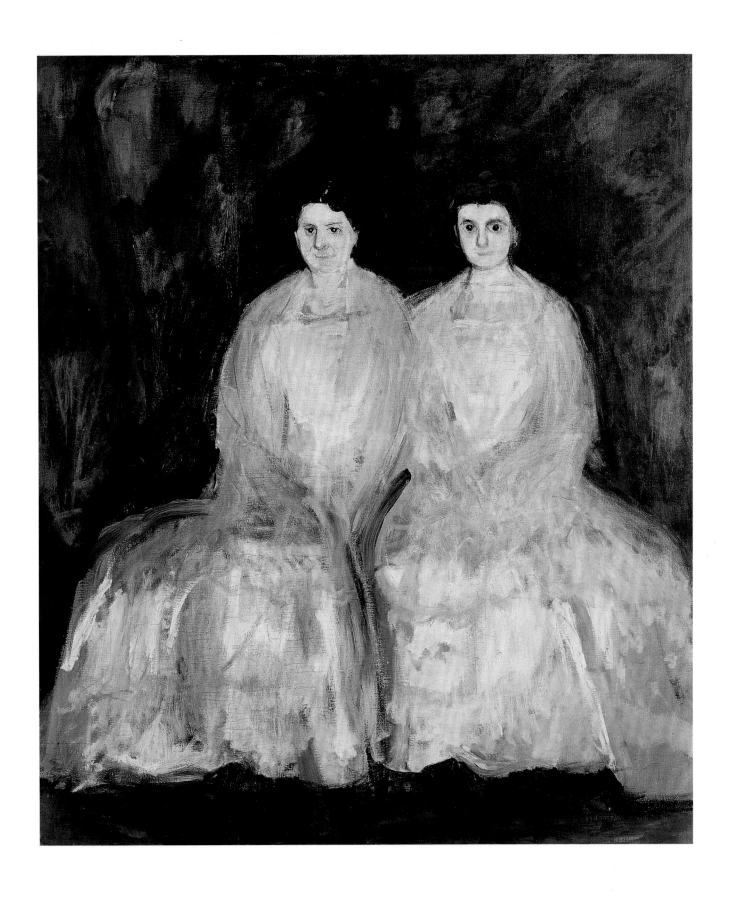

Biedermeier ideals did not vanish as the nineteenth century drew
to a close – quite the reverse. Biedermeier was invoked from different
points on the aesthetic spectrum: to advocate a return to the authentic
simplicity of indigenous Austrian design (as we find in the writings
of Adolf Loos), and to promote the aesthetic values of the Viennese
Secession in Moll's paintings of his new home on the Hohe Warte. In
many respects at odds with each other's views, Loos and the members of
the Secession shared a conviction that the modern is only ever effective
when in harmony with tradition. Auchentaller's 1896 portrait of his
daughter Maria (22, see p. 81) continues the Biedermeier aesthetic
celebration of youth, the gentle flush of the girl's round face juxtaposed
with the elegant geometry of the picture's elaborate gold frame. (Carefully
designed frames were often a significant feature of Secession portraits.)

Nevertheless, there are other instances where we see Viennese
modernist art of this period most boldly expressed through a rejection
of traditional family values as epitomised in Biedermeier painting. By the
early years of the twentieth century, the aesthetic associations of youth
had evolved considerably. The Vienna Secession movement chose *Ver
Sacrum* (Sacred Spring) as the title of its official magazine, in reference
to the classical religious ceremony whereby new communities were
established through a ritual springtime expulsion of young people.
The front cover of *Ver Sacrum*, designed by Alfred Roller, shows a potted
shrub, its burgeoning roots bursting forth from the constraints of
a wooden planter.[20] The Biedermeier potted plant formed part of an
iconography of domestic harmony, which could be invoked in order
to elaborate ideas about aesthetic or social ideals. As shown by Roller's
design, for the late nineteenth-century Viennese avant-garde, aesthetic
innovation could also be represented through images of rupture, the
necessary expulsion of youth from established families and societies.

Early nineteenth-century Biedermeier visual culture has been charac-
terised as 'an immigration into the interior'.[21] By the end of the century
in Vienna (as Carl Schorske has so influentially argued), aesthetic and
cultural preoccupations with interiority (the private as opposed to the
public) returned with new force, albeit in a different political climate.[22]
Delug's 1907 portrait of the Markl family could easily be seen as a nostalgic
reprise of many Biedermeier scenarios of family embrace (25). Seated
together on a banquette in a comfortable middle-class sitting room, an
affectionate daughter and a lapdog lean fondly against a mother (who has

25
ALOIS DELUG (1859–1930)
The Markl Family, 1907
Oil on canvas, 113.5 × 138 cm
Belvedere, Vienna

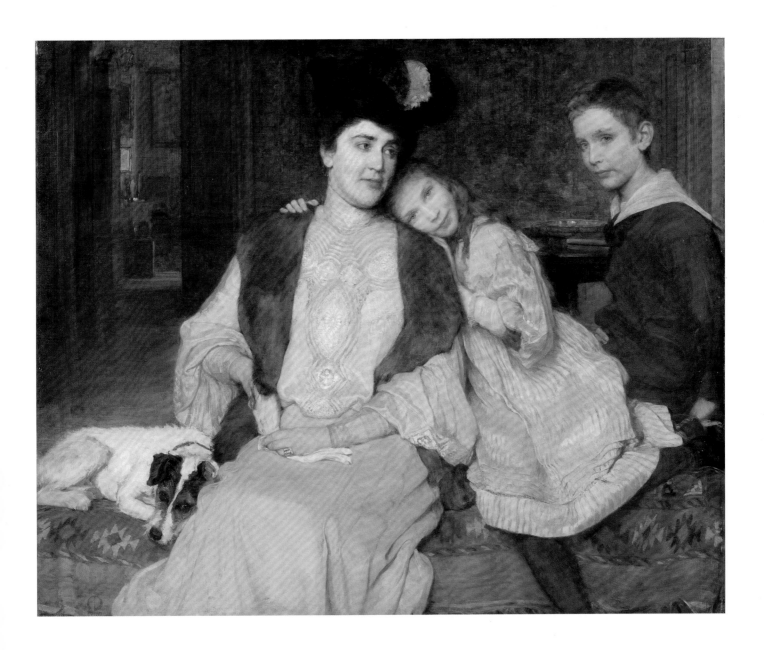

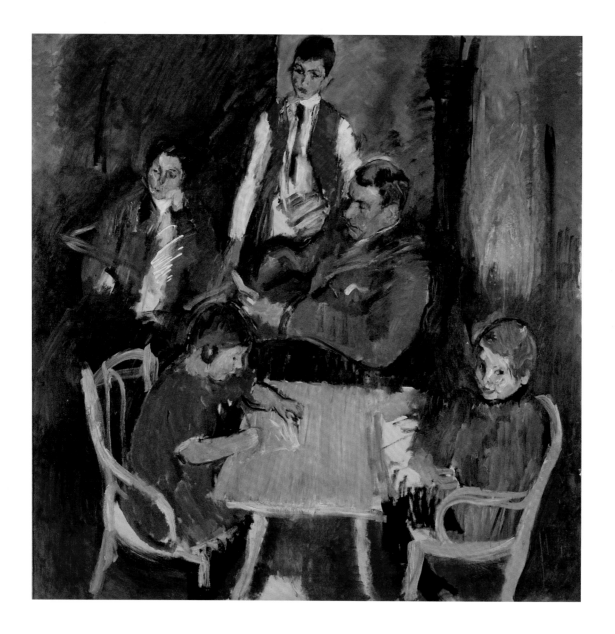

perhaps just returned from an outdoor walk – she still wears a hat). In
early twentieth-century Vienna, however, at a time when psychoanalytic
theory was being developed, such depictions of harmonious domesticity
no longer went unchallenged. Anton Kolig's 1911 portrait of the Schaukal
family shows the two younger children at their small worktable, with
one looking out of the picture space in an engaging manner (26).
Nevertheless, the general tenor of this portrait is withdrawn and
introverted; the Schaukals are represented as individually preoccupied
with their own thoughts. We are not invited to witness a scene of
familial affection.

26
ANTON KOLIG (1886–1950)
Portrait of the Schaukal Family, 1911
Oil on canvas, 160 × 160 cm
Leopold Collection II

27
EGON SCHIELE (1890–1918)
The Family (Self Portrait), 1918
Oil on canvas, 150 × 160.8 cm
Belvedere, Vienna

More stark in its confrontational address to the viewer is Egon Schiele's *The Family*, where father, mother and infant are depicted naked, without any indication of specific occasion or location (27). Painted in 1918, the year that marked the end of the First World War but also the dissolution of Austria-Hungary as a dual monarchy, the painting poses any number of questions. What now constitutes a family portrait? Although the painting ostensibly shows Schiele with his wife and child, Edith was to die before her pregnancy came to term.[23] Following the most devastating war in history, could the family still symbolise a reassuring continuity? The composition presents the family unit as timeless, but also as exposed and vulnerable. No longer, it seems, was it possible to simply assume the reassuring protective power of a benign patriarch, in the context of either family or nation. Such images gain in force through their harsh contrast with the domestic idyll so poignantly depicted in Biedermeier portraiture.

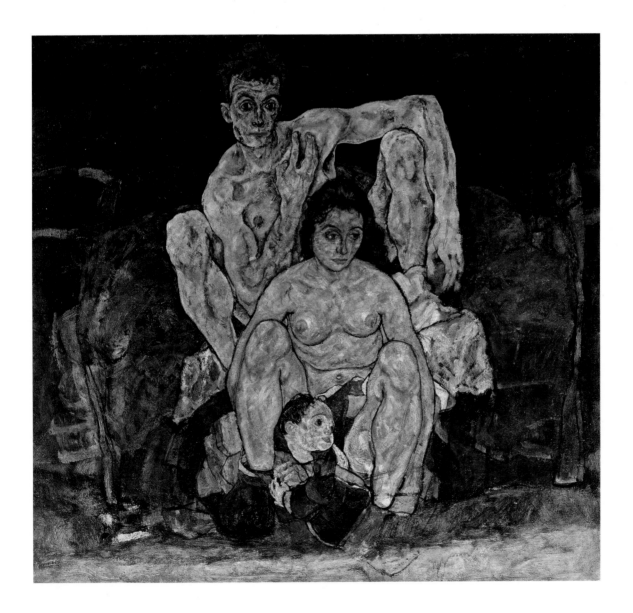

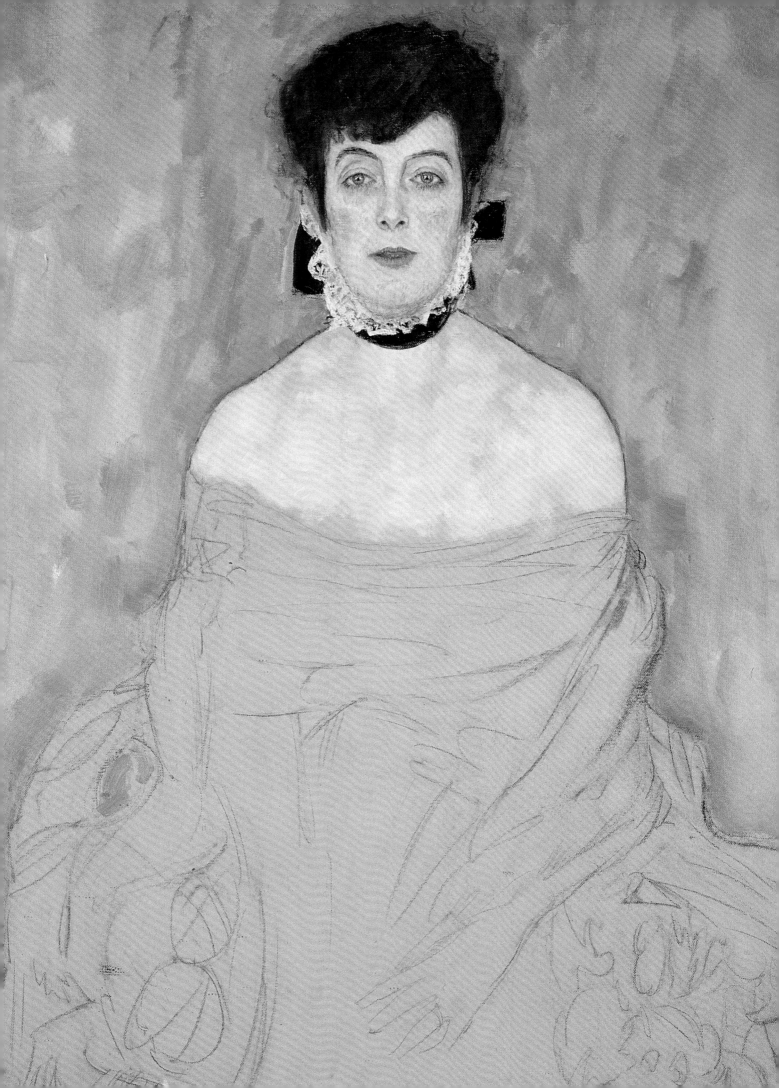

PORTRAYING VIENNESE BEAUTY
MAKART AND KLIMT

Doris H. Lehmann

FIG. 22

HANS MAKART (1840–1884)
Portrait of Helene von Racowitza,
1874
Oil on canvas
Landesmuseum für Kunst und
Kulturgeschichte, Oldenburg

The Ringstrasse period (1857–1914) has also been dubbed the 'Age of Makart' because of the dominance of Hans Makart – the self-styled 'Prince of Painters'. Makart was born in Salzburg and trained in Munich, becoming familiar with the work of Italian and Dutch Old Masters during his studies and travels. In 1868, following his first exhibition successes, he was summoned to Vienna by the Emperor to revive the national art scene. Makart's speciality was interior design for drawing rooms, and his imaginative studio décor and opulent costume festivals influenced Viennese clothes and the furnishings of apartments and studios. His portraits are predominantly of young women from well-to-do and influential families, from the upper middle classes – grown wealthy as a result of the industrial boom – and the lower ranks of the nobility. The portraits of this upwardly mobile group of patrons bear witness to their enhanced social status (many were newly ennobled), and the fact that they had to fight to legitimise their place in the monarchical system, with its strict hierarchical and traditional relationships.

A MONARCHICAL SYSTEM SEES RED — MAKART'S ARTISTIC FREEDOM

Among Makart's few sitters from the ancient nobility was the beautiful Klementina Gräfin Potocka. Her portrait (previously at Schloss Łańcut, but missing since 1944), presumably painted before her marriage to Jan Graf Tyszkiewicz in 1878, hung in the salon of her mother, Marie Clementine, née Princess Sanguszko-Lubartowicz, and acted as a centre of attention and as a pendant to the portrait of her father, Alfred Graf Potocki, painted by Leopold Horovitz in 1883 (fig. 23).[1] Among Makart's upwardly mobile sitters were Bianca Baroness von Teschenberg, *née* Lucas, a former ballet dancer at the court theatre, and Hanna Haupt, who later became Princess Liechtenstein (fig. 24), (28). Besides his portrait sitters, the painter cultivated friendly contacts with a few confident and

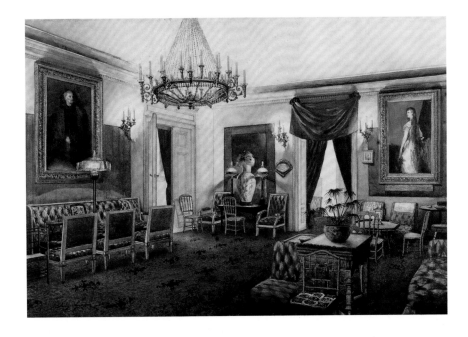

FIG. 23
ALEKSANDER AUGUSTYNOWICZ
(1865–1944)
Salon Potocki with Hans Makart's
Portrait of Klementina Potocka, 1883
Watercolour
Łańcut Castle Museum, Poland

FIG. 24
HANS MAKART (1840–1884)
Portrait of Hanna Klinkosch
(*Hanna Haupt*), 1875
Oil on canvas
Liechtenstein. The Princely
Collections, Vaduz-Vienna

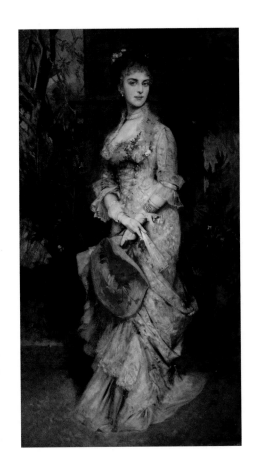

professionally successful women, such as the author and translator
Lili Lauser, and Charlotte Wolter, the famous Burgtheater actress who
had become Gräfin O'Sullivan de Grass on her marriage in 1875 (see
p. 194). These women – with the possible exception of Wolter – probably
did not commission their own portraits, which were ordered and paid
for by their fathers and husbands.[2] Makart also painted a number of
portraits that were probably not commissioned, such as those of his
cousin Clothilde Beer (29; see p. 94) (there is a further portrait at the
Belvedere, Vienna), which allowed him greater artistic freedom.

The Makart specialist Gerbert Frodl has identified three types of
female portraits by the artist.[3] The first, the typical Makart portrait,
distances the figure as though it were a still life, treating it as a pretext
for a virtuoso display of painterly technique.[4] Even if the model is recog-
nisable, these works were not intended as portraits. Splendid colouristic
masterpieces produced with and without commission, they were showy
collectors' items for the art market, and the buyers did not necessarily
know the sitter. One example is the so-called *Portrait of Helene von
Racowitza* (1874, fig. 22), which Grand Duke Peter II ordered via the
Viennese art dealer Hugo Othmar Miethke, who later became Klimt's
exclusive art dealer, for his collection of paintings in Oldenburg. Here
the red hair and the red velvet material are given more significance than
the face. The theme of the picture is painting itself; meaning is conveyed
through the uniform tone and the characteristic use of 'Makart red'.[5]

28

HANS MAKART (1840–1884)
Portrait of Hanna Klinkosch,
about 1875
Oil on wood, 114 × 77 cm
Austrian Collection

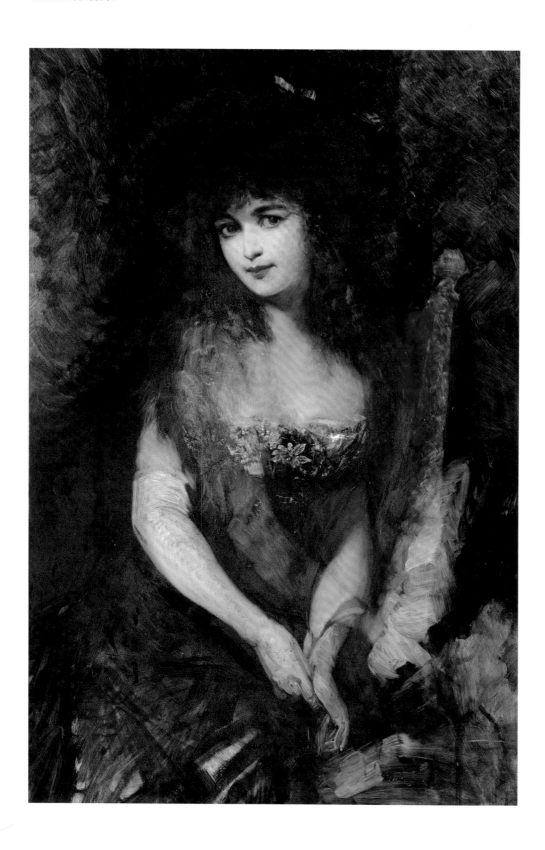

PORTRAYING VIENNESE BEAUTY

The second type of Makart portrait, which includes full-length canvases, is the 'representative portrait' (fig. 24). In these pictures, not only is the face carefully painted in detail but the hands are also well-shaped and fully developed. Whether Makart painted them himself or had them painted is an open question. The artist added nobility to the sitter with a skilfully planned *mise-en-scène*, which focused attention on the face.

The third type is distinguished by careful, individual observation. Makart's portrait of his wife Amalie (around 1872, fig. 25) belongs to these 'family portraits with no great effort for effects and whose ambitions are mainly pictorial'.[6] Here the artist deliberately left the gloved hand unfinished and allowed the outline of the figure to disappear into the coloured textures of the dress. The body is dematerialised beneath the virtuosity of the painting.

There was a longstanding prejudice against Makart's portraits because they were not considered good likenesses.[7] The artist was accused of idealising facial features and neglecting individual details – a practice which was commonplace in portraiture at the time. One contemporary claimed: 'He [Makart] will give all the women large eyes and rosebud lips, they will be proud and disdainful; true, they will all have a strong family likeness…'[8] It is true that the physiognomies are idealised, but Makart remained faithful to the play of eyebrows and the corner of the mouth in order to preserve expression, and the shape of the ears. He emphasised the sitter's assets while erasing the flaws; today these would be removed by Botox or plastic surgery. It is no surprise that the self-conscious beauties of the Ringstrasse allowed Makart to paint their portraits despite violent attacks by commentators who criticised him for poor likenesses, typecasting, lack of psychological depth, anatomical shortcomings and an excess of costume.

The young countesses and princesses from ancient aristocratic families who were Makart's sitters and patrons treated themselves to his portraits as a personal extravagance, so that they could appear publicly receptive to modern trends. They showed a marked preference for historicism, and this meant that Makart as the painter who executed their commissions had to use traditional styles, such as Renaissance or Baroque, or a combination of various historical elements. Makart ennobled his sitters through his approach and technique, but disqualified himself from commissions by members of the highest nobility, as he did not provide an appropriate setting for the social status that was so important to them. On the contrary, he was inclined to consciously blur class boundaries by including fantasy elements in his pictures. Expensive clothes and jewellery were not portrayed as status symbols, but for

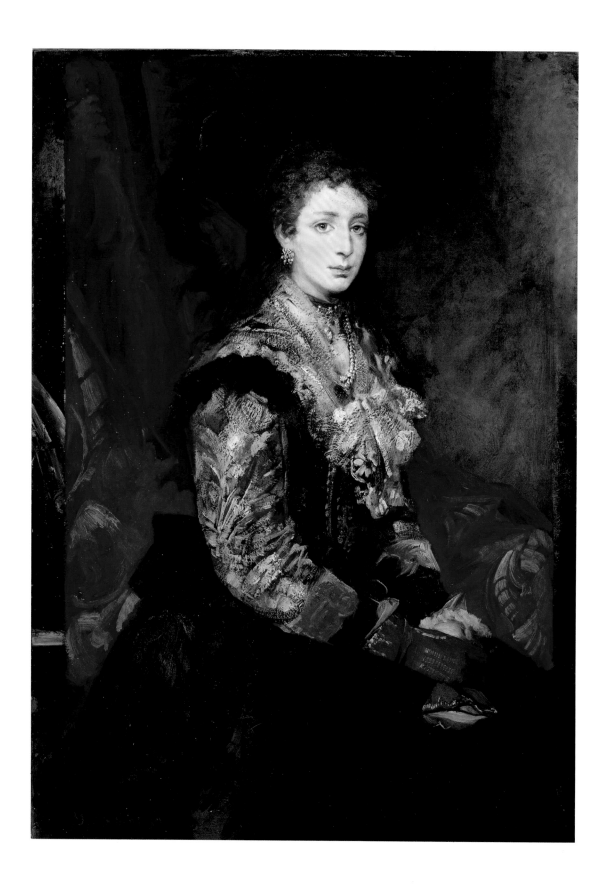

29

HANS MAKART (1840–1884)
Portrait of Clothilde Beer, about 1878
Oil on canvas, 135.3 × 95.6 cm
Salzburg Museum

FIG. 26
Makart's studio in Vienna.
Watercolour, 1895, by
Rudolf von Alt (1812–1905).
Wien Museum, Vienna

decorative effect.[9] There is a good example of this in his portrait of his cousin Clothilde Beer (29), who wears Dutch costume and a large round hat with a broad, flat brim and a feather decoration. Such hats, fashionable at the time, are still known colloquially as 'Makart hats'. Clothilde's smoothly varnished face contrasts with the impasto of her costume and her lavish jewellery, while the surrounding space is so restricted that her chair cannot be seen and the red drapery is reduced to formless flecks of colour.

Makart's fame as a portraitist of Viennese beauties was established in 1873 with the legendary exhibition of his monumental painting *Venice renders Homage to Caterina Cornaro*.[10] Numerous visitors saw the sensational 10.5 metre wide canvas into which the artist had integrated life-size portraits of prominent Viennese figures. He even gave the Queen of Cyprus the idealised features of his beloved first wife. This homage to female beauty persuaded the ladies of Viennese society to see Makart, the 'new Veronese', as their most sympathetic portraitist. Makart adopted the same approach in his mammoth *Entry of Charles V into Antwerp* (1878), which also incorporated numerous female portraits.[11] This work was exhibited at the World Exhibition in Paris in 1878, flanked by the *Portrait of Bianca Baroness von Teschenberg* (1878, private collection) and the *Portrait of Hanna Klinkosch (Hanna Haupt)* (1875, fig. 24). It was claimed that Makart painted Hanna's portrait (which remained in her possession until her death) in nine days and 'sent it to Paris still wet'.[12] The two paintings were honoured as Makart's masterpieces, and were described as *oeuvres parfaites de goût* (works of perfect taste).[13]

Since the portraits of the two women were displayed either side of the monumental painting in which they both appeared, attentive observers could make comparisons between history and portrait as well

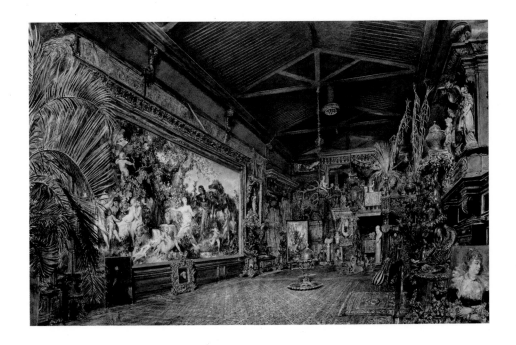

as between history and the present. This was of particular interest for the Viennese. Before her marriage to Baron von Teschenberg, Bianca Lucas had been a member of the corps de ballet at the royal court theatre. In the past she had posed in her dance costume on her *cartes de visite*, but now she proudly represented her newly won status as a minister's wife.

Hanna Haupt *née* Hanna Klinkosch had her portrait painted by Makart three times during her first marriage, and is thought to have been his favourite model.[14] She and her younger sister Paula were the daughters of Josef Carl Klinkosch, a Jewish manufacturer of silverware, and were the city's best-known beauties. Hanna converted to Catholicism before she married the economist Ottmar Haupt in 1874. It was an unhappy marriage, which was annulled in 1884.[15] In 1890 she married her second husband, Aloys Prince of Liechtenstein, and so became a princess. It is she who leads the group of Viennese beauties in the monumental *Entry of Charles V into Antwerp*. Many photographs of Hanna have also survived.[16] The selection from a variety of famous Vienna photo studios (Adèle, Löwy, Ludwig and Victor Angerer, Luckhardt and d'Ora-Benda) testifies to this Viennese beauty's awareness of fashion trends, which spanned decades, as well as her fluctuating position in society. Comparing the photographs with the portraits also gives a good idea of Makart's process of idealisation.[17] He stressed Hanna's expressive eyes and reduced the size of her prominent nose; this effect was particularly suited to the inclined position of the head with the inevitable optical foreshortening. Makart tried out this effect in the uncompleted three-quarter-length *Portrait of Hanna Klinkosch* painted around 1875 (28; see p. 92). Just as in a vignette, everything there is concentrated on the carefully painted face. Nowadays pentimenti (alterations) are visible, and the corrected position of the arm can easily be seen.

Makart's female portraits satisfied the needs of the Viennese upper middle classes and particularly the upwardly mobile. The fact that he had begun by carrying out portrait commissions for the aristocracy marked him out to the newly rich and ennobled as a legitimate artist. But even if this modern painter, who now styled himself 'the new Rubens', could satisfy the wishes of his occasional aristocratic patrons with his unconventional style, access to the commissions of their class was largely denied him. The high nobility of the court, in particular, distinguished themselves from the newly rich clientele of Ringstrasse society by having their portraits painted by Makart's exact antithesis, Heinrich von Angeli, a 'modern Van Dyck'.[18]

FIG. 27
HEINRICH VON ANGELI
(1840-1925)
Emmy von Ephrussi (née Porges),
about 1890
Oil on canvas
Edmund de Waal

Angeli was exceptionally successful as a historical painter and especially as a portraitist, and painted the likenesses of numerous aristocrats and European royalty, including Emperor Franz Joseph, the German Kaiser Frederick III and Queen Victoria. His realistic style was praised in the most extravagant terms by the art critic Emerich Ranzoni, who wrote of 'such speaking likenesses, so captured from life',[19] while the French critic Charles Clément praised his 'sense of moral likeness'.[20] The nobility did not wish to be accused of lacking 'moral likeness', and the critics demanded individuality in portraits, which applied not only to the face but also to the hands, as well as a realistic style that captured the dignity of facial expression, pose and gesture.[21] This dignified element can be seen in *Emmy von Ephrussi* (fig. 27), where the concentration is on the sitter's realistically painted face and her inner strength. The sumptuous black dress forms a delightful contrast with her combed-back, greying hair and precious pearl necklace. This is no imaginative production, as was usual with Makart, but a realistic portrayal of high social position.

Even though Angeli is not as well known as Makart nowadays, he was highly appreciated by his contemporaries.[22] This can be clearly seen in the photo album of Emmy von Ephrussi, *née* Schey (1879–1938), the daughter-in-law of the Emmy discussed above. The album had its origins in a costume ball organised by her around 1904. The ladies who took part in *tableaux vivants* (dramatic recreations of paintings) allowed themselves to be photographed for the album in their costumes and poses. The production of such 'living pictures' was widespread and highly popular in eighteenth- and nineteenth century Europe. For the Silver Wedding of Emperor Franz Joseph I and his wife Elisabeth in 1879 Archduke Karl Ludwig had commissioned Makart, Angeli and Gustav Gaul to design sketches for *tableaux vivants* for the Emperor's family to enact at the celebrations.[23]

Angeli's portrait *My Wife* was one of the pictures chosen for the Ephrussi album – an indication of the esteem in which he was held, as he was the only living artist whose work was enacted.[24] The hostess, Emmy von Ephrussi, posed proudly as Titian's *Portrait of Isabella d'Este* (about 1534–6, Kunsthistorisches Museum, Vienna, figs 28, 29). This portrait, then in the collection of Archduke Leopold Wilhelm, was highly prized by Viennese artists: Gustav Klimt made a faithful copy in 1885. Vienna was alluded to in the people portrayed, the artists whose works were recreated (including Ferdinand Waldmüller), and the collections from which the paintings were chosen. Among them was Velázquez's *Portrait*

of the Infanta Maria Teresa (1652–3), which, like the Titian portrait, was part of the court collection. It inspired Klimt to paint his stylised *Portrait of Fritza Riedler* in 1906 (Belvedere, Vienna).[25]

WIDER HORIZONS – KLIMT'S 'NEW CHARACTERISTICS OR NEW STYLISATIONS'

Around the turn of the century interest in fashionable representative portraiture remained high, although ideals of beauty had changed.[26] After the death of Empress Elisabeth (61; see p. 178) in 1898, the wasp waist fell out of fashion[27] and was replaced by reform clothes, representing a new attitude toward the female body. This change can be seen by comparing Romako's portrait of Isabella Reisser (1884–5, 15; see p. 56) with Klimt's *Hermine Gallia* (1903, re-worked in 1904: 1; see p. 22). The art critic Ludwig Hevesi considered the new developments represented by Klimt, comparing him with Makart, who had been dead for 20 years: 'The Viennese female portrait is experiencing here [in Klimt's work] new characteristics or new stylisations. This is for the first time since Makart. And now for the first time since that great man we see a conquering painter emerge, to whom Vienna must surrender herself.'[28] Even the 'exorbitantly' high prices that the 'new Makart' could demand were legitimised by reference to his predecessor.[29]

Contemporaries could not, of course, foresee that in our own day Klimt's fame would outshine that of his predecessor. But those contemporaries were attentive observers, and it did not escape them that in his portraits Klimt used design principles that he developed in his other work. Thus it was that Hevesi, in his consideration of Klimt's female portraits, started with a detailed observation of one of his landscapes, so that the gaze of his reader might begin with the design of a single picture, then move on, firstly to other landscapes and then to the portraits.[30] This fruitful approach to decorative design principles teaches us how to look beyond stylistic and formal differences and recognise common elements in the work of Klimt and Makart. Both artists linked painting as an end in itself with the form of representation required. This also explains Susanna Partsch's impression that in Klimt's portraits the individual is enclosed by the décor, and it is only occasionally that 'the individuality of a woman, her character and her capacities can be recognised'.[31] Each of Klimt's female portraits is more than just a representation of his model. As Thomas Zaunschirm has written:

'Fundamentally, Klimt was less a portraitist than a painter who used female portraits for the purpose of his own allegories'.[32]

Like Makart, Klimt also succeeded in his first test as a portraitist with a group picture. But whereas Makart had financed his gigantic canvases through collaboration with the art dealer Miethke, Klimt worked on commission and in a notably smaller format. The official commission he received in 1887 to paint *Auditorium in the Old Burgtheater* (fig. 1; see p. 15), featuring 131 prominent Viennese personalities, included the miniature portraits of numerous society ladies. Klimt coped with this task by using photographs. According to tradition, lovely Viennese women subsequently stormed his studio, asking to be included.[33] In the cultural memory of Vienna, this was a repetition of a frequently caricatured scene in which Makart was besieged in his studio by the most beautiful women in Vienna, all wishing to be part of the Silver Wedding Anniversary parade paying homage to the Emperor and his wife, which later became famous as the 'Makart Parade'.[34]

FIG. 28
TITIAN (active about 1506; died 1576)
Portrait of Isabella d'Este, 1534
Oil on canvas
Kunsthistorisches Museum, Vienna

FIG. 29
Emmy von Ephrussi (*née* Schey) posing
as Titian's *Portrait of Isabella d'Este*.
Photograph from her album, about 1904
Edmund de Waal

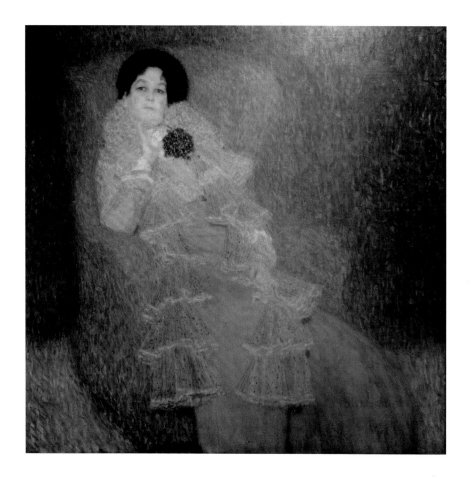

FIG. 30
GUSTAV KLIMT (1862–1918)
Portrait of Marie Henneberg, 1901–2
Oil on canvas
Staatliche Galerie Moritzburg,
Salle (Halle)

FIG. 31
Photographs of the central hall of
Villa Henneberg in Vienna, including
Gustav Klimt's *Portrait of Marie
Henneberg*, reproduced in *Das
Interieur* Vol. IV (1903) pp. 136–7.

136 DAS INTERIEUR IV DAS INTERIEUR IV 137

☐☐☐ HAUS DR. HUGO HENNEBERG. DIE HALLE. KAMIN AUS PAONAZZETTO- ☐☐☐
☐☐☐ MARMOR, EISEN UND VERGOLDETEM MESSING. ☐☐☐

Raum dieser Art zu erzielen, sollte man in den kleinen Stadt- und Landhäusern das
sogenannte Eintrittszimmer ohne Bedenken opfern. Man wird stets die Beobachtung
machen, daß sich eine Gesellschaft am behaglichsten fühlt, wenn sie in einem einzigen
größeren Raum vereinigt ist. Fehlt es daran und müssen sich einzelne Gruppen in
kleinere Nebenräume zurückziehen, so pflegen sie sich wie ausgeschlossen zu fühlen,
und wer zu ihnen hineintritt, findet es schwer, sich anzuschließen und pflegt nach
einem flüchtigen Blicke wieder zu verschwinden. In einem einzelnen großen Raum
fällt das Anschließen und Abbrechen unendlich bequemer, weil es keinen so gewalt-

☐☐☐ HAUS DR. HUGO HENNEBERG. DIE HALLE. ☐☐☐
☐☐☐ BLICK VOM OBEREN ENDE DER HALLENTREPPE. ☐☐☐

samen Eindruck macht, wenn man durch eine Tür in ein anderes Zimmer treten
oder es auf demselben Wege verlassen muß. Was leicht, ungezwungen und unbe-
merkt vor sich gehen müßte, wird durch die leiseste Umständlichkeit als etwas Ab-
sichtliches markiert.

There are two main sorts of 'typical' female portraits in Klimt's mature work. The first type, which includes *Sonia Knips* (1898, fig. 12; see p. 41), *Marie Henneberg* (1901–2, fig. 30) and *Adele Bloch-Bauer I* (1907, fig. 40; see p. 161), has a square format, and shows a three-quarter-length seated figure – whose hands and head are naturalistically presented – framed with ornament. The second type, which includes *Serena Lederer* (1899, Metropolitan Museum of Art, New York) and *Posthumous Portrait of Ria Munk III* (1917–18, 63; see p. 183), has a vertical format and shows the subject standing full-length. The clothing melts and merges impressionistically or ornamentally into the background, and the surrounding space is rendered abstract, concentrating the gaze of the observer on the naturalistically presented face. Hands serve as expressive markers revealing inner states.[35]

Furthermore, the female portraits may be linked to three relevant phases of Klimt's work. At the outset of his career he displayed meticulous fidelity to the original, as, for example, in *Young Girl, Seated* (1894, 21; see p. 80). Around 1900 he began to produce large-scale female portraits, such as *Portrait of a Lady in Black* later identified as Marie Breunig (about 1894, 30) and *Portrait of Hermine Gallia* (1904, 1; see p. 22).[36] Marie is an excellent example of the upward-mobility of the middle classes. She was born in modest circumstances and married the master baker Johann Breunig. His business was so successful that it allowed her subsequently to gain entry to the fashion salon of the Flöge Sisters (which opened in 1904) where, having started off as a customer, she became a friend of Klimt's 'soul mate' Emilie. As early as 1894, Klimt captured Marie's new self-confidence in a portrait which is reminiscent of the work of John Singer Sargent, one of the society portraitists most in demand in Europe at that time. He began using the square format in his *Portrait of Sonia Knips*, which became typical in his work, and can also be seen in the *Portrait of Marie Henneberg*. In this canvas, he experimented with vibrant impressionistic brushstrokes and decorative open spaces in order to create tension, merging chair and background to such an extent that the painting was described as incomplete.[37] The picture, commissioned by the art photographer and woodcut artist Hugo Henneberg, was sympathetically displayed in the house designed by Josef Hoffmann for the Hennebergs on the Hohe Warte, Vienna's artist colony (fig. 31). From her position above the mantelpiece, the lady of the house dominated the Great Hall. The villa was praised for its modernity and admired as a model for interior décor.[38]

In the second phase of Klimt's work there was more of a stress on graphic elements, and the artist enclosed his figures within surfaces

30
GUSTAV KLIMT (1862–1918)
Portrait of a Lady in Black,
about 1894
Oil on canvas, 155 × 75 cm
Belvedere, Vienna, loan from
a private collection

and geometrical ornament. This radical stylisation and ornamentation included not only the backgrounds but also the furnishings and the costumes. But despite his tendency to artistically rejuvenate his models, Klimt held fast to a naturalistic portrayal of face and hands. In the portrait of *Adele Bloch-Bauer I* (1907, fig. 40; see p. 161), the only portrait that can be ascribed to the artist's 'golden period' (if we can speak of one), the sitter's body disappears behind ornamental gold decoration that resembles the costly overlay of an icon.[39] This effect has been described as a 'tendency to escape the corporeal'.[40]

In the later third phase of Klimt's work, the application of colour increased dramatically – following the advent of Fauvism – and the trend towards abstraction was taken further, as can be seen from the *Posthumous Portrait of Ria Munk III* (1917–18, 63; see p. 183). The superimposed spatial planes allowed for varied content, and were characteristic of the way Klimt structured his pictures.[41] This process can be seen in the preparatory stages for the unfinished *Portrait of Amalie Zuckerkandl* (1917–18, 33). Studies for the picture (1913–14, 31, 32) show that Klimt first of all prepared the composition graphically before completing the face and décolleté and adding the overarching decoration.[42]

The *Posthumous Portrait of Ria Munk III*, also unfinished, reveals the complexity of information about a sitter that Klimt could provide artistically. He produced three posthumous portraits of the 24-year-old subject, who had shot herself in the heart in tragic circumstances.[43] In the final one, he added into the decoration significant pointers to Ria's biography that remain invisible to the uninformed observer, using symbols from Christian, Chinese and Japanese art.[44] The references to positive values are threatened, as though by some hostile power, by the poisonous

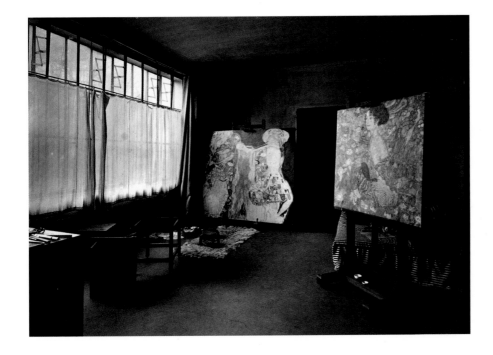

FIG. 32
An interior view of Klimt's final studio in Vienna, showing the two paintings unfinished at Klimt's death, *Woman with Fan* and *The Bride*.
Photograph, 1918

31

GUSTAV KLIMT (1862–1918)
*Study for the Portrait of
Amalie Zuckerkandl,* 1913–14
Pencil on paper, 56.9 × 37.5 cm
Albertina, Vienna

32

GUSTAV KLIMT (1862–1918)
*Study for the Portrait of
Amalie Zuckerkandl,* 1913–14
Pencil on paper, 56.9 × 37.5 cm
Courtesy W&K – Wienerroither
& Kohlbacher, Vienna

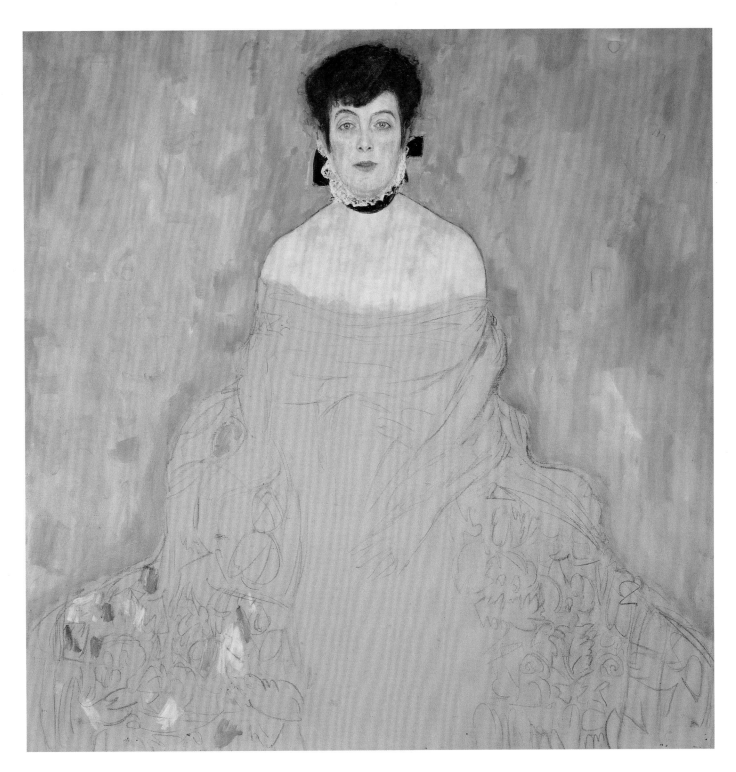

33
GUSTAV KLIMT (1862–1918)
Portrait of Amalie Zuckerkandl,
1917–18
Oil on canvas, 128 × 128 cm
Belvedere, Vienna
Donated by Vita and Gustav Künstler

mandrake root, to which are ascribed magic powers and aphrodisiac effects. This refers to Ria's unhappy love for her former fiancé Hans Heinz Ewers, author of the scandalous novel *Alraune* (*Mandrake*) which had just appeared. As Ria looks at the observer she does not see the flowers around her, which according to the interpretation of dreams means that her love is unrequited.[45]

INVENTING A NEW SOCIETY — MAKART AND KLIMT'S MOVES BETWEEN CONTINUITY AND CHANGE

Hans Makart and Gustav Klimt were both already established artists before they became known as 'painters of women' and reinvigorated the art of Viennese portraiture. Their innovative concepts were sought after by the self-aware and fashion-conscious ladies of Viennese society.[46] None of the independent portraits discussed here were necessarily private. The women pictured represent their social status and display the role of the – usually male – patrons, and most of the portraits were publicly exhibited. Portraits were also reproduced (fig. 31; see p. 100) and domestic presentation was no longer limited only to invited guests. The conventions of portraiture revolutionised by Makart and Klimt fascinated observers and the personal stories of the female beauties portrayed awakened the curiosity of the public.

In their portrayal of femininity, both artists contrasted finely modelled faces with body contours melting beneath costly clothes that blur into the surrounding space. For both, the portrait served as a pretext for artistic virtuosity. In contrast to Anton Romako (15; see p. 57) and Oskar Kokoschka (2; see p. 26), Makart and Klimt were particularly interested in the decorative aspects of painting, and so were their sitters, who wanted their beauty to be shown as a part of their social identity. The female portraits of all four artists also show different ways of revealing the inner psychological states of their models. Despite his strong idealisation, Makart gives his more intimate portraits an individual expression by his sensitive rendering of the glance and the area around the mouth, and his selection of pose. Similar ambivalences are also evident in Klimt's female portraits, in the reticence of facial expression and posture, although the gestures are more forcefully expressive. Even in Klimt's early works the naturalistic hands reveal the nervous state of the sitter, as in the portrait of Hermine Gallia (1; see p. 22). Both Makart and Klimt chose aesthetically filtered forms of presentation and avoided portraying inner states as sharply as Anton Romako. His portrait of Isabella Reisser (15; see p. 56), the wife of Christoph Reisser, who was technical director of the Viennese

daily paper *Die Neue Freie Presse*, reveals her nervous state quite mercilessly. The clear silhouette and her fashionable costume full of tonal contrasts direct the viewer's attention to her face, with its fixed gaze and visible teeth.

The new generation of young artists did not make a radical break with tradition, even though it included such significant representatives of early twentieth-century Austrian art as Egon Schiele, Anton Faistauer and Albert Paris von Gütersloh (37; see p. 121).[47] The heterogeneous *Neukunstgruppe* (New Art Group), which was founded in 1909 under the influence of the Kunstschau organised by the Klimt Group, revered the work of Klimt, Kokoschka and Arnold Schönberg (39; see p. 122).[48] Improvising with colour and erotic subjects, they defined art as 'the actively resistant face of the soul'.[49] This successful 'initial spark' of Austrian Expressionism is nowadays less well known than the German Expressionist groups *Die Brücke* and *Der Blaue Reiter*, presumably because the *Neukunstgruppe* was formally disbanded in 1912–13 when it joined forces with the newly formed *Bund österreichischer Künstler*. However, after the second *Neukunstgruppe* exhibition in Prague in 1910, Faistauer and Gütersloh in particular were much in demand as portraitists.[50] Gütersloh's *Portrait of a Woman* (1914, 34) reveals his preference for Cézanne. The work of this former actor was still being described by critics in 1911 as that of a dilettante, and his free brushwork was referred to as *Klecksographie* (pictures made with ink blots).

Makart and Klimt overshadowed their competitors so completely that many of these artists have since been neglected, and their sitters were long consigned to anonymity.[51] However, the erotic aura of Klimt's and Makart's subjects provoked people to spread rumours about intimate relations with the ladies portrayed[52] – a tribute to the total intimacy achieved in their portraits. It is all the more remarkable that both painters, in contrast to artists such as Anselm Feuerbach (35; see p. 116) showed little interest in self portraits, both preferring to present themselves in photographs.

In spite of a variety of points in common, profound differences exist between the portraiture of Makart and Klimt. Their working methods present a particular contrast. Makart worked fast, but Klimt worked slowly, producing only one portrait a year after 1900. He was a perfectionist who made numerous preliminary studies for his portraits.[53] The portrait for which most preliminary drawings exist is *Adele Bloch-Bauer I* (fig. 40; see p. 161), which took four years to prepare.[54] For the *Portrait of Hermine Gallia* (1903, 1; see p. 22, re-worked in 1904) the preparatory drawings produced after 1902 show Klimt's struggle to achieve the right way of presenting a seated or standing figure as well.[55] Even when he finished

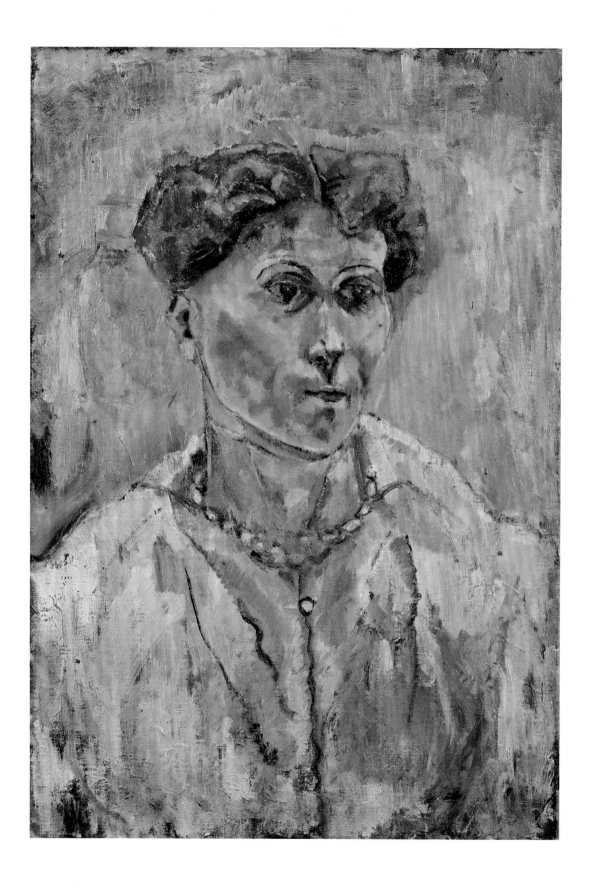

the picture, Klimt declared himself dissatisfied and overpainted it. He repeatedly exhibited pictures which were labelled 'unfinished' and that he later reworked.[56] Nothing is known about the processes that produced Makart's portraits. Presumably he prepared neither colour sketches – which are only known for his group compositions – nor draft drawings. It is possible that he used photographs to supplement studies of his model.

Makart pursued society portraits in the form of three-quarter-length pictures (28; see p. 92; 29; see p. 94) and Klimt followed him in this, just as he did with full-length portrait representations. But instead of following aristocratic set formulae and giving their portraits a brilliant finish (like Angeli, for example), Makart and Klimt drew eclectically on the whole repertoire of pictures established since the sixteenth century. The application of their resources, their new styles and innovations, bear witness to changes in the demands made of portraiture. This should not be underestimated, especially in the age when photography established itself as a portrait medium, albeit in a smaller format. The continuity and change that characterised this period is naturally reflected in the way that women were portrayed by Makart and Klimt.

Makart and Klimt were not court painters.[57] Their clientele was drawn mainly from the upper middle classes and their immediate circle. Commissions also came from limited sections of the aristocracy[58] – in particular those nobles who were upwardly mobile and who needed to establish their place in the social hierarchy.[59] They required a form of portraiture that had not existed before, and their portraits had to be modern so as not to compete with the conventions of the old aristocratic families. The lack of a long family tradition to draw upon was an advantage for both the artists and their clients as it allowed for experimentation with the *mise-en-scène* and brilliant styles of presentation, which led to a fusion of figures and surroundings. Hans Makart's portrait of Magdalena Plach (1870, Belvedere, Vienna), marks the start of this development.[60] But whereas Makart achieves this process of fusion by using a particular colour or tone, Klimt encloses his figures by using surface planes and ornament.[61] The female portraits of Makart and Klimt share idealising details that are typical of the period, like hidden feet (as far as the Emperor was concerned, a lady could not possess legs) and the omission of signs of ageing, but there are also clear differences. Whereas Makart's women in historical dress legitimised the models' status as though they were part of their own non-existent gallery of ancestors, Klimt created pictures for a new forward-looking avant-garde.

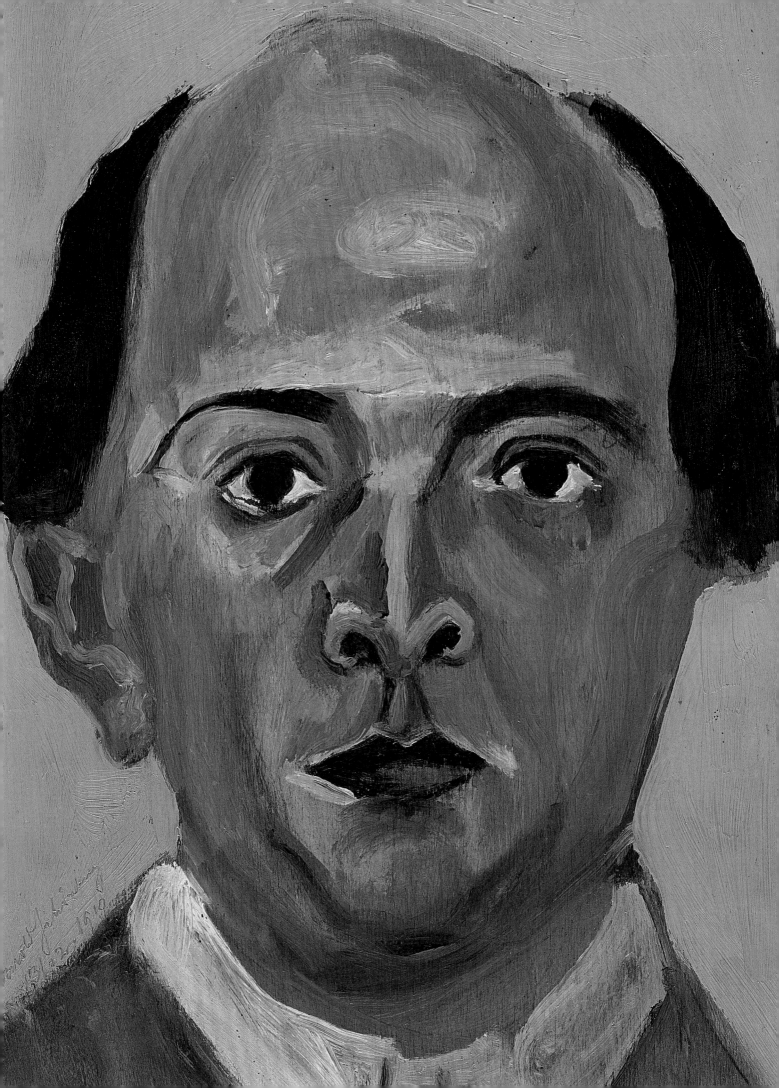

KLIMT, SCHIELE AND SCHÖNBERG SELF PORTRAITS

Gemma Blackshaw

There is no self portrait of me. I'm not interested in myself as a 'subject for a painting' but rather in others, above all in females, and even more in other phenomena … But this is no great loss. Anyone who wants to know anything about me as an artist – and this is the only thing that matters – should look attentively at my pictures and try to discern from them who I am and what I want.[1]

Gustav Klimt completed just one self portrait during his 40-year career – a work he either forgot to mention, or decided against mentioning, in this rare insight into what motivated him as an artist. In 1879, while still a student at the School of Applied Arts, Klimt formed the *Künstler-Compagnie* (Artists' Company) with his brother Ernst and their friend Franz Matsch. The aim of this company was to compete for the public art commissions that typified Vienna's Ringstrasse era, and in 1886 the young artists were contracted to decorate the two grand staircases of the city's new Burgtheater with a series of murals celebrating the history of theatre. On the ceiling of the *Kaiserstiege*, reserved for the exclusive use of the Emperor Franz Joseph and his family, Klimt painted an image of an Elizabethan audience at London's Globe Theatre watching the final crypt scene of Shakespeare's *Romeo and Juliet* (fig. 33). He depicted himself within this audience, dressed in the fashions of late-Tudor England, his head encircled with the white lace ruff of the courtier, seated to the right of the stage below a theatre box. This portrait appears alongside those of his brother Ernst, in a red velvet doublet, and Matsch, in a black bejewelled hat. All three men are shown in character, as caught up in the drama of the tragic deaths of Paris and Romeo as the other open-mouthed members of the audience.[2]

The commission to decorate the new 'Burg' was a highly prestigious one, and Klimt went on to receive the Emperor's 'Golden Order of Merit' for his contribution to the mural cycle. This seal of imperial approval provided the artist, who was from the *Mittelstand* (lower middle class)

FIG. 33
GUSTAV KLIMT (1862–1918)
Wall painting of Romeo and Juliet
scene on the ceiling of
the Burgtheater, 1888.
Burgtheater, Vienna

with his entrance to the world of the *Bürgertum* (upper middle class), a sector of Viennese society with aristocratic pretensions that painters with ambition had to cultivate.[3] The recent death of Hans Makart, who styled himself as the *Malerfürst*, Prince of Painters, meant that this clientele was, rather tantalisingly, within reach. It was in this context of career building and commission winning that Klimt produced what is widely accepted as his first and only painted self portrait. Positioned high above the select steps of the *Kaiserstiege*, Klimt's image was a nod to the ambitions of the *Bürgertum* in the 1880s to assimilate with the aristocracy through the embrace of culture and, in particular, the patronage of the visual arts. Posing in a costume and setting that spoke to the love of this aspiring sector of Viennese society for spectacular forms of historical re-enactment, Klimt presented himself as a contender for the crown of the *Malerfürst*. We see here how a self portrait could be used strategically by an emerging artist to create an identity in tune with the patrons he was hoping to attract.

FROM HISTORICISM TO MODERNISM

The image of Klimt in 'Shakespeare's Theatre' is rarely considered in histories of the self portrait in Vienna 1900. We tend to look past the 'role-playing' of artists working in the historicist mode of the 1870s and 1880s, to focus instead on the 'truth-telling' of the early twentieth-century modernists. This says a great deal about the desires we ourselves bring to self portraits, and in particular to those produced in 'Freud's

Vienna'. More than any other form of portrait, we embrace the self portrait as the image of the tormented human subject as it was conceived by the psychoanalyst, and we think we find this image in the work of such modernists as Egon Schiele and Arnold Schönberg. Neither of these artists addressed Freud's writings directly, but both were similarly concerned with the question of how to represent the intensities of the inner life. As Schönberg stated in a letter to the Russian artist Vassily Kandinsky in 1911: 'But art belongs to the *unconscious*! One must express oneself! Express oneself *directly*! Not one's taste, or one's upbringing, or one's intelligence, knowledge or skill. Not all these *acquired* characteristics, but that which is *inborn, instinctive*.'[4] Freud was highly sceptical of this rhetoric and had no taste for modern painting, but we do not tend to exercise the same degree of critical caution in our engagement with self portraiture in Vienna 1900. Almost without exception, we interpret self portraits by Schiele and Schönberg in Freudian terms, as symptomatic of the artist's psychological conflict. In doing so, we separate these works of art from the cultural and commercial contexts in which they were produced. Modernist artists were far more preoccupied with the self portrait than the previous generation of historicists. But the modernist image of the artist was no less engaged with patrons, audiences, taste and identity, than Klimt's opportunistic appearance on the ceiling of the Burgtheater. Indeed, significant changes in the art market meant that artists such as Schiele and Schönberg had to work even harder than the young Klimt to construct identities with cultural and commercial appeal.

Vienna's art market shifted dramatically during Klimt's career, from the public commissions of the city's liberal heyday to the rise of private patronage, and from the academy system to the commercial gallery and dealer system.[5] The privatisation of the art market was a Europe-wide phenomenon, but the small size of Vienna in comparison with other capitals such as London, Paris and Berlin heightened artists' experiences of these shifts.[6] The Vienna Secession, which was founded in 1897, provided progressive artists with professional representation, but the departure of the Klimt Group in 1905 led to a diminishing of its role in connecting practitioners with patrons. Competition in the city for exhibition exposure and newspaper coverage, and for sales and commissions, was intense. Artist collectives did not by any means die out in Vienna. In 1909, for example, the 19-year-old Schiele became President of the newly formed sixteen-strong *Neukunstgruppe* (New Art Group), which had a contract with a small gallery, the Pisko Kunstsalon. But increasingly, artists had to work independently and in competition with one another.

The image of the artist was critical in this new commercial context, and this goes a long way towards explaining the profound preoccupation with the self portrait in the shift from historicism to modernism in the city. Modernist artists used the self portrait to declare their singularity and to develop a cult of self, and this was due in no small part to their need for the financial and intellectual support of patrons. In painting these patrons as they painted themselves, such artists identified with their supporters, effectively expanding the genre of self portraiture. But this manner of cultivating patrons had to be handled carefully.[7] The hostilities and rivalries of Vienna's public sphere were registered in a patron's taste and identity.[8] Some appeals to their aesthetic sensibilities worked while others failed, and we see this in the career trajectories of Schiele and Schönberg.

Responding to the cultural and commercial climate of modernism in Vienna, these two artists developed different ways of articulating the uniqueness of their vision – their *Erlebnis*. This was a term used by the Romantics of Central Europe in the late eighteenth and early nineteenth centuries to describe individual experience. It denoted a state of consciousness that was heightened by unrequited love, illness and addiction, betrayal and isolation, and it was conceived as the wellspring of artistic inspiration: those who cathartically expressed their *Erlebnis* could create great works of art. Schiele and Schönberg reinvigorated this Romantic concept of artistic genius. Schiele represented the extremes of his inner life through the depiction of his naked body, producing hundreds of nude self portraits on paper and canvas, whose sheer numbers indicate the importance of his *Erlebnis* to the creation of his art. Schönberg, by contrast, was an untrained painter who embraced his naivety, his 'untainted' mode of painterly expression, as a means of conveying his exceptional powers of insight and creativity. By turning to the naked and the naïve, both artists used typically avant-garde strategies of truth-telling and shock-inducing. Schiele's self portraits worked to establish him as one of the city's leading artists with remarkable speed, but Schönberg's failed to interest patrons, despite being based on the same principles. In exploring the alternate strategies used by these artists in their expanded concept of the self portrait, we can begin to appreciate both the dynamics and the limits of the modernist approach to the genre in Vienna 1900.

More than any other genre, the self portrait seduces us into aligning an
artist's life with their work, and this is particularly the case with Schiele.
The artist completed self portraits when he was as young as 16, but by
the age of 20 he was depicting himself with an energy and frequency
that has led many experts to view his work through a Freudian lens
as images of a traumatised and narcissistic individual. The illness and
eventual death of Schiele's father from syphilis during the artist's child-
hood, the closeness of his relationship with his sister Gertrude – who
posed for her brother naked – and the scandal of his 1912 imprisonment
for the crime of allowing children to view indecent drawings in his
studio in Neulengbach outside Vienna, make such psychoanalytical
interpretations compelling. But they also blind us to the cultural and
commercial contexts that Schiele worked within. One of the defining
features of Viennese modernism across the arts was the intertwining
of public and private lives, an entanglement that was produced by artists

35
ANSELM FEUERBACH (1829–1880)
Self Portrait with Cigarette, 1875
Oil on canvas, 66 × 52.5 cm
Staatsgalerie Stuttgart
Lent by the Federal Republic
of Germany

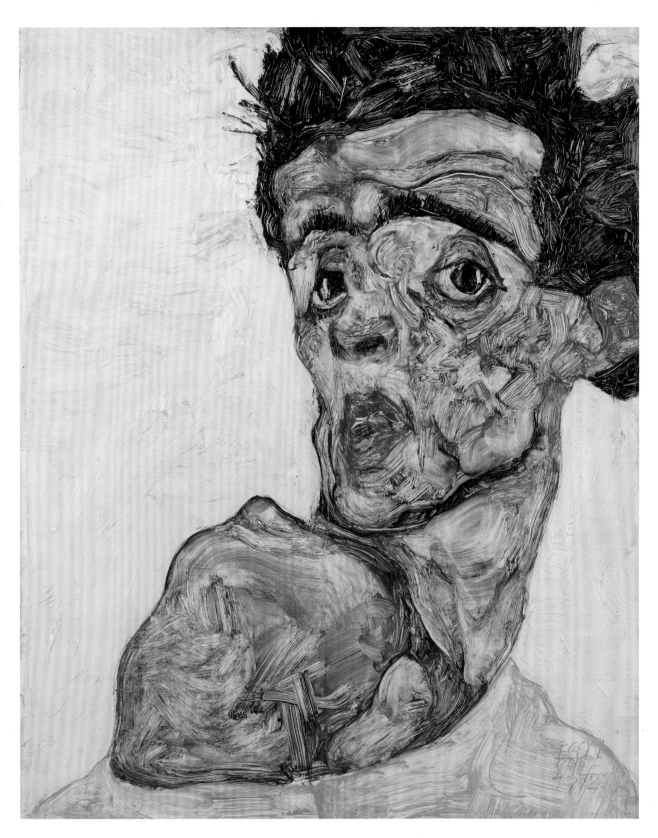

36

EGON SCHIELE (1890–1918)
*Self Portrait with Raised
Bare Shoulder*, 1912
Oil on wood, 42.2 × 33.9 cm
Leopold Museum Private Foundation,
Vienna

and their ardent supporters in order to promote their work to a
market that responded to personality and scandal.[9] The self portrait
was a remarkably economical and effective way of drawing art and
life together, but this is not to say that the genre was limited to the
self. In Schiele's work in particular, the image of the artist was a means
of registering anxieties that were as cultural as they were personal.

In his self portraits, Schiele used his body as a medium of artistic
expression, approaching it as another material to be manhandled.
In an image of the artist of 1912, paint is applied in thick, expressive
strokes with brush, finger and thumb from a highly coloured palette
of reds, blues and browns (36). Scratched through with the wooden tip
of a brush handle, the hairs of the artist's eyebrows stand up as if in
fright. The body is similarly manipulated: the exaggerated slightness of
Schiele's frame – the hollowed cheeks and narrow jaw – and the thrust
of his truncated shoulder out towards the viewer combine to create
the depleted yet dynamic body type that was so central to his portrait
practice. Critics interpreted this physique as the outer manifestation
of the artist's tormented inner life. For example, in a review of Schiele's
exhibition at the Galerie Arnot in Vienna in 1915, Arthur Roessler
described the artist's representation of the body as 'born from the
tortured shudders of a suffering soul'.[10]

Such a self-image and accompanying rhetoric was not particular
to Schiele and his supporters. Bohemian artists of the late nineteenth
century were similarly appreciated for the depiction of their 'anxiety'.
For example, in a self portrait by Anselm Feuerbach (35), the artist's thick
black hair is swept back from his forehead in such a way that the viewer
can imagine tense fingers raking through it. His left hand is held up
theatrically against his chest in a manner that anticipates the awkward
display of hands that so characterises Schiele's own portraiture. The
position of this hand highlights the cigarette smouldering between
Feuerbach's fingers; this replaces the traditional attributes of the artist –
the palette and brush – in order to identify him with transgression and,
ultimately, death.[11] Feuerbach's self portrait was painted in Vienna in
1875; by 1912, the date of Schiele's, concerns about the exhausted state
of modern masculinity and the 'deviant' nature of modern sexuality
were even more central to the cultural life of the city.

In the interrelated fields of medicine, psychiatry, sexology and
criminology, questions regarding the condition of the male body, and
what this condition revealed about its gender and sexuality, were being
anxiously debated. Was homosexuality a sign of effeminacy? What were the
effects of modernity on sexual potency? Was modern man a degenerate

shadow of his former self? Such typically fin-de-siècle concerns, which were related to maintaining the birth rate and the patriarchal structure of society, were not particular to Vienna. However, the political contesting of liberal, and especially assimilated Jewish identity in the city from the 1880s onwards meant that these matters were addressed with an urgency and creativity that set the city apart from other European capitals.[12]

To consider just one example, in his cult book *Sex and Character*, published in Vienna in 1903, the Jewish-born writer Otto Weininger reconceptualised sexuality as a scale along which subjects ranged between the poles of absolute masculinity and femininity. The 'aberrances' that existed between the most manly of men and womanly of women were considered by him to threaten biological and sociological norms. Weininger's attack on the homosexuals, Jews and 'emancipated women' who comprised these 'aberrances' was embraced by many of Vienna's writers and thinkers in the wake of his suicide at the age of 23.[13] In its passionate conception and reception, *Sex and Character* articulated what would become identified as the crisis in modern masculinity.[14] Schiele responded to this crisis in his work, presenting himself provocatively as the embodiment of the concerns Weininger and others raised about the starved and spent condition of modern man.[15] In their reviews of his self portraits, critics pondered the direction taken by the young artist: did the representation of his body signal the end of the history of art, or did it point to a new beginning, a reinvigoration of that tradition of great male painting? In his embrace of the vulnerable male body as a new sign of artistic genius, Schiele acknowledged such anxieties about the emasculation of modern man while simultaneously using them to underline a creative brilliance that maintained his position at the heart of patriarchal power. Women artists, as we will go on to see, could not adopt the same strategy.

The market demand for Schiele's erotic drawings of women is a much-discussed area, but the interest of his patrons in images of the artist receives less attention.[16] Schiele's self portraits, which were conscientiously signed and dated by the artist, were avidly collected by a group of almost exclusively male patrons from Vienna's middle classes. The industrialists Carl Reininghaus and August Lederer were the wealthiest of this group, able to afford the expense of works on canvas, but the majority of Schiele's collectors were fellow artists, critics, intellectuals and professionals – men with a lower-class status and less spending power, who purchased and exchanged among themselves his self portraits on paper.[17] What compelled them to collect these works of art? Schiele's self portraits were effective because they addressed

concerns that went beyond his own experience. But we might also argue that the artist's abject representation of his body, removed from any narrative or material setting that would provide the eye with something other than humiliated flesh to look at, worked on his patrons' feelings in the same way as representations of Christ, inspiring pity, devotion and, we might even say, desire in the onlooker.[18] Schiele's self portraits assumed a harrowing intimacy between artist and viewer, and this enabled him to claim that their relationship was based on something far more profound than art market economics – something even spiritual. As he declared in a passionate letter to his patron Oskar Reichel of 1911: 'I am so rich that I must give myself away.'[19]

Schiele used the image of the vulnerable male nude to engage this very particular group of Viennese patrons, men who were frequently older than him, whom he also approached with ecstatic letters and poems.[20] The representation of his emasculation was ultimately about empowerment, about belonging to this group through representing himself as 'excluded' from the conservative society in which these men operated.[21] Schiele's portraits of these patrons further emphasised their connection with him. By extending the body type of his self portraiture to his portraiture – as we see in Schiele's depiction of his friend and fellow artist Albert Paris von Gütersloh, which is frequently mistaken for a self portrait (37) – Schiele made these men in his own image. The resultant portraits were just as concerned with Schiele's self-expression, with the experiences and feelings of the artist, as his self portraits, and this sense of the all-encompassing reach of the artist, the totalising effects of his *Erlebnis*, connected Schiele with Schönberg.

THE ARTIST AS AMATEUR: ARNOLD SCHÖNBERG

Schönberg was new to the practice of painting, with next to no relationship with the art world, and no circle of influential or wealthy supporters to draw upon, so his claim to outsider status was far more convincing than Schiele's. The composer's decision to turn to painting around 1907–8 was an unexpected foray into the visual arts which coincided with his embrace of atonality in musical composition that culminated in the revolutionary twelve-tone technique of the early 1920s. Schönberg devoted himself to portraiture in particular, and this decision was driven by economics. His aim was to supplement his meagre income as a musician with portrait commissions. His lack of experience meant that his sitters were drawn almost exclusively from his immediate circle of family (44; see p. 131), friends and musicians – individuals who were

37
EGON SCHIELE (1890–1918)
Portrait of Albert Paris von Gütersloh,
1918
Oil on canvas, 140 × 110.3 cm
The Minneapolis Institute of Arts
Gift of the P.D. McMillan
Land Company

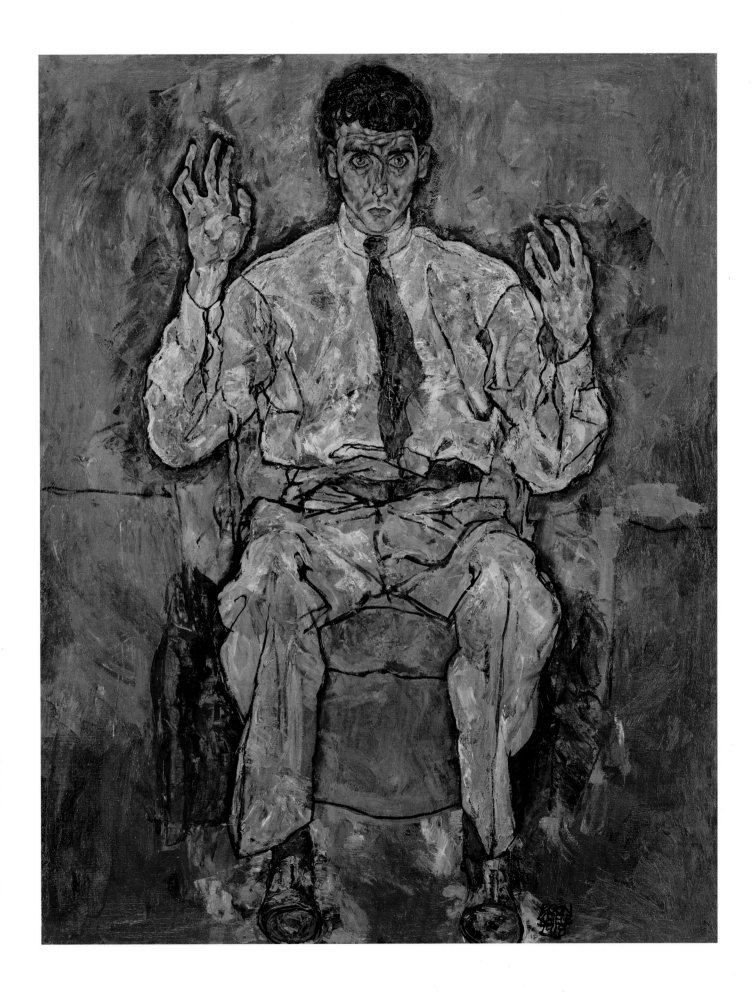

prepared to sit for Schönberg so that he might develop a substantial enough portfolio of work to attract future paying clients.

As an untrained painter, unfettered by institutional cultures and practices, Schönberg was in many ways the archetypal artist-genius. As he declared in his 1911 letter to Kandinsky, no knowledge or skill, no '*acquired* characteristics' could impede the painterly realisation of his artistic vision. Schönberg was an amateur, and this – according to the artist and his supporters – was what made his work so utterly compelling in that it was centred entirely on the artist's intuitions, on 'that which is *inborn, instinctive*'. As the composer Egon Wellesz, a pupil of Schönberg's, explained: 'These pictures … reveal to us the soul and lot of an artist possessed of almost supernatural power … They must be judged by a standard other than that applied to merely pleasant, enjoyable works of art. We must expect no dainty, toying rhythms, but the utterance of a passionate soul, harrowed by doubt, often indulging in sarcasm, but always feeling deeply.'[22]

Such an interpretation was profoundly indebted to Romantic concepts of the anxious and alienated artist, as represented in self portraits by Amerling, Franz Eybl and the young Rudolf von Alt. In a self portrait painted at the age of 63 (38), the balding, bearded Amerling turns away

38
FRIEDRICH VON AMERLING
(1803–1887)
Self Portrait, 1867
Oil on oak, 82 × 62 cm
Gemäldegalerie der Akademie der
bildenden Künste Wien, Vienna

39
ARNOLD SCHÖNBERG
(1874–1951)
Blue Self Portrait, 1910
Oil on three-ply panel, 31.1 × 22.9 cm
Belmont Music Publishers,
Pacific Palisades/CA
Courtesy Arnold Schönberg Center,
Vienna

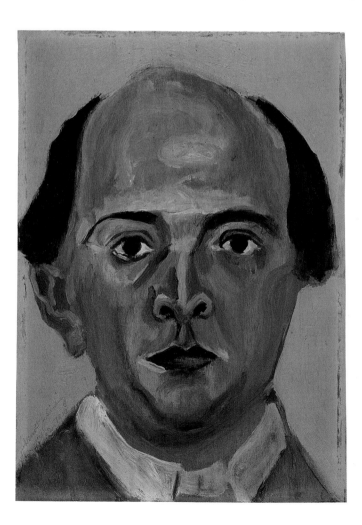

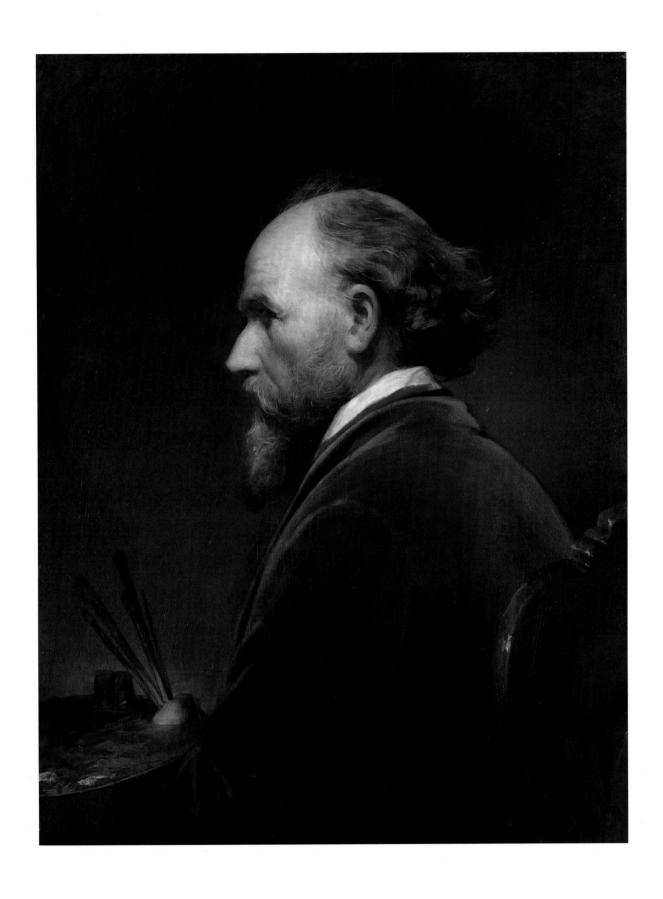

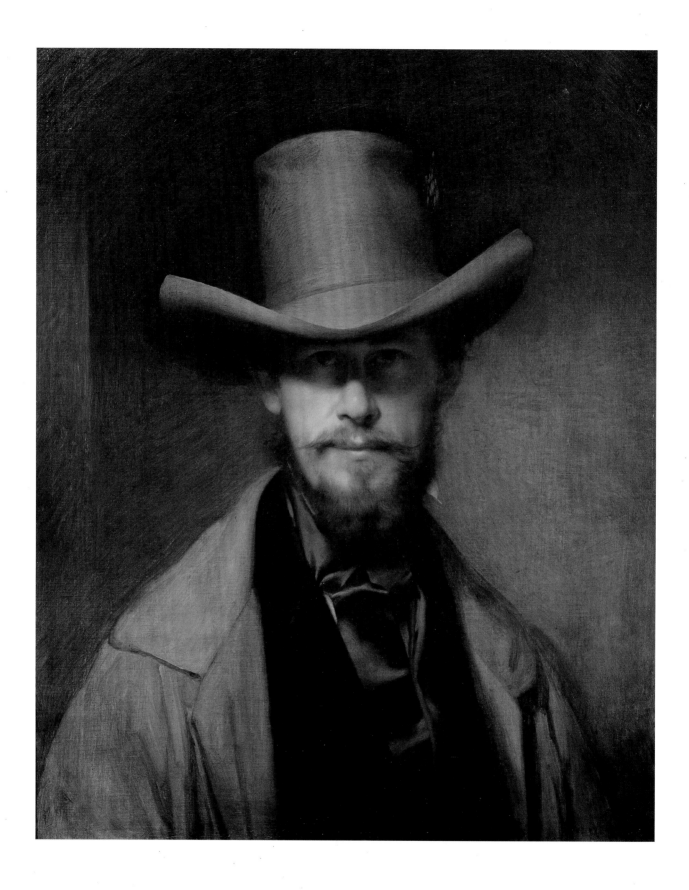

KLIMT, SCHIELE AND SCHÖNBERG

40
FRANZ EYBL (1806–1880)
Self Portrait, about 1840
Oil on canvas, 70 × 55.5 cm
Gemäldegalerie der Akademie der
bildenden Künste Wien, Vienna

41
RUDOLF VON ALT (1812–1905)
Self Portrait, about 1835
Watercolour, 18.3 × 13.3 cm
Wien Museum, Vienna

R. Alt 883

12 46⁵ 56⁵

from the viewer to expose the profile of his face, and his back, clothed in a rich velvet jacket. We stand as if we are the figure of Death, peering over the artist's shoulder to remind him of his vanity and mortality.[23] Eybl, by contrast, faces the viewer, gazing out at us intently from the deep shadows cast by his wide-brimmed hat in his self portrait of around 1840 (40). In Alt's image (41), the artist represents himself with flushed cheeks and heavily shadowed eyes, staring nervously out from the paper. The hastily painted, hesitant watercolour is inscribed with his signature and the words '*das bin ich*' – 'as I am', or, more colloquially, 'this is me'. These words insist on the importance of his authorship. The self portrait is unfinished – Alt's head is painted in a state of emergence from the plain white field, his jacket and cravat are suggested with broad sweeps of the brush – and this sense of incompletion speaks to the Romantic embrace of the unknown, the unrepresentable. How to capture the fleeting moods of the self? How to represent the artist's sense of *Weltschmerz* and *Ichschmerz* – estrangement from the world and from himself? Such questions were addressed through Alt's flickering, allusive brushwork, and continued to preoccupy the artist in self portraits produced later in life (42). In its naivety, Schönberg's painting proposed a new vocabulary for portraiture to that offered by Alt, but in many ways it was a response to these same questions.[24]

In a self portrait of 1910 (39; see p. 122), Schönberg represents himself with an uncompromising frontality, declaring his modernism by painting his face in a vivid blue. Schönberg was inexpert in the depiction of light and shade and the handling of colour gradation, and the image of his face has none of the immediacy with which Alt rendered his features. But this 'non-mastery' laid bare the full force of Schönberg's *Erlebnis*, and in this his work had another precedent in the figure of Vincent van Gogh. Significantly, in his self portrait Schönberg depicts himself without his left ear and this is very likely to have been done in reference to the Dutch artist. Van Gogh's work had been recently reappraised in Vienna in an exhibition of 1906 curated by Carl Moll at the Galerie Miethke.[25] Schönberg's decision to align himself with this artist was an interesting one, because Van Gogh was similarly appreciated at this time as 'a passionate soul' whose work spoke only of the artist, his emotions and experiences. Furthermore, Van Gogh's painting was also considered to be far ahead of its time. In her review of the exhibition at the Miethke, the critic Berta Zuckerkandl remarked that: 'The aura of his personality illuminates possibilities for artistic developments which are still distant. He should perhaps be understood as one who stands at the beginning, as an initiator, and therefore it is imperative that anyone who sees art as

shared experience should take note of him.'[26] Such a statement spoke persuasively to Schönberg's construction of his artistic identity. Schönberg claimed his work stood outside the history of art, but in his *Blue Self Portrait* he tied himself to another artist 'outcast' who was in the process of being canonised by Europe's modern art establishment and whose work similarly tested the limits of painting.

Schönberg's paintings were displayed at the Kunstsalon Hugo Heller in Vienna in 1910. Despite Moll's interest in Van Gogh, Schönberg could not persuade him to exhibit his own work at the Miethke; the small gallery attached to Heller's bookshop was Schönberg's only option. The aim of the exhibition was to generate patronage, but despite the display of portraits of important cultural figures, such as the composer Gustav Mahler and the pianist Marietta Werndorff (43), it was a failed commercial project. According to a review in *Die Neue Freie Presse*, just three works were purchased, one of which was a self portrait.[27] We do not know if these works were the same paintings mentioned in a later letter to Schönberg from his pupil Anton Webern informing him that Mahler, who had recently died, had purchased some of the pictures on display.[28] Whatever the truth of the sales, no portrait commissions came about as a result of the show.[29] The problem was Schönberg's naivety, his lack of technical training and ability. In an essay of 1912, Gütersloh (the painter depicted by Schiele) described Schönberg as working with a 'palette void of linguistically fixed technical functions'.[30] In other words, none could recognise this painting as painting, this art as art. For Gütersloh, Schönberg's images were 'acts of the mind' that challenged artists to think and paint differently: 'Very few trust these pictures. Most people hate them instinctively on first seeing them. So do the artists, who are frightened to death of the idea that they might have to paint like this themselves someday.'[31]

Schönberg's work threatened the future of portraiture on two counts. Firstly, in declaring himself an amateur and in claiming non-mastery as a creative force, Schönberg made a radical critique of the tradition of fine art, a tradition that Vienna's modernists were steeped in. Secondly, in asserting that the identity of the sitter was meaningless compared to that of the artist-genius, Schönberg worked outside a client's expectations of the portrait. As he wrote in a letter to the music publisher Emil Hertzka: 'I cannot consider letting the purchase of a portrait depend on whether the sitter likes it or not. The sitter knows who is painting him: he must also realise that he understands nothing about such things, but that the portrait has artistic value, or, to say the least of it, historical value.'[32] Convinced of his genius, Schönberg emancipated the portrait

43
ARNOLD SCHÖNBERG
(1874–1951)
Portrait of Marietta Werndorff,
before October 1910
Oil on board, 99.7 × 71 cm
Belmont Music Publishers,
Pacific Palisades/CA
Courtesy Arnold Schönberg Center,
Vienna

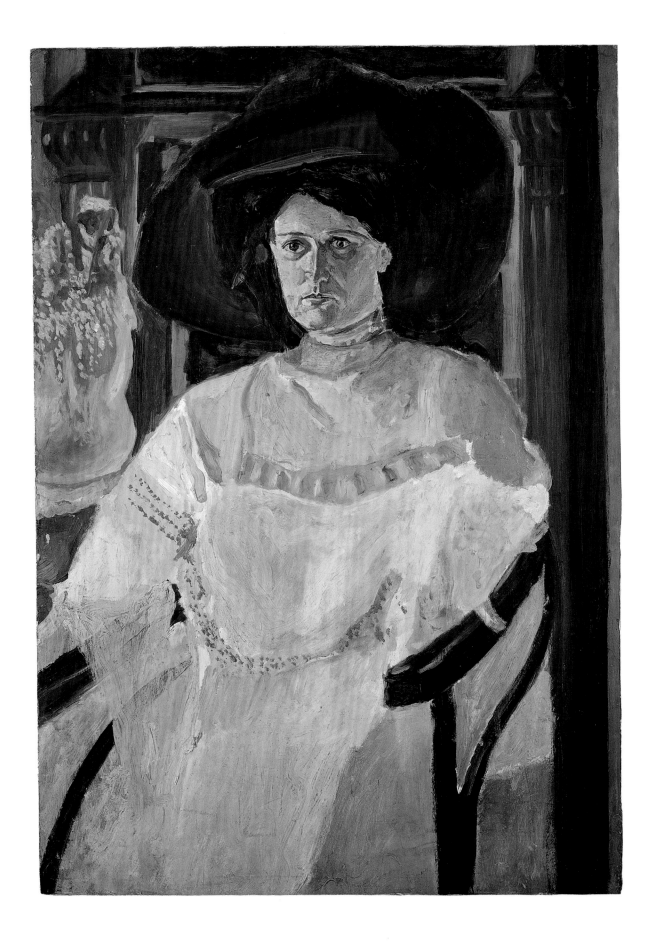

from the idea of the human subject and their likeness, an idea that remained central to Schiele's portraiture, no matter how contorted the body. Schönberg claimed that his portraits were about something more than physical reality, something so profound that it couldn't be rationally explained or artistically evaluated. That something was embodied in the artist, so that all portraits, all works of art, spoke only of him.

THE APPEAL OF THE ARTIST

As different as their art appears, in their portraits Schiele and Schönberg pursued the same question of representation: how to make visible that which lies within. Their respective turns to the naked and the naïve were artistic strategies aimed at a particular audience and art market that worked in Schiele's case, and failed in Schönberg's. In order to consider why, we should return to Klimt's depiction of 'Shakespeare's Theatre' on the ceiling of the new 'Burg'. In its celebration of costume and masquerade, of the artful and theatrical, Klimt's appearance in the guise of an Elizabethan is seen as the antithesis of self portraits by Schiele and Schönberg. Modernism depends on such a sense of rupture, of generational revolt. This has become central to how we understand the advent of modernism in Vienna in particular, and Freudian analysis has played an important role in this.[33] But the shift from Klimt's work to Schiele's was not as stark as we might think, and this may explain the success of his practice compared to Schönberg's. Theatre was as important to the modernists in the early twentieth century as it was to the historicists in the late nineteenth century. As Tobias Natter has argued in his work on Schiele: 'The capital of the Austro-Hungarian Monarchy on the eve of the dissolution of this political entity offered an ideal context for the artistic investigation of nakedness and its public display. In no other city was the love of theatre so great or the pleasure derived from a sensuous performance the source of such excitement. Nowhere else was the notion of "unveiling" celebrated with such refinement...'[34] Schiele's representation of his naked body as, to quote Roessler, 'born from the tortured shudders of a suffering soul' should be seen in this cultural context. In their histrionic distortions and convulsions, his self portraits were as theatrical, as staged, as Klimt's costumed body. They continued a rich tradition of performance and display, and in their public address, their appeal to audiences, they worked to establish Schiele as one of the most marketable artists of Vienna 1900. By contrast, the naïve work of Schönberg, the composer-painter, would not be appreciated until the end of the twentieth century.

44
ARNOLD SCHÖNBERG
(1874–1951)
Portrait of Georg Schönberg,
February 1910
Oil on three-ply panel,
50 × 47 cm
Belmont Music Publishers,
Pacific Palisades/CA.
Courtesy Arnold Schönberg
Center, Vienna

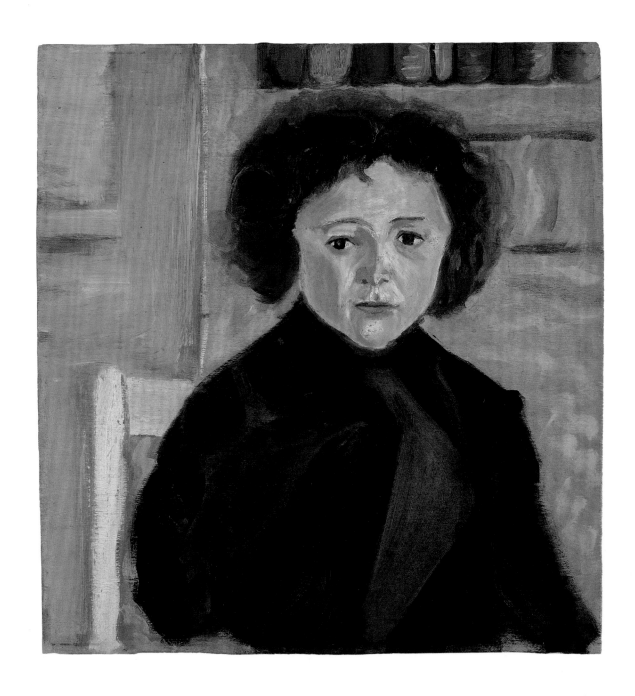

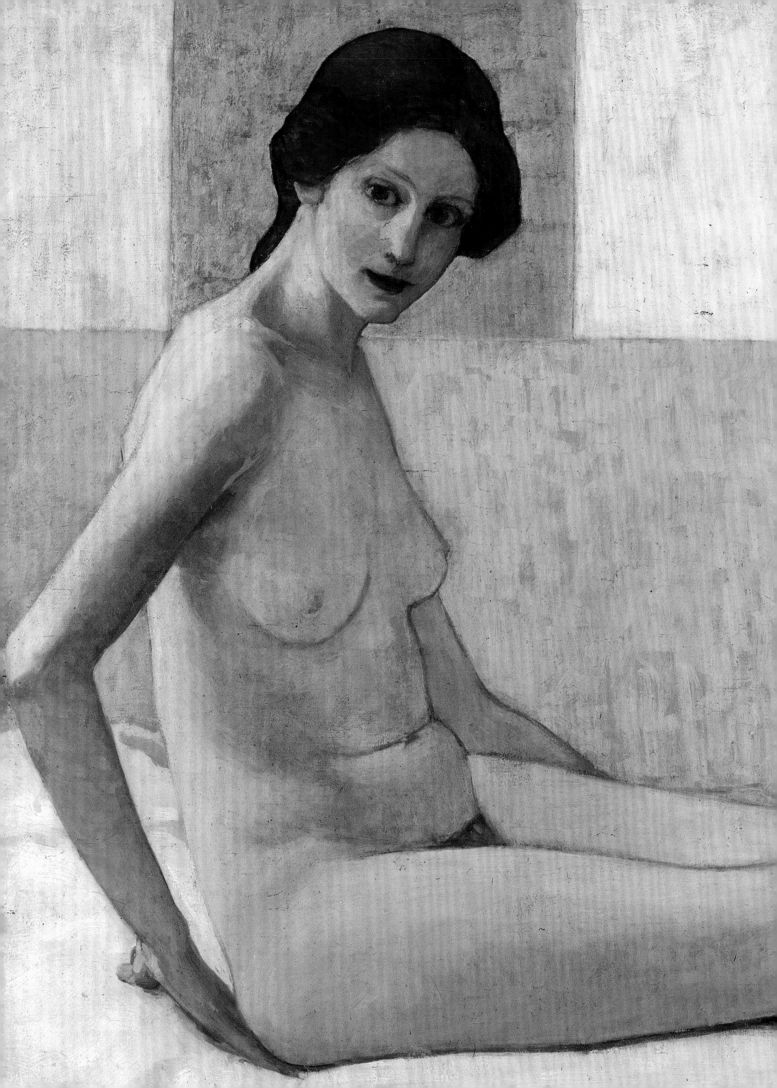

WOMEN ARTISTS AND PORTRAITURE IN VIENNA 1900

Julie M. Johnson

45
BRONCIA KOLLER (1863–1934)
Nude Portrait of Marietta, 1907
Oil on canvas, 107.5 × 148.5 cm
Eisenberger Collection, Vienna

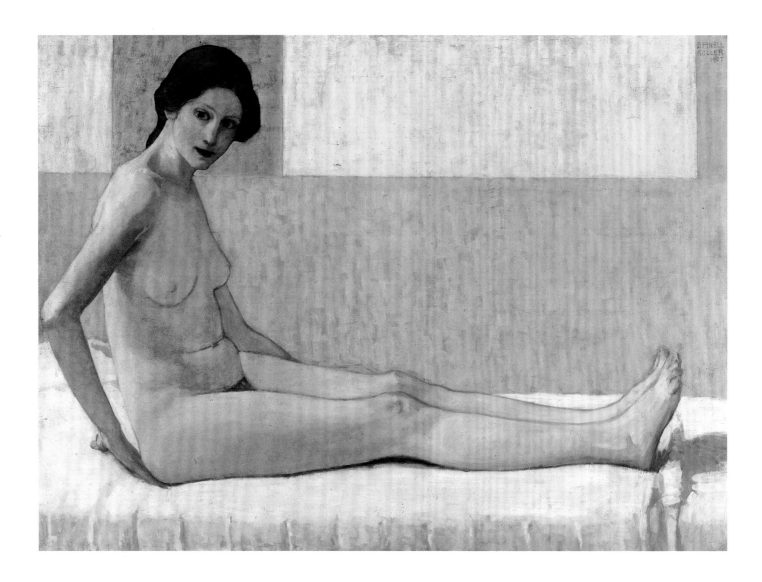

Portraiture was traditionally considered an appropriate genre for women because of its associations with family albums and copying.[1] In the hands of Vienna's modernist women artists, however, portraiture became a genre of extreme experimentation. Broncia Koller's *Nude Portrait of Marietta* (1907; 45), for example, offers a new take on the classic genre of modernism, the reclining nude. Koller's innovative approach is to represent the model as a studio nude and as a portrait, stretching the limits of the genre. The model gazes serenely at the viewer while sitting in an upright, straight-backed position. The large canvas is both modernist and feminist in outlook. The artist reduces the narrative element to a white mattress, one so simple that it recalls the kind of white tablecloths found in still lifes. The background is a harmony of gold, grey and cream paint, the brushstrokes visible on the flat planes of colour. Koller focuses on the individuality of the model rather than the sexualised encounter more typical of modernism.

The painter of two genre-stretching works discussed in this book, Koller is now among the forgotten women artists of Vienna 1900, many of whom were Jewish. Because their history has been suppressed, some scholars have assumed that women were not allowed to exhibit their work in Vienna's public spaces.[2] Nothing could be further from the truth. In fact, one of the earliest arenas for achieving career success for a woman in Vienna was in the field of the fine arts – to practise required no licence or official diploma and alternative educational paths were abundant.[3] That is not to say there were no obstacles. The Secession, Vienna's elite exhibition organisation, did not officially accept women as members, and historians have understandably seen 'Freud's Vienna' as being too restrictive for women. Indeed, Vienna's art educational institutions and exhibition houses were heavily subsidised by the Ministry of Religion and Education, and offered only very limited opportunities for women when it came to official, state-funded benefits. However,

to merely focus on restrictions obscures the successes that women did have.

Despite the legalistic issues of membership, women often exhibited their work at the Secession, and one third of the artists included in the 1908 Kunstschau, a landmark exhibition in Vienna over which Gustav Klimt presided, were women. Some women organised alternative women-only artist groups, for which they created new art publics, with enviable financial and social success. By 1910 there were myriad opportunities for women artists to exhibit their works in established exhibition houses as well as alternative spaces. To tell the social history of Vienna's women artists, therefore, requires an examination of how each woman negotiated the art world. The women discussed here – Koller, Elena Luksch-Makowsky and Teresa Ries – all had careers as public artists in Vienna. With varying degrees of freedom and ingenuity, each was able to chart her unique path. Each worked with portraiture for her own reasons: for Koller it was connected to the aesthetics of European modernism; for Luksch-Makowsky it was connected to her idea of an epic art form; and for Ries, who was a sculptor, most commissions came in the way of portrait busts and funeral monuments.

BRONCIA KOLLER AND THE KLIMT GROUP

Koller exhibited primarily with the Klimt Group, with whom she shared an aesthetic, but her portraits have not always been recognised as experimental works by scholars, because they include images of her family. Koller's portrait of her daughter gazing intently at a birdcage (1907–8, 46), doubles as a genre painting, and can also be read as a meditation on the attention of a child, which at the time was seen as a model for creativity by Lou Andreas-Salomé, her closest friend. Koller experiments with planes of colour in a square format canvas, contrasting the serene black tiles of the floor and the interior setting with the raucous colours of the birds and her daughter's red reform dress. She exhibited the picture at the 1909 Kunstschau, having already shown portraits of family and friends at the Kunstschau the previous year. In the 1980s, however, her works were misread as the mere hobby portraits of an art enthusiast and patron who was also a mother. Actually, the aesthetic of the Klimt Group was to reconnect art and life, and Koller's Kunstschau room of portraits, including one of her mother now at the Belvedere and one of Koller by her studio partner Heinrich Schröder (now lost), related to the Secessionist ideal of the art-permeated life and the Biedermeier ideal of the friendship portrait.[4]

46
BRONCIA KOLLER (1863–1934)
Silvia Koller with a Birdcage, 1907–8
Oil on canvas, 100 × 100 cm
Eisenberger Collection, Vienna

FIG. 34
BRONCIA KOLLER (1863–1934)
Egon and Edith Schiele, about 1918
Oil on canvas
Private collection

FIG. 35
EGON SCHIELE (1890–1918)
Portrait of Hugo Koller, 1918
Oil on canvas
Belvedere, Vienna

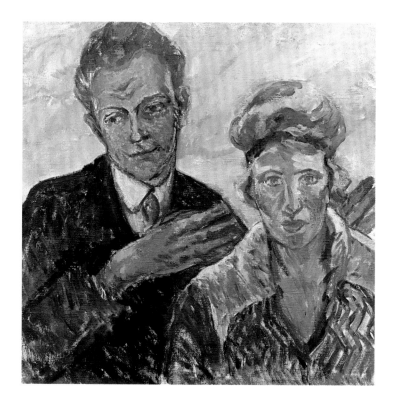

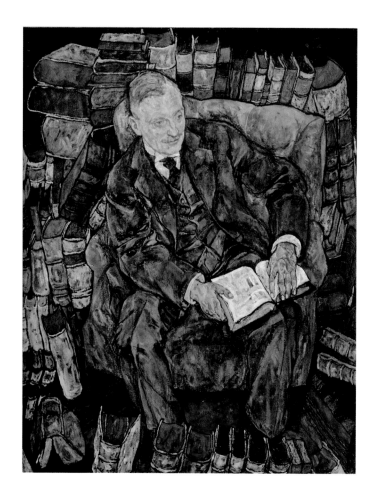

Koller practised the significant genres of modernism – still life, landscape, the nude and portraiture – but the social dimension of portraiture had added appeal. Her friendship portraits helped connect her to artists she admired, and her commissions were also meant to contribute financially to the art community. Her relationship to the genre as both artist and patron can be seen in a nexus of portraits from 1918, when she became part of a new artist association, the *Neukunstgruppe,* which centred around Egon Schiele.[5] Koller often served as a confidante and peace broker for the group; Albert Paris von Gütersloh and Schröder were also members. She commissioned Schiele to paint her husband Hugo and to give Silvia art lessons at their estate in Oberwaltersdorf. Schiele's humorous rendition of Hugo shows the bibliophile engulfed by towers of his rare books (fig. 35). During one of these visits Koller painted Schiele accompanied by his wife Edith in a little-known double portrait (fig. 34). Edith gazes out at the viewer, while Schiele's eyes are downcast. Wearing a suit and tie, Schiele has a deferential, shy demeanour that is atypical, at least in comparison to his self portraits (36; see p. 117), but his hands frame Edith's face in a characteristic gesture. The double portrait format inevitably added a psychological dimension to the picture, whether it was painted as a gesture of friendship, as Koller's certainly was, or

commissioned, as was Kokoschka's portrait of the Stein children, *Children playing* (47). Here, the interaction between the two children at play is conveyed through the expressive arrangement of their hands; clenched and flexed, they have none of the innocence of Silvia's fingers, as painted by her mother, that rest so gently on the birdcage.

If women in Vienna 1900 had fewer legal rights than today, figures like Koller could nevertheless wield considerable power in its social class system. Vienna, still the residential city of the Habsburg monarchy, offered vastly different experiences to women, depending on their titles, wealth and family mores. When Koller set up residence with her husband and children on her estate in Oberwaltersdorf, they made it a centre for intellectuals, artists and musicians. She did not live in a separate sphere of femininity, caged by domestic duties, but frequented artist cafés and studios and often travelled to Paris. Koller socialised with progressive feminists Lou Andreas-Salomé, Rosa Mayreder and Marie Lang, as well as Klimt, who is better remembered today for his intemperate love life, erotic drawings and sexualised representations of women than for including them as fellow artists in exhibitions. But he had been president of the inclusive Kunstschau, and when he formed a new exhibition group, the Union of Austrian Artists (referred to by critics and artists as the 'Kunstschau Group') in 1912, he included women as members with equal rights. Klimt nominated Koller as a member and she remained active in the group through the 1920s. She was well received in art critical reviews during her lifetime – it was only after she died that the word 'dilettante' was ever used to describe her. She was no dilettante, but rather a gifted painter and printmaker who exhibited her work over a long career.

THE EXPERIENCE OF MISOGYNY

If Koller experienced the positive aspects of Viennese modernism as an individual, there was a noticeable backlash against women and Jews in the larger cultural landscape. Vienna's contradictory nature materialised at the 1908 Kunstschau, in the year of Koller's first success with the Klimt Group. It was here that Oskar Kokoschka debuted his unmistakably misogynist play *Murderer, Hope of Women*, a brutally violent drama in which a man murders a woman; the title refers to the woman's desire for murder. Koller was incensed by the scandal and publicity the young artist drew. Her reaction explains much: she thought he did it for the sake of scandal, and disliked the fact that Klimt, the artist she admired most, exhibited his work with Kokoschka. The play reflected a misogynist strain in society, while its slashing expressionistic style conveyed violence. [6]

Other manifestations of misogyny appeared in best-selling books. In *Degeneration* (1892), Max Nordau warned his readers that mixing education and motherhood would lead to a degeneration of the human species, claiming that if women attended university, their milk would go bad.[7] Because of his interest in genius and creativity, Otto Weininger was especially keen to discuss women artists, which he often did as 'proof' of his argument in *Sex and Character*, first published in 1903. The reasons for this may be apparent in his discussion of 'emancipated women':

> Emancipation, as I mean to discuss it, is not the wish for an outward equality with man, but what is of real importance in the women question, the deep-seated craving to acquire man's character, to attain his mental and moral freedom, to reach his interests and his creative power ... All those who are striving for this real emancipation, all women who are truly famous and are of conspicuous mental ability, to the first glance of an expert reveal some of the anatomical characters of the male, some external bodily resemblance to a man. Those so-called 'women' ... have almost invariably been what I have described as sexually intermediate forms.[8]

His thesis was that human plasma was made up of male (m) and female (w) particles, and that everyone had a mix of the two; however, the ratios could become completely imbalanced. Among Weininger's proofs for his theory was the outward appearance of historical women artists who were notably talented: 'The face of Lavinia Fontana was intellectual and decided, very rarely charming; whilst that of Rachel Ruysch was almost wholly masculine.'[9] He added: 'It would be a serious omission to forget Rosa Bonheur, the very distinguished painter; and it would be difficult to point to a single female trait in her appearance or character.'[10] In Weininger's world, Bonheur was not primarily a woman; indeed, her surplus of 'm', or male plasma, was the real source of her artistic talent.

The woman who would rebut his arguments in her own book was Koller's friend, Rosa Mayreder (1858–1938). Mayreder had studied painting with the Impressionist Tina Blau (1845–1916), and co-founded the progressive Art School for Women and Girls in Vienna. She found her true calling as a public intellectual and feminist activist. Mayreder, who was of the lower middle class, was denied the academic educational opportunities that her intellectually less able brothers were afforded. Expected to follow middle-class gender norms, she instead began to critique those norms while co-editing the feminist journal *Dokumente der Frauen*. Her rebuttal to Weininger was published in 1905 in a book,

Kritik der Weiblichkeit (Critique of Femininity, translated into English in 1913 as *A Survey of the Woman Problem*). Mayreder demonstrated how the author had contradicted himself: 'When Weininger denies a soul to even the most masculine woman but grants it to the most feminine man, he fetters the soul to the most primary sexual feature and involuntarily exalts the phallus as the vehicle of the soul.'[11] Furthermore, she argued, by declaring the feminine particles of plasma 'soulless' and stating that the woman's body was always in a state of coitus, Weininger was reiterating ideas present in the *Malleus Maleficarum*, the infamous book that gave rise to superstition and the witch trials.[12]

Weininger's ideas, though extreme, had an audience. And when women exhibited their works in women-only group exhibitions, commentators sometimes employed those ideas. These often appeared in *feuilletons* – long, impressionistic opinion columns, given prominent space in a variety of newspapers. Whether the criticism was meant seriously or as a provocation or joke, it had a readership. When women showed their works in elite venues with the Klimt Group they were rarely, if ever, subjected to such gendered commentaries. The misogyny that appeared in print was due in large part to anxiety about changing female social and cultural roles. The separate women's art exhibitions became a forum for discussing women's issues, their role in society and especially the all-important role of motherhood.

On the occasion of the first international retrospective of historical women artists, which took place at the Secession in 1910, the misogynist ideas of critics were most apparent. Because the show covered the history and the idea of the woman artist, it invited speculation about difference, genius and talent. The exhibition was curated by two women artists, and planned as the debut show of the newly founded Austrian Women Artists' Association. Sculptor Ilse Conrat (1880–1942) became involved when she was appointed an officer of the new union and was coaxed by its president, Baroness Olga Brand-Krieghammer, to co-organise the retrospective.[13] The exhibition, *The Art of the Woman*, covered the history of art from the Renaissance, beginning with Sofonisba Anguissola, to 1910, represented by members' works. Including sculpture, painting and works on paper, the show embraced all genres: nudes, landscapes, still life, portraiture, and history and genre painting. Its thesis was that women had 'kept step' with male artists through the centuries, and that women had no separate aesthetic.[14] From Conrat's point of view, it encompassed the best works available, limited somewhat so that the Secessionists, who hosted the exhibition, would not meddle too much.[15] Conrat and Brand-Krieghammer divided the European countries

between them, Conrat choosing Belgium, England and the Netherlands as her destinations. Her task was to select works of art in public and royal collections, armed with a letter of introduction from the imperial court, and to borrow the works for the exhibition.

Because the show was so large (it filled the entire Secession, with over 300 works), it was widely reviewed, including in Italian and Hungarian publications. Conrat's newsclipping service provided her with 70 reviews, but there were more than that, if one includes the *feuilletons* that used the exhibition as an occasion to comment on the woman question, or to ponder the creative abilities of women. Several critics linked the many portraits by women on display with copying, applying makeup and narcissism, essentially confining women artists to private social roles. 'Mirror, mirror on the wall,' wrote one critic, 'who is the fairest of them all?'[16] He claimed to have witnessed female spectators comparing themselves to the portraits from different centuries on the walls of the Secession, concluding: 'The greatest art work of the fashionable woman is her smile, which she squanders like alms, and is her salon, in which she builds a world which looks at us smilingly, as if she were only appearance and merry deception.'[17] He and other critics compared the act of painting to putting on face powder with brushes. The focus on makeup as a surface painting activity (comparing the artist's activity with her face to her work on a portrait), connected women to the low side of modernity – the opposite of truth and seeing through, for which artists like Kokoschka were admired.

The essayist even claimed that the exhibition represented the social self of woman: her happy side was in the front rooms, represented by the large portraits in fancy dress, while her worried dark side remained hidden, in the upstairs gallery (this is where the works on paper with Käthe Kollwitz's suffering mothers were). Such ideas were viewed by intellectuals as exercises in narcissism or jokes, not to be taken as seriously as those of art historians who wrote about the exhibition. Nonetheless, two affiliates of the Vienna school of art history wrote that the exhibition proved that women were not 'original' creators. Josef Strzygowski wrote an essay with echoes of Weininger: the argument of the show, he said, is that women can take over the role of creative originators:

Luckily, nature takes its own course and does not follow directions. Nature has shown that art is a thing of men; the title of the show, 'the art of the woman,' will be mistaken by no-one to mean that from now on art should be given over to women.[18]

Conrat's sister Erica Tietze-Conrat, the first woman Ph.D. in art history (seen in Kokoschka's double portrait; 55, p. 168), wrote a more reasoned, albeit prejudiced, essay for a scholarly journal. She argued that the exhibition proved only the quality of suggestibility which allowed women to become artists, and it was therefore no surprise that over the centuries women artists had often come from artists' families.[19]

The contradictory nature of Vienna's modernism can be seen by comparing the prejudiced reviews to the spectacular scope of the show. There would not be such a large and comprehensive exhibition of historical women artists again until 1976, when the travelling exhibition *Women Artists 1550–1950* made its rounds in the USA.[20] By then, the 1910 exhibition had been completely forgotten by art historians, and the historical women artists once discussed in Vienna's newspapers had been excluded from art-historical surveys. While Klimt and the Secessionists were also once connected with popular fashion and modishness by anti-modernist critics, this history was suppressed in favour of a more heroic narrative that focused on their conflicts with society.[21]

TERESA RIES

Although women could not enrol at the Academy of Fine Arts until 1921, there were other paths to an education. Conrat had the support of her parents and travelled to Belgium to study sculpture with Charles van der Stappen while she was still a teenager. And when Teresa Ries emigrated from Russia to Vienna, she convinced one of the Academy's professors, Edmund Hellmer, to take her on as a student. Technically not allowed to attend, she nevertheless had an elite education: Hellmer simply gave her space in his studio. Vienna could be a place of restrictions, or great freedoms, as it clearly was for Ries, who originally came from a wealthy household close to the Tsars, where she was expected to conform, but did not. She explained in her autobiography that her Russian parents had only indulged her wish to study in Vienna on her own after her marriage ended in the loss of a child and divorce while she was still a teenager. She had been ejected from the Academy in St Petersburg for questioning her teacher's authority.

Although she is little known today, Ries was once one of Vienna's most famous artists. Her career spanned a period from when there was only one exhibition house, the Künstlerhaus, to a time of multiplying artist groups and alternative exhibition venues – some of which she helped pioneer. When the Klimt Group seceded from the conservative Künstlerhaus artist association to form the Secession, Ries moved her

FIG. 36
Photograph of Mark Twain sitting for his portrait by Teresa Ries in her studio, 1897. Österreichische Nationalbibliothek, Vienna

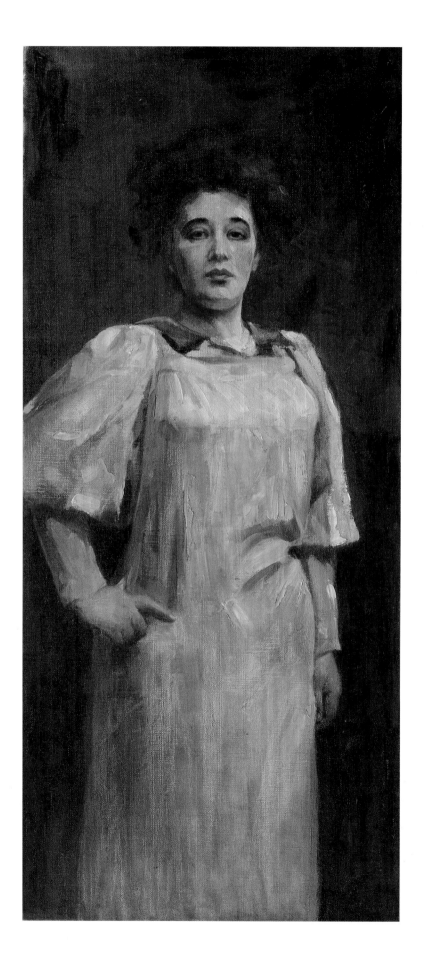

TERESA RIES (1874–1956)
Self Portrait, 1902
Oil on canvas, 157 × 70.5 cm
Wien Museum, Vienna

FIG. 37
Photograph of Ries's studio
reproduced in her autobiography
Die Sprache des Steines, 1928.

loyalty with them. She also became an organiser and founding member of the *8 Women Artists*. This alternative exhibition group showed at the elite modern art dealer's salon owned by Gustav Pisko, beginning in 1901. By simply bypassing conventional artist associations, the *8* ushered in a new tendency in Vienna to exhibit with art dealers (Schiele's *Neukunstgruppe* would follow suit eight years later).[22] The publics the *8 Women Artists* cultivated included powerful and elite members of society. At one opening, prominent socialite and titled princess Pauline Sandor von Metternich served as their tour guide, bringing publicity and patronage to the group.

Ries had the honour of being the only artist selected by the Prince of Liechtenstein to have her own studio and exhibition space at his palace. She received visitors in the five-room atelier, where she negotiated a steady stream of new commissions for portraits and funeral monuments. A photograph of her sculpting a bust of Mark Twain, who was a fan of hers and a resident of Vienna for two years, appeared in the newspapers (fig. 36).[23] She also used the space to show her works in one-person exhibitions on two occasions. Her commanding *Self Portrait* of 1902 (48) can be seen in a photograph of the studio (fig. 37). She wears a simple work smock, and her direct appraising gaze conveys her self-confidence

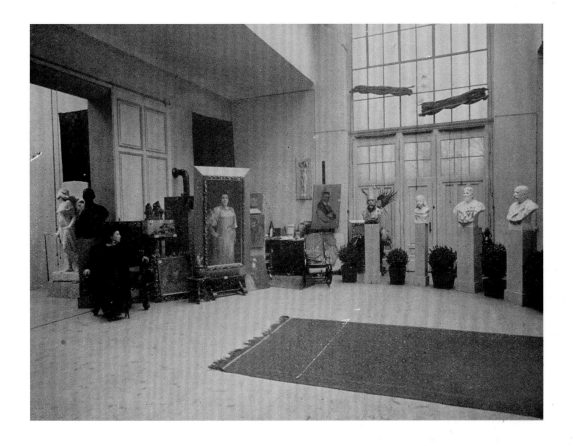

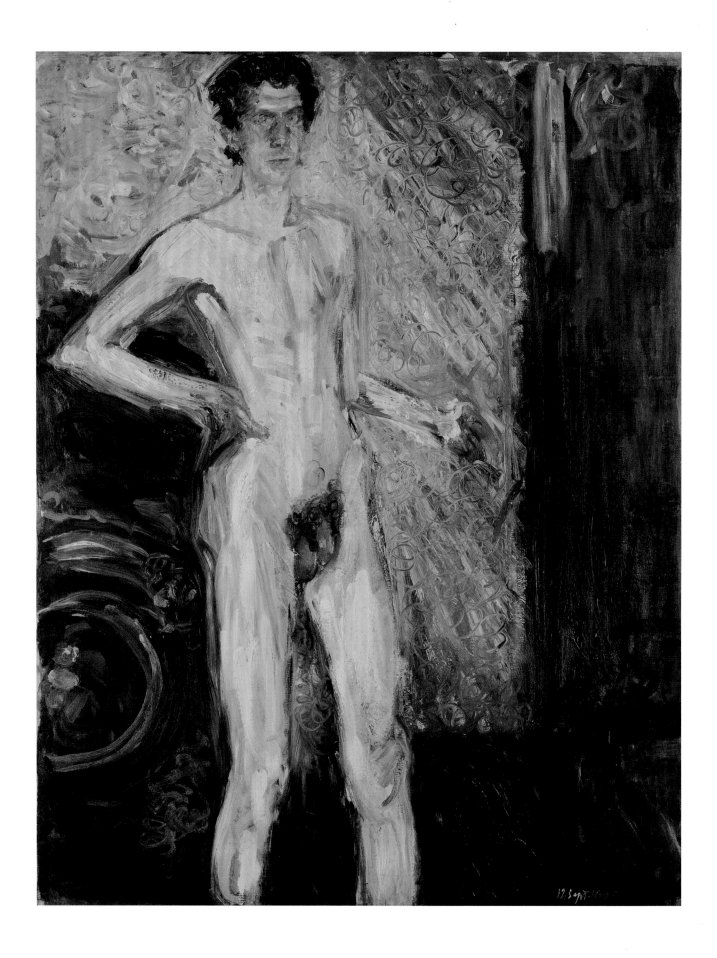

and role as public artist. In scale and stance her composition is similar
to Richard Gerstl's nude self portrait (49); yet it is hard to imagine such
unusually frank self exposure working for Ries in the gender dynamic of
the time, even if it is commonplace for women artists today. In a play by
Roda Roda, whose works were often shown at the Cabaret Fledermaus,
an avant-garde artist's locale/comedy club, she was thinly disguised as
'Frau von Landiesen', a voluptuous woman sculptor who seduced men
by asking them to sit for portraits in her atelier. The description of her
character read: 'A beautiful lady, an elegant lady, somewhat eccentric.
The genius of divorce. One suspects arousing undergarments.'[24] The
play reversed the gender roles of the studio, where the male artist was
imagined to seduce his female models and sitters. With her penetrating
gaze, Ries seems to stride out of the canvas towards the viewer. Her gaze,
in fact, is the point of the painting. There is not a hint of the narcissism
that one reviewer accused women artists of possessing in a 1910 review
of *The Art of the Woman*. In her autobiography, as in her portrait, Ries
focused on the creative process of the mind rather than the labour of
the chisel. Her ideas arrived quickly, sometimes fully formed. In the
self portrait, she creates the illusion of a spontaneously painted likeness;
it is as if the artist is about to speak, or is moving into the spectator's
space. By contrast, Gerstl's self portrait offers a retreat to an inner
psychological world, the self laid bare in a private studio scene. His
expressive vertical brushstrokes and frenetic wet-on-wet squiggles
on the studio walls behind him are analogies for the artist's personal
vision. Ries focuses on her inner life differently, using the genre of the
self portrait to convey her persona as public artist, as if encountering
a patron or an art public.

ELENA LUKSCH-MAKOWSKY

Perhaps the most experimental of the three women artists under
consideration, Elena Luksch-Makowsky, a Russian by birth and a
Viennese by marriage, first showed her work at the Vienna Secession
in 1901. Portraiture became her focus because she wanted to create what
she called an 'epic' art. She did not paint portraits as commissions or
as tokens of friendship, but rather as character studies or symbolist
meditations. Luksch-Makowsky was well received by the Klimt Group
and often featured in the installations of the Secession's early years. Her
love of narrative, which the group shared, and her impeccable education
were two reasons for this. She was admitted to the Academy of Fine Arts
in her native St Petersburg when she was still a teenager living at home.

She won a stipend to study in Munich, landing in Vienna after marrying a fellow student, sculptor Richard Luksch, who joined the Secession.

Before moving to Vienna she began to experiment with nearly life-size character studies – including a man holding a cat, with the gruesome title of *The Cat Eater*, and an equally large dwarf, whose height was indicated by the position of a door handle in the canvas (both were recently acquired by the Belvedere, Vienna). A work from this series was first shown in Vienna, in a room with Klimt's ceiling painting *Medicine*. Koloman Moser designed a life-size row of portraits enclosing the figures in a curved frame (fig. 38). The effect was to surround the spectator with their gazes, and to create a total work of art out of the unrelated portraits. Luksch-Makowsky's offering was a sinister-looking woman in a cape (visible in the installation photograph at the far left). One critic thought she was hiding a vial of poison behind her cape and admired her vengeful state and diabolical eyes. Another marvelled that the group was incredibly varied, while appearing at first glance to have been connected through its format and arrangement.[25] Indeed, Luksch-Makowsky's dark character study was the opposite of Klimt's commissioned portrait of a placid Serena Lederer in white, seen in the centre of the group.

In 1901 Luksch-Makowsky experimented with a unique self portrait in late-stage pregnancy, not nude as Paula Modersohn-Becker represented

FIG. 38
Installation by Koloman Moser of Room 3 of the 10th exhibition of the Vienna Secession, 1901, reproduced in *Ver Sacrum* Vol. 4 (1901).

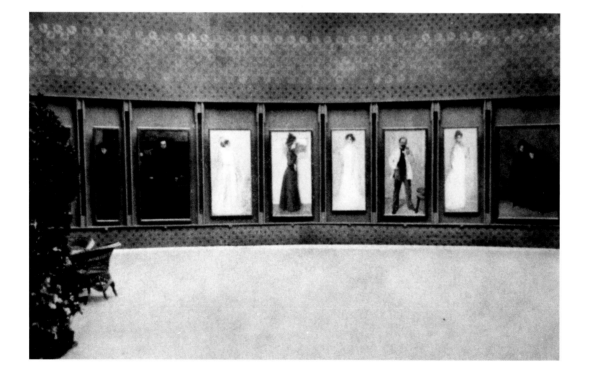

50
ELENA LUKSCH-MAKOWSKY
(1878–1967)
Self Portrait with her Son Peter, 1901
Oil on canvas, 94.5 × 52 cm
Belvedere, Vienna

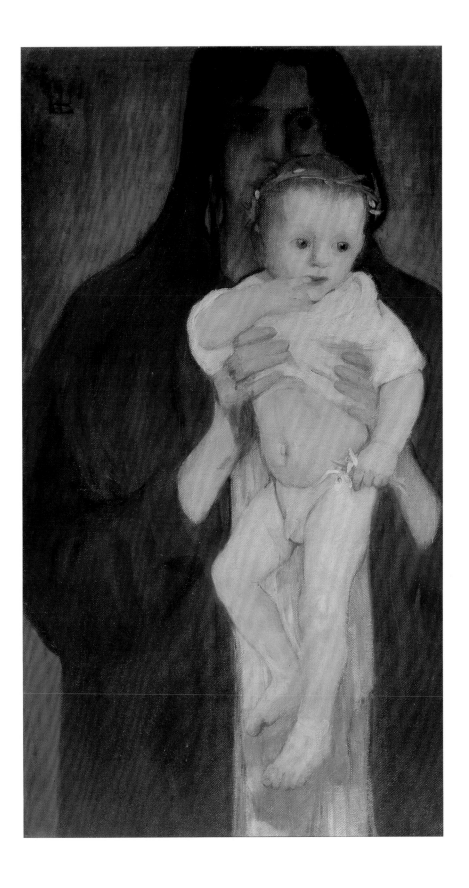

herself in 1906, but wearing the heavy drapery of maternity clothing.[26] After giving birth, she created a self portrait that was part Byzantine icon, part commentary on motherhood, and, in the context where it was shown, the idea of sacred renewal. She holds the baby as if presenting him; his pale skin, white loincloth, and crown of green laurel sprigs contrast with her shadowy cinnabar red robe. Now titled *Self Portrait with her Son Peter* (1901, 50), it was shown at the Secession in 1902. The original title, *Ver Sacrum,* referred to the Secession's journal of the same name. Using hybrid sources the artist comments on the Secession's goals and aesthetics regarding the sacred spring and creativity, suggesting that childbirth is the ultimate creative act.

Koller and Luksch-Makowsky were affiliated with the Klimt Group at different times; neither exhibited with women artists' groups, purely for aesthetic reasons. As a result, neither artist was subjected to the gendered commentaries that separate, women-only exhibitions attracted. The misogynist criticism, in turn, should be viewed in the context of the history of art exhibitions more generally, and against the examples of Koller and Luksch-Makowsky. From this vantage point, the 70 reviews of the 1910 exhibition *The Art of the Woman* do not provide a clear window into the culture of Vienna 1900 on their own, but are rather more like a peephole into its misogynist heart. A more panoramic view of the culture shows that women were admired for their aesthetic innovations by other artists and accepted into the elite venues of Vienna.

The stories of these women artists show that fin-de-siècle Vienna was much more than the birthplace of modernism in many fields: it was a site of 'ambivalent modernism', a phrase that reflects both its positive and negative aspects.[27] The imperial metropolis became an early staging ground for a combination of populist politics and racism, serving as an incubator for modernism's negative potential: misogyny and anti-Semitism. Koller was erased from histories of the period, not because her work lacked quality, but first because she was Jewish, and then because she was a woman. While she experienced the positive aspects of Viennese modernism during the last years of the empire, after 1918 anti-Semitism increasingly became an issue. After 1938, Austria was annexed to Nazi Germany, and adopted a policy of systematically erasing all traces of Jewish contribution to civilisation. Koller died in 1934, but her children watched, frightened, as Hitler marched into Vienna in 1938. Silvia, once a curious child in a red dress, who had studied to become a painter, lived through the war as a half Jew with her father and brother in their small hometown of Oberwaltersdorf.

Many other women artists were murdered in concentration camps; their stories are more difficult to recover. Traditional painter Malva Schalek (1882–1944), who had a portrait studio above the Theater an der Wien, was murdered at Birkenau. She had spent the two previous years interned at Terezin, where she drew portraits of internees. The history of her portrait studio in Vienna remains unwritten and very few of her paintings have been recovered. The women artists who were able to emigrate typically had to leave behind their life's work, which was then dispersed or destroyed. Ries, suddenly appearing in documents as Teresa 'Sara' Ries (the middle name was given to all Jewish women), escaped to Lugano, Italy, in 1942. She left her works behind in the studio at the Liechtenstein palace, which had been taken over by the air-raid police. Several sculptures were destroyed. Ilse Conrat committed suicide in Munich when she received deportation papers in 1942. She had already destroyed most of her works when she moved to a smaller studio in the suburbs. Luksch-Makowsky, who was not Jewish, lived out the war in Hamburg, unable to return to her native Russia. Her husband had divorced her and she could barely make ends meet as she cared for her two sons.

This period of erasure, murder and emigration has obscured our view into the world of Vienna 1900, making it difficult to see the more panoramic tableau of its cosmopolitan creativity. Vienna's women artists, many of whom were Jewish, have been the last to be rediscovered. Vienna's ambivalent modernism, it turns out, was richer than previously thought in its once positive potential for women artists. Fin-de-siècle Vienna was a city of misogyny and restrictions, but also one where women had careers as public artists, sustained their own studios for receiving commissions, and showed their works in spectacular exhibitions.

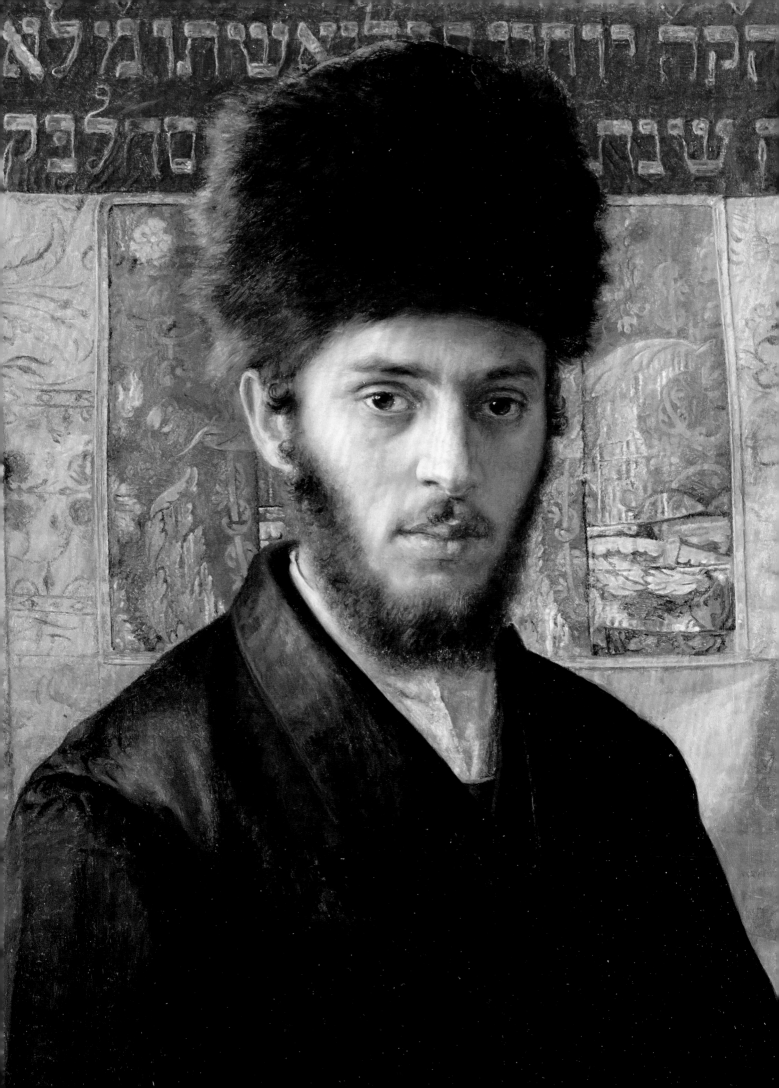

IMAGING THE JEW
A CLASH OF CIVILISATIONS

Elana Shapira

51
FRIEDRICH VON AMERLING
(1803–1887)
Portrait of Cäcilie Freiin von Eskeles,
1832
Oil on canvas, 151.1 × 102 cm
Germanisches Nationalmuseum,
Nuremberg

The process of Jewish cultural integration into Viennese society began before and continued after the 1867 *Ausgleich*, which granted equal rights to all citizens of the Austro-Hungarian Empire. As part of this acculturation, Jews increasingly adopted the basic markers of the larger society, such as language and dress, and creative attempts were made to secure shared cultural platforms for Jews and Christians in the city's museums, concert halls, theatres and philanthropic organisations.

Yet from the beginning of the nineteenth century, Jewish patrons intended not to imitate but to establish new models of representation. Friedrich von Amerling's portrait of the salon lady Cäcilie Freiin von Eskeles (1832, 51) shows her as an authority on German culture. The letter on the desk may refer to her correspondence with Goethe, the most celebrated German writer of the day.[1] There are four books on the divan next to her, and she holds a miniature portrait, possibly showing her children Denis and Marianne, which refers to her pride in motherhood. But she challenges the ideal of the obedient asexual Austrian woman through her fashionable dress and self-assured posture.

German nationalism was on the rise in Vienna, and in 1897 the anti-Semitic Karl Lueger was inaugurated as Mayor of Vienna.[2] A month before Lueger was inaugurated the Jewish genre painter Isidor Kaufmann received a prestigious prize for his painting *Sabbath*, depicting a Shabbat service at a synagogue, which was exhibited in the annual exhibition at the Wiener Künstlerhaus.[3] The conservative Viennese art scene appreciated Kaufmann's subtle yet captivating handling of Jewish cultural difference despite the rise of anti-Semitism.[4] More than a decade later, Kaufmann painted his *Young Rabbi From N.* (about 1910, 52). Representing a self-assured Jew with a trimmed beard and a direct unwavering gaze, Kaufmann's rabbi championed a proud reclamation of Jewish culture. The beautiful and exotic-looking sitter conforms to the stereotype of the Jew as a 'foreigner'. He wears a traditional black silk caftan and a fur hat and sits in the studio in front of a fancy Torah curtain covering the *Aron*

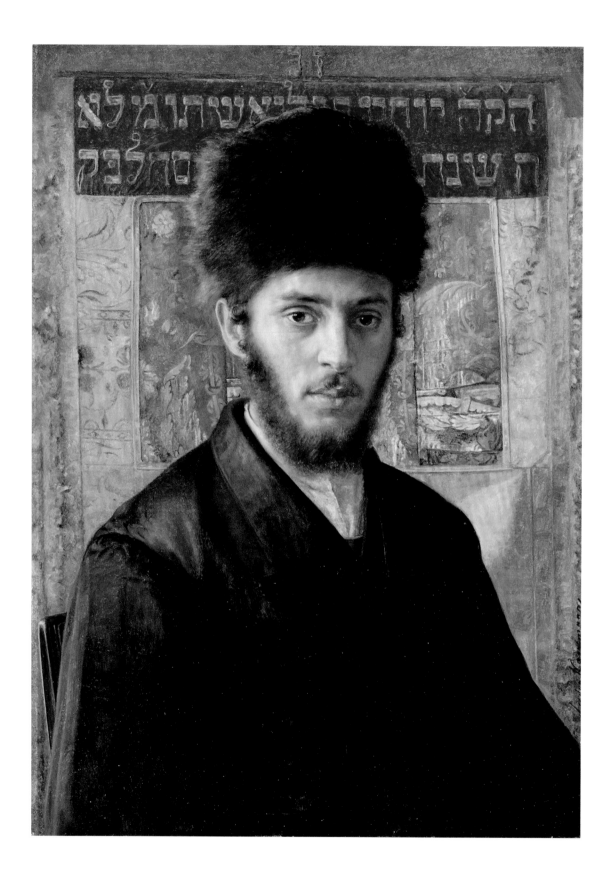

52

ISIDOR KAUFMANN (1854–1921)
Young Rabbi from N., about 1910
Oil on wood, 38.1 × 27.6 cm
Tate, London

ha-Kodesch (the closet of the Torah scrolls in the synagogue). His austere appearance contrasts with the striking green, dark red, gold and light blue of the curtain, which provides evidence of the richness of Jewish tradition. The Hebrew letters (possibly a dedication) confirm his authority. Kaufmann's rabbi stands as a witness against anti-Semitic accusations that Jews were 'ugly' and 'disrespectful', but also against the trend towards assimilation. Yet the dark, fine dress and luxurious setting, which add to the rabbi's appeal, are at odds with the reality of the poverty experienced by Kaufmann's Jewish sitters.[5]

In contrast to Kaufmann's rabbi, those who sat for portraits by Gustav Klimt and Oskar Kokoschka were wealthy, middle class, and identified with Western European culture. Like Kaufmann, these artists chose the dress and setting for their portraits carefully, in order to convey their Jewish sitters' special positions as 'outsiders' in Viennese society. Klimt's sitters are striking, their dark hair and eyes standing out against their white clothes and pale backgrounds or their decorative golden dresses and shimmering settings. Kokoschka's sitters are discomforting in their scruffy clothes and dirty surroundings. In contrast to Kaufmann, Klimt and Kokoschka used their portraits to address the cultural difference of Jews, actively engaging in public debate about their position in society in order to find authentic shared platforms for culture. The Jewish Expressionists Richard Gerstl and Arnold Schönberg also engaged in the debate about cultural difference. But unlike Klimt and Kokoschka, they challenged the recognised aims of Jewish acculturation by depicting their Jewish sitters as 'strangers among us' who threatened the fragile relationship between the two cultures.

Rudolf Lothar, the Jewish journalist and editor of the journal *Die Wage,* praised the new Secession building as a stage for inspiring a new *Streitkultur* or 'culture of debate'.[6] The debate about fashioning Viennese modernism largely centred upon Jewish acculturation and cultural difference.[7] This was at the heart of a dispute between two prominent Jewish journalists, Karl Kraus, the cultural critic and publisher of the journal *Die Fackel* (The Torch), and Berta Zuckerkandl, an art critic who wrote for the *Wiener Allgemeine Zeitung* and other liberal and art journals. Kraus considered Klimt's paintings and the modern Secessionist style to represent 'Jewish taste'.[8] Zuckerkandl, on the other hand, perceived Klimt's Secessionist art as a platform for rapprochement between Jews and Christians in the city.[9]

Jewish patrons commissioned prominent artists to paint their portraits to demonstrate their respectable social position. They did not want to be represented in the same manner as Gentile patrons, but

wished to engage in a culture of debate in order to promote a new critical consciousness in Viennese society. Jewish personalities, motivated by an urgent need for public discussion about their dependency on and their daily confrontation with Christian society and its irrational, anti-Semitic attitudes, used their portraits to challenge prejudice and to promote their authority as producers of Austrian culture. 'Imaging the Jew' became an essential part of the creation of Viennese modernism.

FASHIONING JEWISH CELEBRITIES

The dark appearance of Kaufmann's rabbi and the colourful curtain fitted a romantic preconception of Jews as 'foreigners' and 'Orientals'. Yet this prejudice also appeared in anti-Semitic caricatures in popular humorous journals, art journals and conservative papers (fig. 39). The desire to dispute this stereotype led some Viennese Jewish patrons to become supporters of a radical aesthetic agenda that encouraged debate about the prejudice against Jews as 'ugly', 'foreigners', 'wealthy' and 'anxious'. Their openness to understanding modern man and woman also led them to question middle-class codes of respectability, and eventually to position themselves as modern 'Others'.

At first sight, it looks as though Gustav Klimt has overpowered Adele Bloch-Bauer with oriental symbols in her portrait, endowing her with an artificial theatrical aura,[10] and thus undermining her identification with Western spiritual and cultural values (fig. 40). In his portraits Klimt revived the romantic and exotic physiognomic depiction of the Jewess, emphasising black wavy hair and large, deeply shadowed eyes, and at

FIG. 39
'Bei Fregoli', caricature in
Der Floh, 1 January 1899, p. 4
The cartoon's dialogue
translates as:
'Are you the famous master
of metamorphosis?'
'Si Signor, how can I help?'
'Can you do me a favour
and transform my wife?
How much will it cost?'

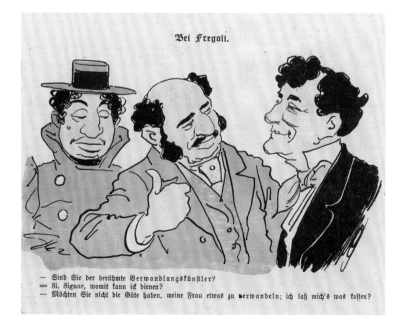

Bei Fregoli.

— Sind Sie der berühmte Verwandlungskünstler?
— Si, Signor, womit kann ich dienen?
— Möchten Sie nicht die Güte haben, meine Frau etwas zu verwandeln; ich laß mich's was kosten?

IMAGING THE JEW

FIG. 40
GUSTAV KLIMT (1862–1918)
Adele Bloch-Bauer I, 1907
Oil and gold leaf on canvas
Neue Galerie New York

times including a trace of a Semitic nose.[11] Yet he used Semitic looks to challenge the 'Oriental' stereotype. He had depicted the Jewess as a shy angel in a flowing white new-imperial style dress with no jewellery in his 1899 portrait of Serena Lederer (Metropolitan Museum of Art, New York), but the 1907 Bloch-Bauer portrait is more dramatic, with its daring tight golden dress, golden robe, shining necklace and armbands. Bloch-Bauer is seated majestically on a luxurious golden armchair, against an opulent golden background. Klimt crowned her as a new Jewish queen, transferring the prejudice identifying Jews with the power of wealth into a timeless mythological sphere. Yet she also represents a new type of modern woman. Her entrapment by convention is represented through the disappearance of her body behind the overwhelming ornamental fabric associated with Wiener Werkstätte decorative patterns, yet Klimt acknowledges her spiritual independence by encircling her head and focusing on her facial expression. At the centre of the composition her naked hands clasp each other in a romantic gesture.[12]

In a similar fashion, in an earlier Klimt portrait of 1904, Hermine Gallia (1; see p. 22) appears calm and collected, her joined hands contrasting with the folds of her sensual white reform dress and the

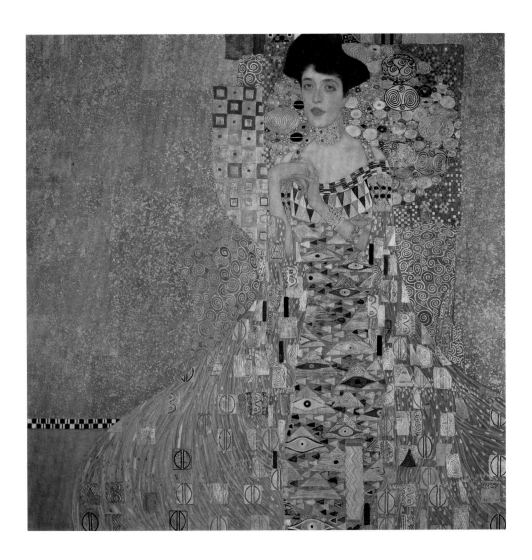

white shawl covering her shoulders. The dress, which was possibly designed by Klimt's lover, fashion designer Emilie Flöge, flows like a stream of water along the contours of her body. Klimt's innovative portrayal of Jewish women related their 'Jewish looks' to prejudices associating Jews with wealth, their taste for fashion trends, and wild sensuality. He used their sensual dresses and dark appearance to expose stereotypes about their 'Otherness' as Oriental and exotic, and in doing so transformed them into modern celebrities.

THE JEWISH SUBJECT AND THE CLASH OF CIVILISATIONS

Oskar Kokoschka rejected Klimt's depiction of Jewish sitters as celebrities and champions of a luxurious lifestyle because of his empathy with them. He consciously used his Jewish subjects in order to offer a more critical contribution to the Viennese culture of debate, as he witnessed it in Kraus's *Die Fackel*. His sitters accepted his creative claim because – as he noted – their special historical experience had taught them to be discerning in their judgement:

> Most of my sitters were Jews. They felt less secure than the rest of the Viennese Establishment and were consequently more open to the new and more sensitive to the tensions and pressures that accompanied the decay of the old order in Austria. Their own historical experience had taught them to be more perceptive in their political and artistic judgments.[13]

Kokoschka's modernism was supported by the architect Adolf Loos and Karl Kraus, and it has been argued that this was because it was seen as a political weapon against 'Jewishness', in the light of Kraus's critique of the superficiality of Klimt's art as expressing 'Jewish taste'.[14] Yet this raises the question of whether Kokoschka's modernism actually claimed to represent the contribution of authentic and modern Jewish culture, conveying the conflicts and the 'false promises' of Jewish assimilation, as well as his sitters' openness to recent developments in psychology.

A comparison between Kaufmann's dignified young rabbi, with his penetrating gaze, and Kokoschka's portrait of Peter Altenberg (1909, 54) with his shapeless dress, dirty hands, and helpless look, seems to support the prejudice against the tortured assimilated Jew expressed by cultural critic Hermann Bahr in his review of Theodor Herzl's play *The New Ghetto* (1898).[15] Altenberg was the most celebrated poet of the Viennese avant-garde, known for his short Impressionistic verses. He appears surprised and emotionally shaken.[16] Contemporaries identified an 'Outsider'

element in his portrait, describing it as 'Half coffeehouse Jesus, half cab driver of eternity' and 'a study of expression of the *Ahasver* [the Wandering Jew] of modern-poetry of the soul'.[17] Kokoschka's portraits did not describe a middle-class environment but stressed their sitters' psychology. Altenberg was an ideal subject since he rejected the *bürgerlich* lifestyle and offered the exotic appeal of a 'homeless' poet.[18] Kokoschka used an Expressionistic presentation to explore the relationship between the poet's artistic persona and his psychology. The question is, why should this have made Altenberg look ugly? His eyes protrude, his moustache hangs down sadly, and his neck appears creased and wrinkled. The murky background further reflects the poet's inner turbulence. In September 1909, just before Kokoschka portrayed him, Altenberg had used the prejudice against Jews as hysterics in order to describe his creative licence as 'hysterical impressionability'.[19] He created a provocative artistic persona that played on the perception of Jews as hysterics who had given up their claim to a respectable position in society, who lacked respect for earlier European traditions and escaped into art.[20] Kokoschka depicted the relationship between Altenberg's artistic persona and his psychology as a struggle with an unseen partner. The shadow – an unformed black halo behind Altenberg's head – reveals his inner conflict. His bloody hands and red neck further suggest that the struggle is strenuous and violent, and possibly responsible for transforming him into an ugly man.

Another radical exposure of an existential drama is found in Kokoschka's portrait of the tubercular Count Verona (53) painted in a Swiss sanatorium. Kokoschka depicts a fragile Italian, who appears to be overpowered by sickness.[21] The bloody hand print behind his right shoulder refers to the fact that he coughed up blood; the black spot on his left shoulder spreading along his arm hints that death is about to take

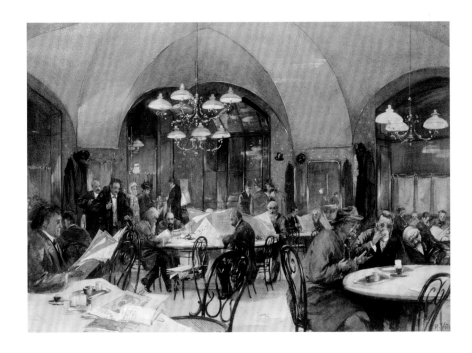

53
OSKAR KOKOSCHKA (1886–1980)
Count Verona, 1910
Oil on canvas, 70.6 × 58.7 cm
Private collection, Hong Kong

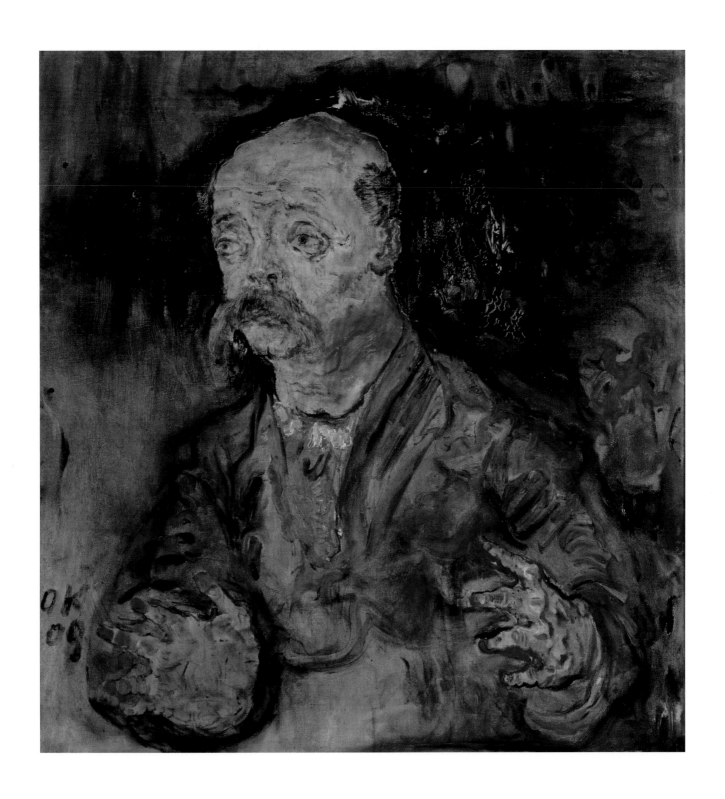

54
OSKAR KOKOSCHKA (1886–1980)
Portrait of Peter Altenberg, 1909
Oil on canvas, 76.2 × 71.1 cm
Private collection,
Courtesy Neue Galerie New York

possession of him. Yet in his portraits of well-known Jewish personalities Kokoschka consciously took up the challenge of making a shared and critical contribution to an urgent Viennese debate concerning cultural difference and the clash between Jewish and Christian cultures.

Unlike Altenberg, Lotte Franzos – society woman, member of the coffee house circle of Kraus and Altenberg, and art patron – appears initially noble and distant in Kokoschka's 1909 portrait of her (fig. 42).[22] Lotte's choice of 'Otherness' is demonstrated by her short hair and artistic tie, which allowed friends to associate her with the French author George Sand.[23] Kokoschka used her modern appearance to expose inner conflict in a different way than in his portrait of Altenberg. Edith Hoffmann described Kokoschka's sensitive portrayal of Lotte wearing a close-fitting knitted white dress as 'youthful coyness, the reserve of middle-class woman who neither could nor would let herself go, and perhaps the pensiveness of one who has unexpectedly discovered that respectability is not everything'.[24] Lotte did not like her portrait, yet she continued to support Kokoschka even after it provoked a furious debate about the ethics of propriety during its display in the Hagenbund exhibition in Vienna in 1911. In the *Deutsches Volksblatt* there was a warning to visitors against images of sickness and decay threatening to corrupt pregnant women and children.[25] The display of her portrait forced Lotte to 'let go' – to give up her 'respectability'.

Kokoschka used fashionable theosophical ideas, which aimed to prove through mysterious visual manifestations that man has a soul, to give Lotte a 'modern aura' that in fact exposed the complexity of her sexuality.[26] His choice to encircle her in blue and yellow transformed her into a new 'religious' revelation. He described his vision of her as a 'flame of a candle – yellow and clear, light blue on the inside, an aura of intense, dark blue on the outside.'[27] Yet this modern Jewish saint communicates ambiguous feelings: the blue outline around her body seems to express frigidity, while a purplish brown aura around her head expresses her sensual thoughts. Did Kokoschka use his Jewish sitters to promote a new modernist consciousness, did he encourage their assimilation through portraying them as modern icons,[28] or did he 'allow' his secular Jewish sitters to criticise German conservative ideals by using Christian iconography provocatively to demonstrate new psychological insights?

Kokoschka's double portrait of the art historians Hans Tietze and Erica Tietze-Conrat (1909, 55) raises the question of how the representation of a fully assimilated subject could signal Jewish identity.[29] It has been argued that the interpretation of Jewish identity in the portrait resides as much

with the viewer's subjectivity as it does with the subjects portrayed.[30] Kokoschka shows his empathy with his Jewish sitters – how their lack of security made them 'more open to the new and more sensitive to the tensions and pressures that accompanied the decay . . .'[31] Integral to the contribution of Jews to the Viennese culture of debate discussed in Kraus's *Die Fackel* was the redefinition of gender roles and relations between the sexes.[32] Kokoschka used the double portrait, which was commissioned as a symbol of the couple's married life,[33] to show that existential insecurity is integral to modern relationships. He painted the pair with separate poses and gazes, first Hans in profile facing Erica and then Erica facing their viewer, identifying him as 'the lion' and her as 'the owl'.[34] Expressive hand gestures expose the complex physical and psychological dynamics between the couple. Hans Tiezte connected the robust hands with delicate fingers with his Jewish family, particularly the physical strength of his grandfather, associating him with the strength of a lion.[35] Erica's thick glasses may have led to her association with an owl.[36] The scratched imagery in the background includes a sun, whose rays appear behind Hans's back, while the moon is placed behind Erica's head. The animal and cosmic imagery shows their different characters.

One writer has explained Tietze's frozen hand gestures in terms of Kokoschka's drama *Murderer, Hope of Women*.[37] In the play, 'Woman' meets a tragic fate when she is killed by the mere touch of 'Man's' finger, so Tietze's pose may be protective. The double portrait has also been compared by Jaroslaw Leshko with Rembrandt's *The Jewish Bride* (about 1665, fig. 43).[38] In both portraits, the hand gestures establish the relationship between the pair. In the Rembrandt this is achieved by the gentle touch of the man's right hand on the woman's breast and her implicit consent. In the Kokoschka, this comes about through the tense near-touch of the man and woman's hands, which are reminiscent of Michelangelo's Creation scene on the Sistine ceiling.[39] Kokoschka's work emphasises the outline of the two figures, and the man's only point of contact with the woman is his energised left hand, which penetrates her silhouette.[40] While the couple in Rembrandt's painting are intimate and the gestures of closeness are harmonious, the Tietze couple appear to be trying to overcome a sense of alienation. The energetic scratches in the background highlight the figures and their gestures evoke sexual tension between two strong characters, opposed to each other like day (sun) and night (moon).[41] Hans is trying to approach Erica, and she protects her chest with her right hand, yet reaches out with her left. The thin layers of paint creating a hazy atmosphere, and the lively and dynamic scratches of the paint, expose the intensity of longing and the fear of

55
OSKAR KOKOSCHKA (1886–1980)
*Portrait of Hans Tietze and
Erica Tietze-Conrat*, 1909
Oil on canvas, 76.5 × 136.2 cm
The Museum of Modern Art,
New York
Abby Aldrich Rockefeller Fund

FIG. 43
REMBRANDT (1606–1669)
The Jewish Bride, about 1665
Oil on canvas
Rijksmuseum, Amsterdam

physical intimacy between the two, underscoring the portrait's deep psychological drama. The couple supported Kokoschka yet refused to lend their portrait for an exhibition in Europe. After their forced emigration to the USA in 1939, they sold it to the Museum of Modern Art in New York.[42] In the context of the persecution of Jews and their exclusion from Austrian culture, they used the public exhibition of their portrait as witness to their identification with modern Austrian art.

THE STRANGER AMONG US

Kokoschka's sitters' presumed acceptance of their 'ugliness' transformed the taboo subject of the 'ugly Jew' into a symbol of cultural prestige, representing their self-conscious and progressive artistic judgement. The support of Kokoschka's Jewish sitters did not represent their acceptance of 'the judgemental canons and the aesthetic criteria of others';[43] rather, it demonstrated how integral their 'Otherness' was to Viennese modernism. In a more deliberate manner the Jewish Expressionists Richard Gerstl and Arnold Schönberg used their portraits as violent attacks against the ethos of the middle classes by making the sitters appear *Unheimlich*.

Sigmund Freud analysed the phenomenon of *Das Unheimliche* (the uncanny) as a repression of the *Heimlich* (at home/secure/trusted).[44] According to Freud, the experience of the *Unheimlich* is a reversal of the wish to return to the secure image of home. Jews were represented in anti-Semitic paintings and caricatures as *Unheimlich*, negating the German Christian *Heimlich* (familiar) canon. Yet when they rejected their Jewish identity, assimilated Jews were haunted by their repressed heritage.[45] Gerstl and Schönberg represented 'the uncanny' in their portraits in order to disclose fears accompanying the repression of Jewish identity and to confront viewers' prejudices against Jews as 'strangers'.

In 1906, the young artist Gerstl met the composer Schönberg, whose music he admired (fig. 44), and asked for permission to paint his portrait.[46] A friendship developed between them, and Schönberg suggested that it was his own amateur attempts to paint and their discussions that led to Gerstl's abrupt change in style from Impressionism to Expressionism. Yet it was Gerstl who first dared to question the 'sacredness' of the familiar-looking portrait. In Gerstl's 1907 portraits of the Jewish composer Alexander Zemlinsky (1908; 56) and of Zemlinsky's sister and Schönberg's wife, Mathilde (after February 1908; 57), the artist used a free adaptation of Impressionist and pointillist techniques in order to dissolve the familiar image of the subject. Gerstl transformed his Jewish sitters into a painterly construct of brushstrokes, converting

FIG. 44

ARNOLD SCHÖNBERG

(1874–1951)

Manuscript of *Pelleas and Melisande*
1903, inscribed 'Pelleas und
Melisande Symphonische Dichtung
(nach Maeterlinck) für großes
Orchester op. 5', detail.
Ink on lined paper
Arnold Schönberg Center, Vienna

the familiar (*Heimlich*) into the strange (*Unheimlich*). A possible
explanation for this is related to their common experience of crossing
frontiers from Judaism and Christianity.[47]

The term 'iconoclasm' refers not only to the rejection of any visual
representation of God as prescribed in the Second Commandment, but
also to the act of smashing 'cultural idols'.[48] Gerstl's sense of suspension
between two different cultures, Jewish and Christian, may have inspired
him to exalt and then to disfigure the faces in his later portraits. His
radical creative process is documented in his *Nude Self Portrait with
Palette* (1908, 49; see p. 148), in which it appears as if his naked body
has left its surroundings and his *Unheimlich* body is now coming to
life, threatening to cross the frontier and get closer to his viewer. The
promise to keep a safe distance between viewer and sitter, Christian
and Jew, is being challenged.

Schönberg's portraits are also iconoclastic in the *Unheimlich* strange
look of their sitters, such as the music critic Hugo Botstiber (1910, 18;
see p. 61). In his own *Blue Self Portrait* (1910, 39; see p. 122) the blue face
suggests that he is the 'living dead', and the melancholic gaze of his
son Georg Schönberg (1910, 44; see p. 131) gives the viewer a sense of
discomfort by questioning his illusion of happy children.[49] By projecting
the image of 'the uncanny', both artists expressed the fears prevalent in
Viennese society of the Jew as a stranger who negated their German/
Christian self-image.

Klimt, Kokoschka, Gerstl and Schönberg all represented their Jewish
sitters as 'Others' in Viennese society. They provoked by revealing
their subjects' Jewish identity in order to challenge given styles and
to establish leading positions in the battle over modern art. The four
reworked anti-Semitic rhetoric and tried to come to terms with Jewish
culture: Klimt and Kokoschka in order to create a shared cultural
platform between Jews and Christians, and Gerstl and Schönberg
in order to expose the problems behind this artistic aim.

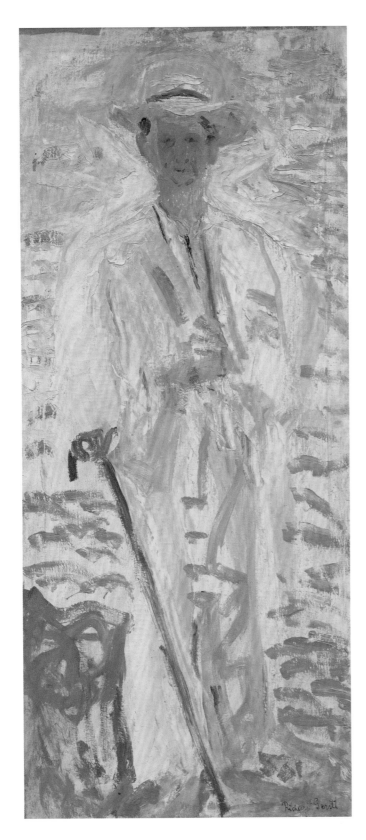

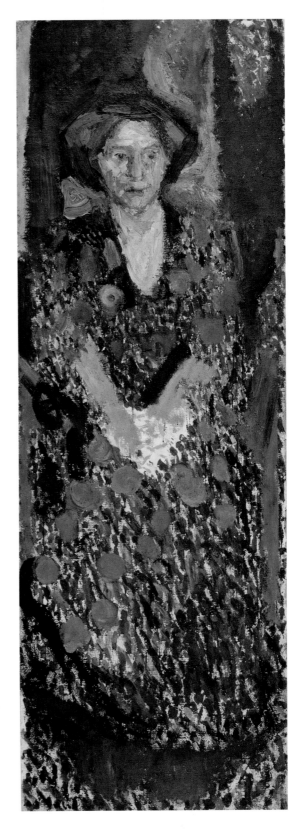

56
RICHARD GERSTL (1883–1908)
Portrait of Alexander Zemlinsky, 1908
Oil on canvas, 170.5 × 74.3 cm
Kunsthaus Zug, Stiftung Sammlung
Kamm

57
RICHARD GERSTL (1883–1908)
*Portrait of Mathilde Schönberg in
the Studio*, after February 1908
Oil on canvas, 171 × 60 cm
Kunsthaus Zug, Stiftung Sammlung
Kamm

A BEAUTIFUL CORPSE

VIENNA'S FASCINATION WITH DEATH

Sabine Wieber

58
FRANZ VON MATSCH (1861–1942)
*Emperor Franz Joseph on
his Deathbed*, 1916
Oil on card, 51.5 × 69.5 cm
Belvedere, Vienna

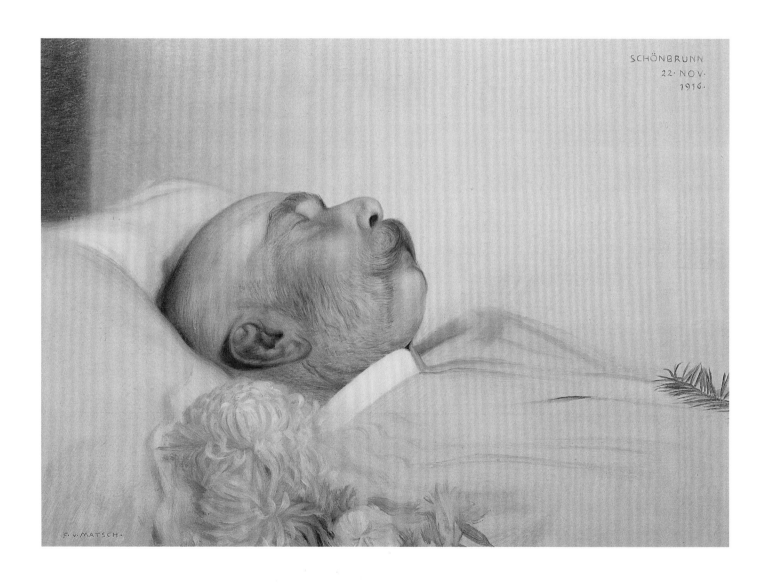

Austria-Hungary's beloved 86-year-old Emperor Franz Joseph died in his sleep on 21 November 1916 while the multi-ethnic Empire he had ruled for almost seven decades was on the brink of collapse. Once the royal physician had officially confirmed Franz Joseph's death, the renowned Viennese painter Franz von Matsch (1861–1942) was dispatched to Schönbrunn to execute a posthumous portrait of the ruler. Time was of the essence, as the ravages of death would soon distort Franz Joseph's face (58). Matsch set to work with a soft palette of oil paints, using mainly oranges, pinks and whites, which he applied very thinly to the paper. This allowed him to capture the Emperor as a frail mortal at peace with himself and the world rather than as a stern regent at war with his neighbouring nations.[1] Franz Joseph's profile is bathed in ethereal light and lacks any signs of suffering, implying that he has at last found eternal peace. Matsch knew Franz Joseph quite well as he had painted several portraits of him during the Emperor's lifetime, and the two men enjoyed a congenial relationship.[2] The delicate oil sketch is thus marked by a gentle intimacy and tenderness that cannot be found in more conventional 'life' representations of Franz Joseph – even when they show the Emperor at leisure. Franz Joseph almost looks as though he is asleep, but Matsch shows this is a deathbed portrait by including the top of a fir branch traditionally placed in a corpse's folded hands alongside a rosary, as well as two pale-pink and yellow dahlias. The date of the picture (22 November 1916) and the place (Schönbrunn) of Franz Joseph's death are also recorded in the upper right-hand corner of the work.

Matsch took into account visual conventions for commemorative deathbed portraits that can be traced back to the seventeenth century.[3] Throughout the nineteenth century, deathbed portraiture was closely linked to an emerging middle-class culture that became increasingly inward-looking and a concurrent shift in religious practice, which was moving away from preaching eternal damnation after death. Poets and artists idealised death as a moment of transition during which body and

soul were united for one last time, and upper-middle-class interest in posthumous portraits across different media was widespread.⁴ But Matsch's portrait of Franz Joseph on his deathbed also alluded to Biedermeier paintings of dead loved ones, especially children and relatives, conceived as emotionally charged mementoes for those left behind.

Franz Eybl's *The Artist Franz Wipplinger, looking at a Portrait of his Late Sister* is a perfect example (59). It shows the young painter in formal attire, lost in deep thought while looking at a miniature portrait of his beautiful sister who has obviously died before her time. The miniature portrait is turned towards the viewer so we can see what has captured Wipplinger's attention. He has removed one of his white gloves to hold a pair of spectacles, presumably to take a closer look at his sister as though he is not willing to miss a single feature of her face. Nothing detracts from this touchingly private moment between the two siblings – one dead and the other alive – and the viewer almost feels like a voyeur. Eybl further heightens the painting's emotional impact by casting most of the room in dark shadow, focusing the soft illumination on the two protagonists' faces. Friedrich von Amerling's portrait of his wife Antonie on her deathbed (60) is another powerful example of a Biedermeier painter's emotionally charged representation of a loved one who has slipped beyond his reach forever.

59
FRANZ EYBL (1806–1880)
The Artist Franz Wipplinger, looking at a Portrait of his Late Sister, 1833
Oil on canvas, 126 × 100 cm
Belvedere, Vienna

60
FRIEDRICH VON AMERLING
(1803–1887)
Antonie von Amerling on her Deathbed, 1843
Oil on canvas, 47 × 39 cm
Wien Museum, Vienna

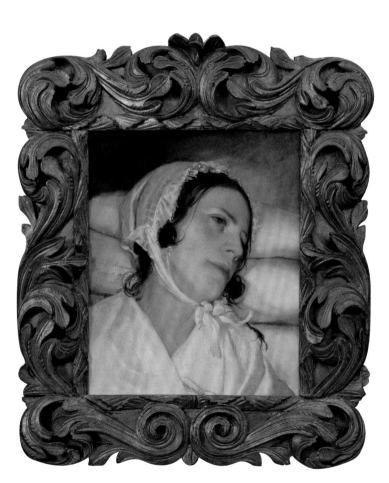

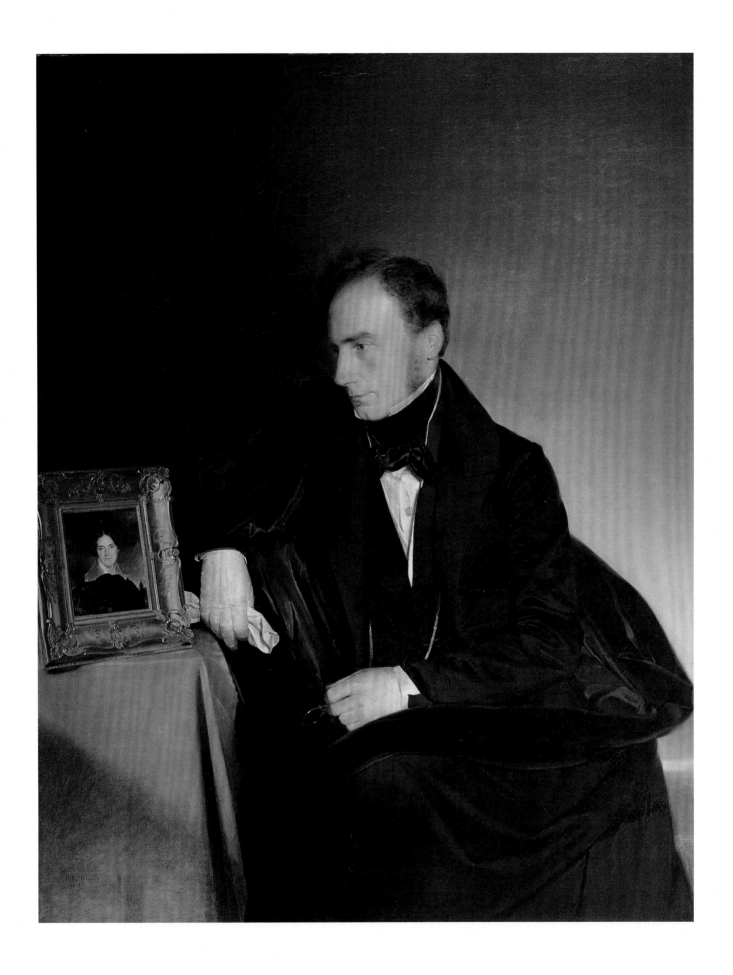

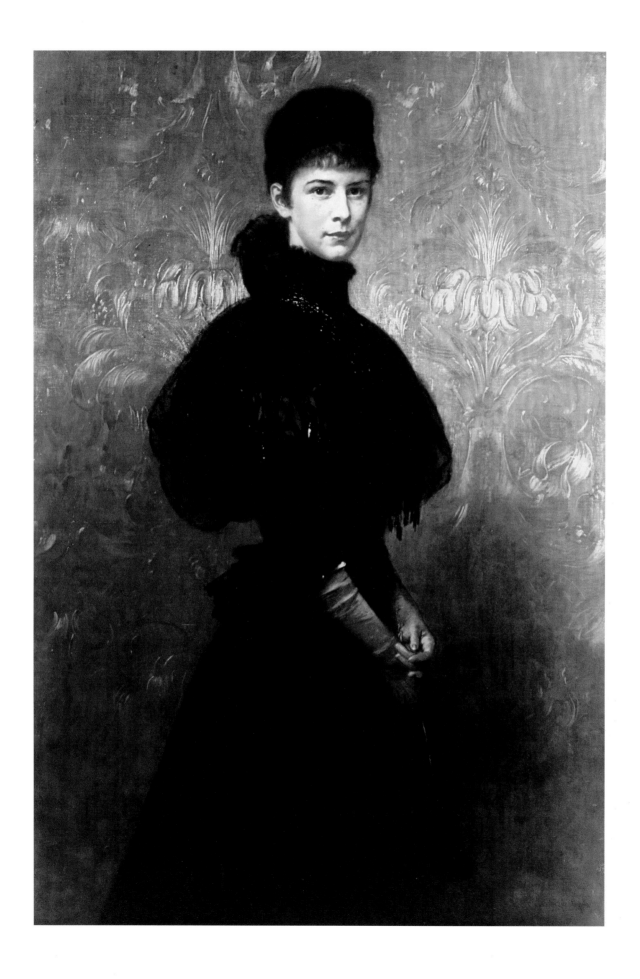

Commemorative miniatures such as the one in Eybl's painting were popular throughout the nineteenth century. But by the 1880s, a thriving market for photographs of fully dressed and styled dead family members (usually wives or children), who were either incorporated into a formal portrait or posed on their own, started to compete with these more conventional modes of representation. This type of portraiture was so fashionable in late nineteenth-century Vienna that the municipal government enacted a law in 1891 forbidding the presence of corpses in photography studios. Placed within a larger context of Viennese death portraiture across diverse media, Matsch's oil sketch and Eybl's painting fulfilled one of portraiture's most basic functions: to record the subject's likeness for posterity as a bulwark against their physical absence and to assuage grief.[5] Although both paintings were intended for intimate consumption by relatives of the subjects, these boundaries were sometimes blurred. Eybl's miniature, for example, was included in Wipplinger's portrait, actually allowing viewers to witness the latter's intensely private meditation on his sister's death. Matsch's private death portrait of Franz Joseph, on the other hand, represented just one aspect of a much larger and more public commemoration of the Emperor's death, which included a series of photographs and prints of the ruler lying in state at the Court Chapel that were published in newspapers and magazines across Europe.

Gyula Benczúr's portrait of Franz Joseph's wife, the Empress Elisabeth, provides a more conventional, but no less interesting, example of a commemorative portrait, as it was painted one year after the Empress's 1898 assassination in Geneva (61). Benczúr painted 'Sisi' from photographs taken much earlier in her life, as she refused to have her picture taken after she turned 32 in 1869.[6] Although the Empress was 61 when she was assassinated, Benczúr produced a painting of a virtually ageless beauty. This portrait had particular meaning for the Hungarian artist because the often aloof and politically uninterested Empress cultivated an especially warm relationship with her Hungarian subjects.

Historians have long argued that Vienna's cultural fabric during the period covered by this book was marked by a fascination with death and dying.[7] In this context, Vienna is often postulated as Europe's fin-de-siècle capital of cultural pessimism.[8] Indeed, Ludwig Wittgenstein's philosophical treatises, Sigmund Freud's dark journeys into the human psyche, Arthur Schnitzler's cynical critique of social mores, Arnold Schönberg's discordant twelve-tone system and Gustav Klimt's troubling

61
GYULA BENCZÚR (1844–1920)
Portrait of Empress Elisabeth, 1899
Oil on canvas, 142 × 95.5 cm
Hungarian National Museum,
Budapest

62
GUSTAV KLIMT (1862–1918)
Ria Munk on her Deathbed, 1912
Oil on canvas, 50 × 50.5 cm
Private collection
Courtesy Richard Nagy Ltd, London

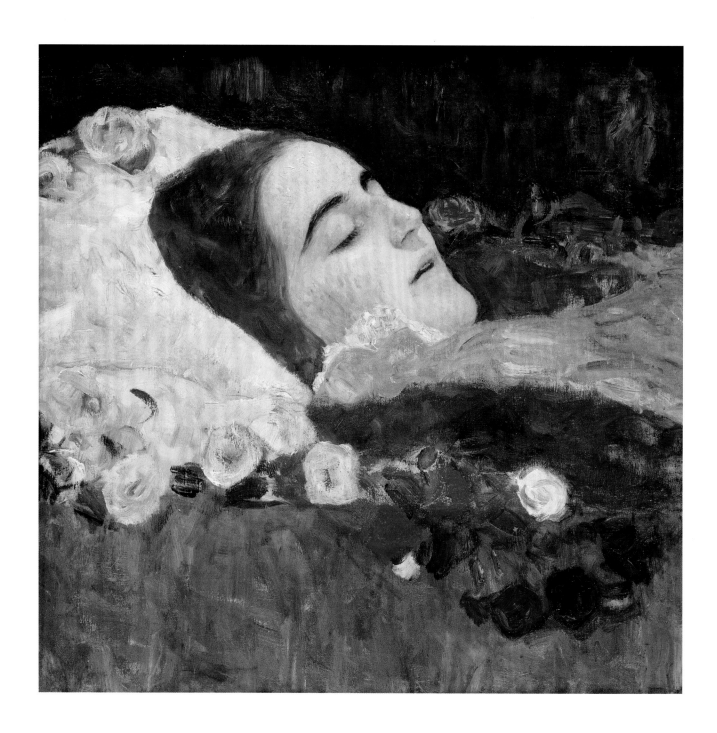

depictions of life bound to death – most notably his epic University paintings (1900–3) – support this assessment. This cultural pessimism and preoccupation with dying can in part be explained by an emerging socio-medical discourse that linked urban life to alcoholism, disease epidemics, poverty, warfare and poor hygiene. But these conditions were not unique to Vienna. In an attempt to understand the morbid zeitgeist of Vienna 1900, it is worth considering the city's strong Roman Catholic devotional culture connected to relics and pageantry; its overly articulated cult of the individual and concurrent 'celebrity culture'; its exceptionally high suicide rate (especially among the city's Jewish population); its oppressive, institutionalised anti-Semitism; its displaced ethnic groups arriving from the far reaches of the Empire; its merciless socio-economic stratification; and its ingrained military culture and bureaucratic jungle.[9] But Vienna's fascination with death was not entirely negative, and there were instances when the city's inhabitants rejoiced in the celebration of a particularly 'beautiful corpse' (a schöne Leich), which was not limited to the body itself but extended to the pomp and circumstance of the funeral and wake.

BEAUTY, SLEEP AND DEATH

Placed against the psycho-historical landscape of Vienna 1900, it is no surprise that many key artistic figures were drawn to the physical and spiritual realities of death and dying. Gustav Klimt's posthumous portrait of the 24-year-old Ria Munk on her deathbed provides a clear example of the artist's unrequited longing for a 'beautiful corpse' (62) – although in Klimt's case, we should also keep in mind his complicated relationship with female sexuality and his own sexual magnetism. He lived with his mother until her death in 1915; he never married but fathered multiple children with different women; he vacillated between painting alluringly fragile young women and threatening femmes fatales; and he regularly drew working-class models in sexually explicit poses for private consumption. In this posthumous portrait of Ria Munk, Klimt offered no visual indication of Munk's violent suicide in 1911 after a supposedly unhappy love affair with the notorious German novelist Hans Heinz Ewers. Instead, he represented a highly sensualised young woman resting on a pillow surrounded by flowers, who seems completely oblivious to the viewer's probing eyes. Were it not for the orange and purple fabric carefully draped over her upper body (probably intended to hide the horrific wounds she had sustained from shooting herself in the heart), Munk could easily be mistaken for someone asleep rather than

dead. Compared to Franz Joseph in Matsch's deathbed portrait, Munk looks surprisingly healthy as her cheeks are still pink, her mouth is slightly open and her features have not yet sunk into her skull. Ria Munk came from a prominent Jewish family, and Klimt's posthumous portrait incorporated a number of visual conventions that the artist had developed in his society portraits of upper-middle-class Viennese beauties – often, but not exclusively, from the assimilated Jewish families who were among Klimt's most loyal supporters.

Klimt's juxtaposition of beauty, sensuality, sleep and death in Ria Munk's deathbed portrait troubled her bereaved mother and she rejected the work, only to commission a second posthumous, life-size, portrait of her daughter, which Klimt most likely began to paint from photographs in 1913. In response to Aranka Munk's criticism of the first portrait as being too death-like, Klimt now decided to show Ria very much alive and as an exotic seductress standing upright, exposing her bare breasts and posing languidly in a highly fashionable Chinese silk robe before an orientalising wallpaper with flowers and a set of peculiar-looking Asian figures. This portrait has been likened to Shakepeare's Ophelia, as Ria is surrounded by flowers as famously visualised in John Everett Millais's *Ophelia* (1851/2, Tate).[10] Not surprisingly, Aranka also rejected this second attempt, and Klimt subsequently renamed the painting *The Dancer* (*Ria Munk II*) (fig. 45). In 1917, Klimt turned to the subject for a third time and started to work on *Posthumous Portrait of Ria Munk III* (63). He again posed Ria before a highly animated wallpaper, but the Asian figures carrying the whiff of demi-monde opium dens and brothels were replaced by even more stylised flowers. Ria holds her robe demurely closed and her facial expression is much less seductive. She looks directly at the viewer but a rather shy smile plays on her lips. Her formerly chic bob has been replaced with a much more conventional hairstyle and her face almost floats above the picture plane. This version pleased Aranka, and although Klimt did not finish the painting, she kept it in her possession until 1941, when she was deported by the Nazis to Łódź Ghetto (German-occupied Poland's second largest ghetto for Jews and Roma), where she was murdered shortly thereafter.[11]

Klimt died from a stroke on 6 February 1918, and his death at the age of 56 sent a shockwave through the international art world. Although Egon Schiele had denounced Klimt's painterly practice, he admired Vienna's 'father of modernism' as a friend and mentor throughout his life, and executed three drawings of Klimt as he lay dead in the morgue of Vienna's General Hospital. In one of these drawings (fig. 46) Schiele captured a haggard Klimt who was clearly marked by the ill-effects of the

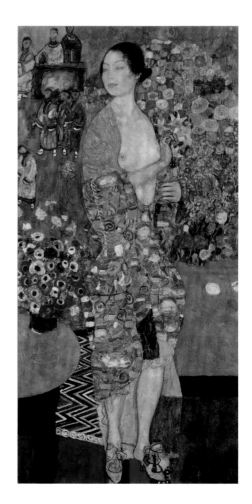

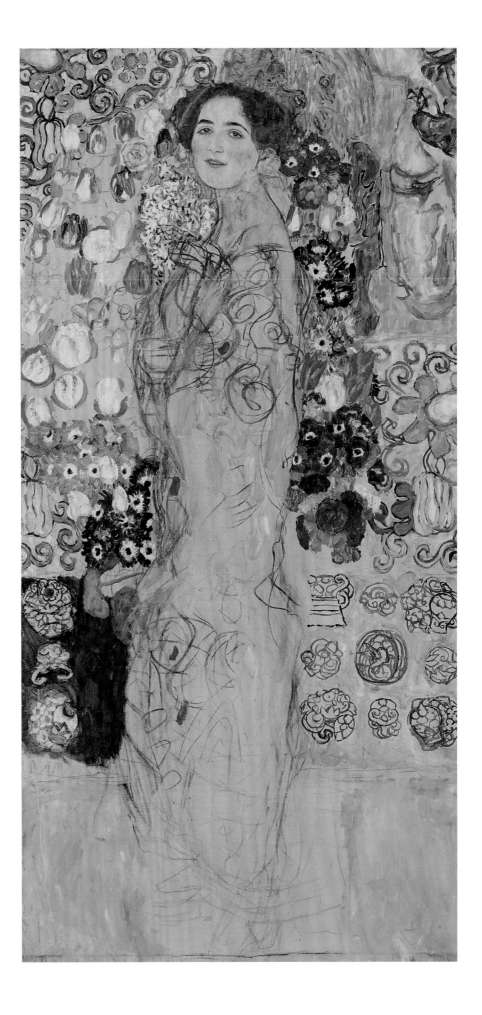

FIG. 45 (opposite)
GUSTAV KLIMT (1862–1918)
The Dancer (Ria Munk II), 1916
Oil on canvas
Private collection

63 (right)
GUSTAV KLIMT (1862–1918)
Posthumous Portrait of Ria Munk III,
1917–18
Oil on canvas, 180.7 × 89.9 cm
Property of The Lewis Collection

GUSTAV KLIMT

FIG. 47
Egon Schiele on his deathbed, photographed by Martha Fein, 1918

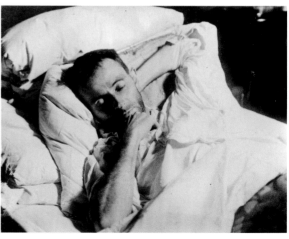

EGON
SCHIELE geg. 27.Ⅹ. 1806.
28. Oktober 1918

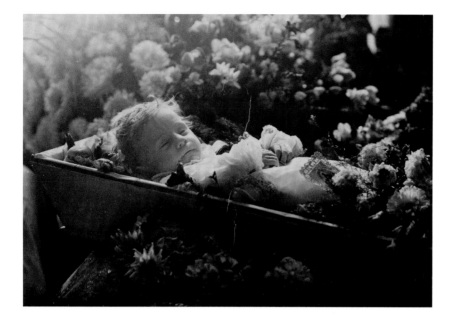

65
Otto Zimmermann, 1902,
photographed by Studio S. Fleck
Photograph, 10.2 × 16.5 cm
Diethard Leopold Collection,
Vienna

66
GUSTAV KLIMT (1862–1918)
*Portrait of the Artist's Dead Son,
Otto Zimmermann, 1902*
Chalk on paper, 39.5 × 24.7 cm
Diethard Leopold Collection,
Vienna

pneumonia he had contracted after his stroke. Hospital attendants had
removed Klimt's beard, and Schiele's drawing forms a stark contrast
to the bearded and virile artist that we are so familiar with from photo-
graphs taken when Klimt was alive. Compared to Matsch's depiction of
Franz Joseph, the black lines of Schiele's drawings expose Klimt's final
countenance with brutal honesty. Matsch's oil sketch is no less honest,
but Schiele did away with any superfluous elements (such as the pillow,
the flowers, the fir branch and even the soft colour palette) and reduced
his representation to a bare minimum. Indeed, Klimt's head seems
strangely disembodied as Schiele did not even bother to draw much
below the face.

Seven months later, on 28 October 1918, Schiele's pregnant wife
Edith succumbed to the Spanish influenza. Schiele was devastated, and
when he picked up his black crayons to draw his dying wife for one last
time, he bore witness to her suffering from the disease that ultimately
killed her, but also alluded to her former beauty (64).[12] Despite Schiele's
numerous affairs with models such as Wally Neuzil, this drawing repre-
sents a loving testimony to their married life. One could even argue
that the drawing helped Schiele to articulate his grief in the same way
as his mentor Klimt, who had committed his own despair to paper when
his son Otto died in 1902 (65, 66). It was Schiele's final contribution to
the art world, as he also died of the Spanish influenza only three days
after his wife, on 31 October 1918, aged 28 (fig. 47). Within one year,
two generations of Viennese modernists (Klimt 'the father' and Schiele
'the rebellious son') had been obliterated.

The death masks of Klimt and Schiele form part of the Wien Museum's significant collection of over 280 such objects (67 and 68).[13] Despite the known physical struggles that accompanied the artists' illnesses, both masks convey a strong impression of peace. The eyes are closed, an important visual convention in all death masks, and the face muscles are relaxed, leading to a virtual absence of wrinkles. Klimt's death mask is more complete than Schiele's as it includes part of his neck and his ears. Schiele's characteristically protruding ears have been omitted and his face looks slightly lopsided. Josef Humplik's death mask of the famous Viennese architect, designer and theoretician Adolf Loos further illustrates some of the sculptural conventions for death masks (69).

In its purest form, a death mask is a plaster impression of a deceased person's final facial expression. Death masks have a long and multi-faceted history that some scholars trace back to the plastered skulls found in Jericho from around 7000 BC. The first modern death mask – that is, an emotionally charged commemorative object made for private contemplation – was cast from Germany's most venerated Enlightenment writer and philosopher Gottfried Ephraim Lessing in 1781 (fig. 48). By this time, taking a direct imprint of nature formed an important technique in physiognomic, medical and ethnographic research. The German anatomist and founder of phrenology Franz Joseph Gall (1758–1828), for example, used casts of the cranium as well as death masks to assess an individual's character and mental abilities.[14] This compulsive interest in the physical traces of internal characteristics soon percolated into the arts, and in 1727 the sculptor Louis-François Roubiliac (1702–1762) took a plaster mould of Isaac Newton's face to help him realise a 'life-like' portrait bust of the recently deceased physicist. Such castings of life and death masks as tools in artistic practice (primarily sculpture) caused controversy well into the nineteenth century, and artists and critics hotly debated the aesthetic value of these unmediated casts.

During the Vienna 1900 period, death masks were made by first applying a very thin layer of liquid plaster to the deceased's face, followed by a thicker and more viscous second layer. The challenge lay in removing the plaster from the face, and often a piece of string was inserted from forehead to chin, so that the caster could pull it off in halves, which were quickly reconnected to make a whole face. This negative imprint was then used to make a final plaster cast or a wax for

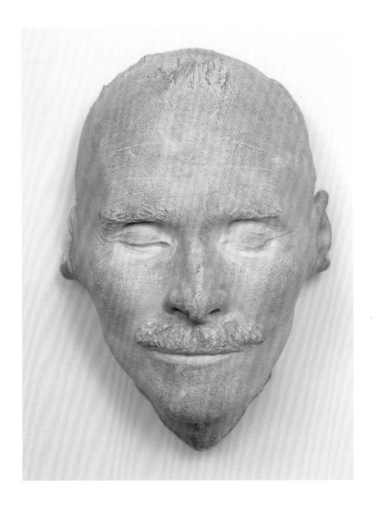

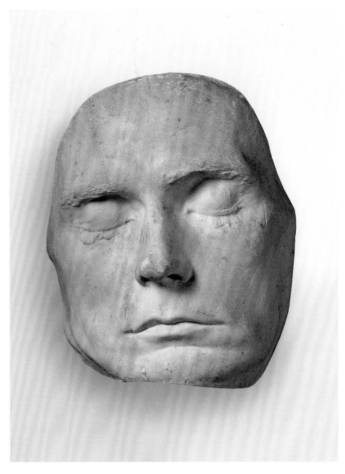

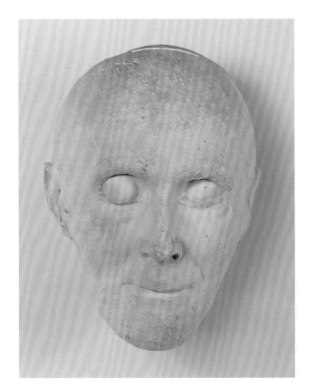

67
MORIZ SCHROTH
(Dates unknown)
Death Mask of Gustav Klimt, 1918
Plaster, 27 × 21 × 18 cm
Wien Museum, Vienna

68
UNKOWN
Death Mask of Egon Schiele, 1918
Plaster, 19.5 × 15.5 cm
Wien Museum, Vienna

69
JOSEF HUMPLIK (1888–1958)
Death Mask of Adolf Loos, 1933
Plaster, 24 × 18.5 × 17 cm
Wien Museum, Vienna

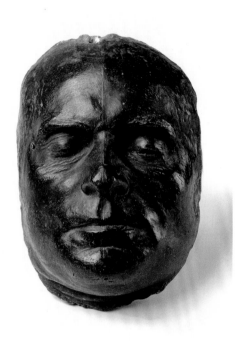

bronze casting. Many casters reworked the surface of their final cast to emphasise particular features or smooth out imperfections, but some of their colleagues frowned upon this practice.

Death masks were not mass-produced and retained their status as highly prized collector's items even when cheaper copies began to emerge at the turn of the last century. High-quality death masks were sold through fine art auctions or antique dealers. Plaster casts were the most sought-after, but also the most fragile type of mask. In Vienna, the initial cast was taken by craftsmen or (medical) model makers, and by 1900 a specialist trade in the production of death masks had evolved. Moriz Schroth and Johannes Benk, for example, were two sought-after casters who produced some of the most famous death masks of the day, including Klimt's. Although technically not particularly challenging, the making of death masks required experience and a steady hand, as the caster had to work very quickly to capture the all-important final expression of the face before it collapsed and became unrecognisable. Artists were called upon less frequently to create these objects, and Carl Moll's immortalisation of Gustav Mahler's final facial expression represents an intriguing rare example (70). This mask is very unusual because it

FIG. 48 (above left)
CHRISTIAN FRIEDRICH KRULL
(1748–1787)
Death Mask of Gotthold
Ephraim Lessing, 1781
Bronze
Schiller-Nationalmuseum,
Deutsches Literaturarchiv,
Marbach

70 (above right)
CARL MOLL (1861–1945)
Death Mask of Gustav Mahler, 1911
Plaster, 35 × 29 × 16 cm
Wien Museum, Vienna

not only gives an impression of the composer's face but also includes his neck and partial shoulders. These additional elements move Mahler's death mask closer to the realm of conventional sculpture, as Moll tried to achieve a three-dimensional totality of Mahler's head.

In Vienna 1900 death masks were almost exclusively collected and displayed by an educated elite, whose members were keen to demonstrate their intellectual and emotional links to the 'genius' made manifest in plaster for eternity. Death masks of famous composers, literary figures, politicians, artists and philosophers graced the walls of homes across the Austro-Hungarian Empire, and conjured up an intellectual genealogy for the individual who displayed them. The photograph of an anonymous young pianist with Beethoven's death mask above his piano and a print of Richard Wagner and Johannes Brahms on each side (with small statuettes of Brahms, Mozart and Liszt placed on the piano itself) shows a popular late nineteenth-century domestic context for death masks, namely the music room (fig. 49).

Death masks triggered important philosophical questions about the nature of death. When engaging with Mahler's death mask, for example, contemporary beholders would certainly have experienced a sense of loss over the death of one of Vienna's leading, albeit not uncontroversial,

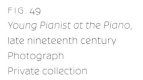

FIG. 49
Young Pianist at the Piano,
late nineteenth century
Photograph
Private collection

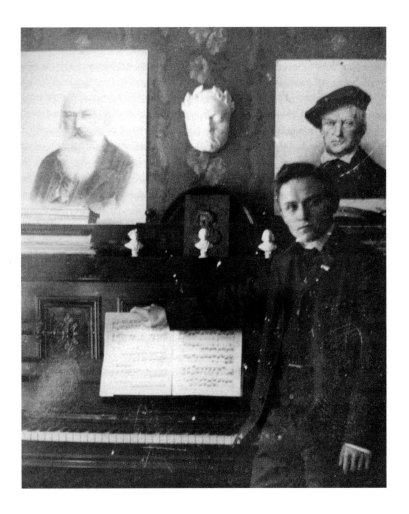

composers and conductors of his generation. But equally, they would have been very conscious of the implications of displaying his death mask in their homes, as this not only signalled their cultural and social sophistication, but also their political alliance with liberalism. Shown alongside portraits in music rooms and salons (in late nineteenth-century Vienna the two spaces were closely linked), death masks also served as conversation pieces during social gatherings, which were key events in Vienna's complicated and notoriously fickle social life.[15] On a more personal level, death masks, and indeed death portraits, facilitated a kind of private meditation that was driven by emotion rather than intellect.

Domestic displays of death masks functioned as shrine-like sites for aesthetic and philosophical contemplation. The materiality of the death masks holds the key to their popularity among Vienna's educated upper middle classes. Rather than merely looking at the portrait of an esteemed cultural figure, the beholder could handle a death mask and form an embodied relationship with the individual, thus inserting himself (the bond was usually male-to-male) into the long trajectory of Austria-Hungary's artistic and cultural achievements. In this way, death masks literally and metaphorically filled the empty space left by a departed body. But these fragments had to conjure up a formerly unified whole that no longer existed, or indeed, might never have existed in the way it was reconstituted in the beholder's mind.

The death mask of Ludwig van Beethoven (1770–1827) is one of the oldest and most iconic masks in the collection of the Wien Museum (71).[16] Today, we have the privilege of being able to compare Beethoven's death mask with a life mask taken in 1812 by Franz Klein.[17] Beethoven died on 26 March 1827 after a long illness. Ever wary of being poisoned, he stipulated in his will that an autopsy be performed upon his death, which resulted in the slight disfigurement of his face due to a post-mortem examination of his ear canals (as he was famously deaf in his final years)[18]. This makes Beethoven's death mask by the two young Viennese painters Josef Danhauser and Matthias Ranftl even more of an achievement, as they had to deal with an anatomically damaged face in the advanced stages of rigor mortis. Beethoven's death was clearly marked by pain as his mouth is set in a tight grimace and his forehead is contracted in a deep frown. Fairly crude incisions and the collapse of part of his skull are visible. To their credit, Danhauser and Ranftl handled this challenging situation with particular confidence, and it is no surprise that they would soon emerge as two of Vienna's most cherished Biedermeier painters. While at Beethoven's deathbed, Danhauser also

71
JOSEF DANHAUSER (1805–1845)
and **MATTHIAS RANFTL** (1804–1854)
Death Mask of Beethoven, 1827
Plaster, 25 × 17 × 15 cm
Wien Museum, Vienna

72
JOSEF DANHAUSER (1805–1845)
Beethoven's Hands, 1827
Oil on canvas, 42 × 34 cm
Beethoven-Haus, Bonn

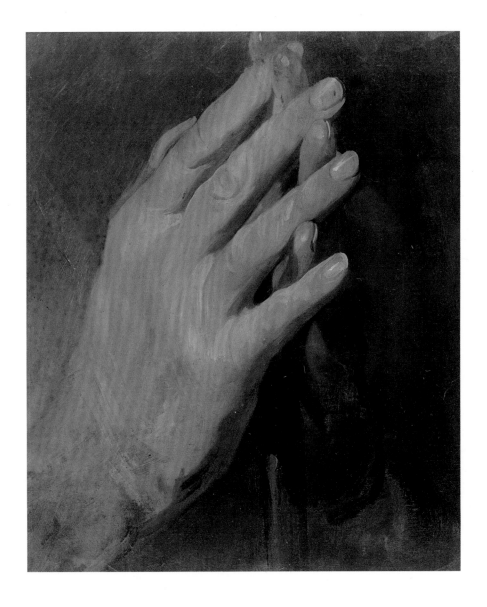

executed several drawings, and his oil sketch of the composer's withered and disembodied hand carries particular pathos (72). Even more of a fragment than the death mask, this hand synthesises all of Beethoven's talent as a composer and his suffering as a human being into one single instance: the tense hand becomes the conduit of his artistic genius.

Beethoven died at a historical moment when individual sensibility, creative turmoil and tragic yearning were advocated as keystones of 'original genius' – a concept first embraced by poets of the late eighteenth-century German *Sturm und Drang* literary movement. The composer was celebrated as an 'original genius' in Vienna throughout the nineteenth century, and in a way his death mask became a secular reliquary. It not only served as a physical reminder of his creative and spiritual struggles, but also enabled its upper-middle-class beholders to mentally transport themselves into a rarefied pseudo-religious realm that was otherwise reserved for poets and artists.

Very few death masks of noteworthy Viennese women – actresses and literary figures – made it into the nineteenth-century virtual pantheon of great minds. For contemporary viewers in Viennese patriarchal society, images of young women's beautiful corpses, such as Klimt's *Ria Munk* or Schiele's drawing of his wife, often functioned as a means of escape from death's corporeal realities. One historian has convincingly argued that looking at the representation of a beautiful dead young woman catapulted (usually male) viewers into the realm of the imaginary and opened up a space to dream her death.[19] The physiological 'truthfulness' of female death masks, which showed wrinkles, imperfections, scars and facial hair, short-circuited such an escape into the imaginary realm of idealised beauty and pulled the beholder back into the here and now. Heinrich Heine (1797–1856) alluded to the problematic materiality of female death masks in his unfinished novel *Florentine Nights* (1839), when in response to the main protagonist Maximilian's desire to preserve the beauty of his terminally ill female friend through a death mask, the attending physician tries to deter him: 'Death masks put us off our beloved's memory. We believe that this plaster still contains traces of their life …, [it] is nothing but death itself.'[20] What Heine saw as the challenging corporeality in female death masks, coupled with the overall lower status of women in late nineteenth-century intellectual circles, helps us understand why so few death masks of prominent women were commissioned and collected in late nineteenth-century Vienna. The death mask of Charlotte Wolter, one of the most famous stage actress of Vienna in her day, is a notable exception (fig. 50). She died aged 63, and her highly naturalistic death mask does not hide the effects of time

FIG. 50
Death mask of Charlotte Wolter
(died 1897), as reproduced in Egon
Fridell, *Das Letze Gesicht*, Zürich, 1929

on her face. Rather than detracting from her former beauty, however, this honesty adds a sense of dignity and gravitas to her countenance that marks a fitting end to a long and successful career.

HUMAN ANATOMY

In order to understand how death masks fitted in with the Viennese material culture of death, we need to consider the field of anatomical research, as nineteenth-century Vienna was renowned as one of Europe's capitals in that area. Carl Rokitansky (1804–1878) was a key figure in the founding of the Second Vienna School of Medicine, which was characterised by a focus on pathological anatomy – that is, the diagnosis of disease grounded in the close examination of the (deceased) body. Dissection was the key scientific mode of investigation, and medical historians have argued that ready access to corpses in Vienna played an important role in the development of the School's reputation.[21] Anatomical wax models were used as a way to communicate and foster this new knowledge about the human body to medical students from across Europe. The University of Vienna's wax models collection dates back to Emperor Joseph II (1741–1790), who founded Vienna's Medical-Surgical Academy in 1784. Joseph was keen to attach a collection of anatomical wax models to his medical faculty, and commissioned the Florentine wax workshops of Felice Fontana (1730–1805) to produce and ship over 1,000 waxworks to Vienna. At the time, northern Italy – especially the towns of Bologna, Florence and Venice – was famous for its medical wax modellers, who produced specimens for anatomical collections across Europe.[22] Vienna's wax models primarily served as a

FIG. 51
PAOLO MASCAGNI (1755–1815)
Medicean Venus, 1785
Wax model from a collection
(Anatomia Plastica) commissioned
by Joseph II to benefit the
training of military doctors.
Sammlung der Medizinischen
Universität Wien, Josephinum,
Vienna

teaching collection, but the space was periodically opened to the public. The collection remains virtually unchanged to this day and is still housed in its original eighteenth-century building, the Josephinum (named after its founder).

The centrepiece of any anatomical wax model collection of the time was the so-called *Anatomical Venus*: a full-length, dissectible female figure. And indeed, Fontana's workshop produced a beautiful and sexually alluring female wax figure, with a long blonde wig made from human hair and a string of pearls around her neck, for Joseph's museum (fig. 51). She rests on a luxurious satin sheet and her reclining pose brings to mind Titian's iconic *Venus of Urbino* (1538). The *Anatomical Venus* thus draws on the idealised bodies of Venuses from classical antiquity and the Renaissance who signified beauty, desire and sexuality as well as art's primacy over nature. But a closer look at Vienna's *Anatomical Venus* reveals that she has a removable abdominal wall allowing access to her internal organs, each of which could be taken out for closer examination.[23] This enabled experts as well as occasional lay persons to conduct what could be conceived as 'dissections by proxy'. These kinds of anatomical waxworks produced and communicated important new scientific knowledge about the healthy and pathological body beyond the tightly controlled space of the anatomical dissection theatre.[24]

It can be argued that, on one level, death masks performed a similar function to these anatomical wax models. They captured an individual's facial features at the very moment of death and thus participated in the creation and dissemination of new knowledge about the human body and the physiology of death and dying. Since death masks were not confined to the medical spaces of the university or the hospital, they literally brought anatomical knowledge right into the homes of Vienna's cultural elites.

In Vienna, non-specialist audiences had plenty of opportunities to encounter what have been termed 'public anatomies'[25] across the city. One of the most interesting spaces to offer such popular medical science was the Präuscher's Panoptikum and Anatomical Museum, housed in the grounds of the Prater, Vienna's legendary amusement park which operates to this day (although Präuscher's establishment was destroyed in 1945). Hermann Präuscher, a German circus-animal trainer, opened his Panoptikum in 1871 to exhibit 2,000 objects, among them life-sized wax mannequins re-enacting historical scenes in appropriate costume, as well as a special section with anatomical, pathological and ethnological specimens.[26] In many ways, Präuscher's museum built on the commercial

FIG. 52
LEONHARD POSCH (1750–1831) and **JOSEPH GRAF VON DEYM ZU STRITETZ** (1750–1814)
Bust of Ferdinand IV of Naples, about 1791–2
Painted wax with glass eyes, human hair and plaster
Österreichische Nationalbibliothek, Vienna

FIG. 53
Head of an Indian Chief, from the Panopticon of Hermann Präuscher, Vienna, about 1870
Painted wax
Kunstkammer Georg Laue, Munich

A BEAUTIFUL CORPSE

success of wax figure cabinets such as 'Madame Tussaud's Exhibition' in London (1835).[27] But the quality and technical sophistication of Präuscher's wax figures must not be underestimated.

Throughout the eighteenth century, Vienna was famous for its fine art wax portraiture, such as the wonderful portrait of King Ferdinand IV produced by Leonhard Posch and Joseph Graf von Deym zu Stritetz in 1791–2 (fig. 52). In this wax portrait, Ferdinand is represented warts and all, and Präuscher clearly wanted the same kind of veracity for his Panoptikum figures. The striking painted wax *Head of an Indian Chief* displayed in the ethnological part of his museum, for example, bears a frightening semblance to a human being and yet is a lifeless object (fig. 53). This 'über-lifelike' wax bust triggered an experience of both attraction and repulsion, pleasure and horror – articulated by Sigmund Freud in 1919 as the uncanny, or the *Unheimliche*. The uncanny is also part of the experience of death masks, as they trigger an experience of fracture between recognising a familiar person and realising that it is not them.

Präuscher's anatomical museum intended to teach visitors about the ethnographic human body through wax models as well as body parts and skeletal remains, and it employed some of the display techniques used in the Josephinum's anatomical museum. In the light of the diverse socio-economic composition of Präuscher's audiences, however, the pedagogical message became somewhat distorted, and many visitors must have found the exhibits simply gruesome.

Contemporary viewers formed intellectual and visual habits through their encounters with the representation of the deceased human body across a broad spectrum of contexts ranging from fine art to philosophy, medicine and popular entertainment. If one believes that the way people look at the world and process what they see is anchored in the specific and ever-changing conditions of a time and place, then each of the examples discussed above – posthumous portraiture, death masks, anatomical models and wax figures – played a key role in the formation of a distinctly Viennese way of seeing and beholding death.[28]

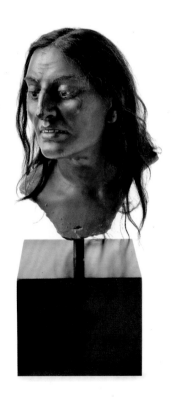

Notes

ON STAGE: THE NEW VIENNESE

1 Zweig 1964, p. 16.
2 Franz Matsch worked with Klimt in the
 Künstler-Compagnie (Artists' Company) they
 formed in 1879. He was also commissioned to
 paint the interior of the old Burgtheater, but
 the prestigious Emperor's Prize was awarded
 to Klimt. Matsch's watercolour is also held in
 the Wien Museum.
3 Josef Löwy produced a photogravure of the
 painting, which provided a numbered key
 naming the most important individuals
 depicted. One hundred and thirty-one people
 were identified in this index of cultured
 society, though the painting included many
 other anonymous portraits.
4 Vienna (Wien Museum) 2012, p. 112.
5 For a discussion of this see London and
 Vienna 2009–10.
6 Under the terms of the Ausgleich, the
 sovereignty of Hungary was recognised.
 Austria and Hungary had separate parlia-
 ments that met in the capitals of Vienna
 and Buda (later Budapest).
7 See Timms 1986, pp. 22–8.
8 I am indebted here to Bourdieu 1987.
9 For a comprehensive mapping of artistic life
 in the Empire see Clegg 2006.
10 See for example the Great Impressionist
 Exhibition of 1903. Robert Jensen considers
 how this exhibition 'naturalized art that had
 heretofore either been entirely unknown or
 radically unfamiliar. Cézanne most notably
 was publicly canonized in Vienna long
 before the French cultural establishment
 so honored him.' Jensen 1994, p. 4.
11 The term Biedermeier is a combination of
 a common German surname (Meier) with
 the word bieder, which means honest and
 straightforward; it related specifically to the
 middle classes.
12 For an extended discussion of these see
 Schorske 1981, pp. 24–115.
13 As D.J. Olsen argues: 'To display oneself and
 be seen, acknowledge and be acknowledged,
 was one such duty to oneself, one's class
 and one's sovereign.' Olsen 1986, p. 241.

14 Zweig 1964, p. 22. On the significance of the
 Jewish contribution to Viennese cultural life
 see Beller 1989.
15 L.W. Rochowanski, Neues Wiener Journal,
 13 January 1929, p. 18.
16 For a history of the rise of this party
 see Boyer 1981.
17 Cajetan von Felder was Mayor of Vienna
 from 1868 to 1878.
18 Vienna (Belvedere) 2000, pp. 105–7.
19 Bourdieu describes taste as 'one of the
 most vital stakes in the struggles fought
 in the field of the dominant class and the
 field of cultural production'. He goes on
 to define the important relationship
 between 'culture as that which is cultivated
 and culture as the process of cultivating'.
 Bourdieu 1987, p. 164.
20 Bonyhady 2011, p. 22.
21 Schorske 1981.
22 Following the success of his work for the
 new Burgtheater, Klimt was commissioned to
 produce three ceiling paintings to celebrate
 the University's faculties of Philosophy,
 Medicine and Law in 1894. The resultant
 works (Philosophy), 1901 (Medicine) and 1903
 (Jurisprudence), were exhibited at the Secession
 in 1903 and caused an unprecedented scandal
 because of their 'pornographic' depictions
 of the human figure.
23 Schorske 1981, p. 271.
24 Wiener Allgemeine Zeitung, 15 November 1903.
25 J. Strzygowski, 'Junge Künstler im
 Hagenbund', Die Zeit, 9 February 1911.
26 Kokoschka and Marnau 1992, pp. 18–19.
27 Schorske 1981, p. 215.
28 Zweig 1964, p. 15.
29 For a recent example see 'The Viennese
 Avant-garde and Psychoanalysis' in Foster,
 Krauss, Bois and Buchloh, 2004, pp. 52–6.

PAST TIMES AND PRESENT ANXIETIES
AT THE GALERIE MIETHKE

1 Schönberg's opus was indebted to Maurice
 Maeterlinck's play, Pelléas et Mélisande, which
 was first performed in Paris in 1893.

2 Arnold Schönberg, programme notes for
 a radio broadcast of Pelleas und Melisande,
 1949 in Muxeneder, 'Pelleas und Melisande',
 Arnold Schönberg Center, Vienna. Retrieved
 6 December 2012.
3 It is not known exactly when Freud's Three
 Essays was published, but it certainly preceded
 by some months the publication of his case
 history on the female hysteric Dora, which
 appeared in October 1905.
4 Gay 1998, p. 148.
5 For more information on this study for the
 Emperor's official portrait see Munich 2012,
 pp. 56–9.
6 Hohe Warte 1904–5, pp. 295–8.
7 Vienna (Miethke) 1905. The Miethke
 exhibition on the Alt-Wiener portrait followed
 a retrospective devoted to the work of
 Ferdinand Georg Waldmüller (November–
 December 1904); these two exhibitions were
 conceived as a pair and were treated as such
 in the accompanying reviews. Haberfeld
 wrote the catalogues for both.
8 The attacks on Klimt's paintings for the
 University of Vienna were collated by his
 supporter, the art critic Hermann Bahr, and
 published as Gegen Klimt (Against Klimt) in
 1903. Commenting on Philosophy, the first in
 the series, one critic remarked: 'Even if we
 may willingly admit that anyone who studies
 thoroughly the different systems even of
 German philosophy alone must suffer an
 attack of mild insanity, nonetheless, there
 is no reason why Herr Klimt should inflict
 this painted madness upon us.' Quoted in
 Vergo 2001, p. 55.
9 Berta Zuckerkandl, 'Galerie Miethke', Wiener
 Allgemeine Zeitung, 29 April 1905.
10 A. Friedmann, review of the Klimt-Kollektive
 exhibition at the Secession, Wiener Zeitung,
 17 November 1903.
11 Wiener Zeitung, 17 November 1903. The
 reference is to the French writer Charles
 Baudelaire's volume of poems Les Fleurs
 du Mal (1857).
12 Wiener Allgemeine Zeitung, 29 April 1905.
13 Vienna (Miethke) 1905.
14 Prior to Moll's appointment, the Secession

was divided between the *Klimt-Gruppe* (Klimt Group), with their interest in architecture and design, and the *Nur-Maler* (Pure Painters), committed to Fine Art practices. Moll's post at the Miethke provided the *Klimt-Gruppe* with the representation it needed to become independent of the Secession.

15 A.F. Seligmann, *Die Neue Freie Presse*, 20 November 1904.

16 Moll's painting can also be related to Jan Vermeer's *The Artist in his Studio* of *c*.1665/6 (Kunsthistorisches Museum, Vienna). This painting was in private collections in Vienna from the eighteenth century onwards and was exhibited in the Secession's sixteenth exhibition – a survey of Impressionism – in 1903; Vermeer was claimed as a forerunner of the Impressionists. The Secession's interest in nineteenth-century French and seventeenth-century Dutch imagery of middle-class life offers another view on the development of modern Viennese painting.

17 See, for example, Carl Moll, *Terrace of the Villa Moll*, about 1903 (Wien Museum, Vienna).

18 Vienna (Miethke) 1905.

19 Policies on the censorship of the press were set out in the Carlsbad Decrees of 1819, overseen by Metternich in response to fear of revolution.

20 Vienna (Miethke) 1905.

21 The *Bürgergarde* was a form of home guard comprising middle-class men from local communities who were trained to defend and protect populations at times when there was no army or police presence.

22 Schorske 1981, p. 4.

23 Galerie Miethke, November–December 1905.

24 See, for example, Silverman 1989.

25 Coffer 2011.

26 Paul Wilhelm, *Neues Wiener Journal*, 10 January 1909.

27 *Neues Wiener Journal*, vol. 18, no. 6093 (9 October 1910), 13–15. Quoted and translated in Meyer and Muxeneder 2005, p. 129.

28 Vienna (Miethke) 1905.

29 Hohe Warte 1904–5.

BIEDERMEIER MODERN: REPRESENTING FAMILY VALUES

1 Schindler was Alma's maiden name. Mahler-Werfel 1998, p. 105 (17 March 1899) and p. 143 (23 May 1899). Klimt's *Schubert at the Piano* was commissioned by the industrialist Nikolaus Dumba as one of two overdoors for the music room in his home. The painting was destroyed during the Second World War.

2 S. Messing, 'Klimt's Schubert and the Fin-de-Siècle Imagination' in Leggio 2002, pp. 1–35. See also Messing 2008.

3 The Café Museum still exists at 6 Friedrichstrasse, in Vienna's first district, close to numerous cultural institutions such as the Secession building, the Künstlerhaus and the Academy of Fine Arts. See 'Coffeehouse Encounters: Adolf Loos's Café Museum' in Gronberg 2007 pp. 69–96.

4 The Congress of Vienna took place between November 1814 and June 1815. Following the French revolutionary and Napoleonic wars and the dissolution of the Holy Roman Empire, it was concerned with redrawing European boundaries. The major powers involved included Austria, France, Britain and Russia.

5 For a reconsideration of late eighteenth- and early nineteenth-century Austrian history and modernity see Robertson and Timms 1991. See also Erickson 1997 (Part One).

6 For an account of Schmid's painting see S. Messing in Leggio 2002, pp. 4–5.

7 Interior design is a literal, albeit somewhat reductive, translation of *Wohnkultur*, lacking the German connotations of domestic living as a refined 'culture' or 'art'. The professional and middle classes were the chief patrons of late nineteenth- and early twentieth-century Viennese avant-garde movements such as the Vienna Secession and the affiliated Wiener Werkstätte (Vienna Workshops, specialising in decorative arts and architectural commissions).

8 On Biedermeier visual culture, see for example Waissenberger 1986; Norman 1987; Erickson (Part Three) 1997; Milwaukee, Vienna, Berlin and Paris 2006–8.

9 There is a detailed assessment of Adolf Loos's preoccupation with Biedermeier culture in Long 2011.

10 Vienna (Belvedere) and Paris 2009.

11 In this respect, Biedermeier middle-class aspirations to claim status through art and culture would seem to prefigure the late nineteenth-century *bürgerlich* desire to assimilate with the aristocracy, as argued in Schorske 1981. See p. 295 ff.

12 Franz I was popularly known as the *Blumenkaiser*. See Vienna (Historisches Museum) 2002, p. 47. See also C. Riedl-Dorn, 'Biedermeiergärten: kleine Paradiese im Vormärz' in Vienna (Belvedere Orangery) 2007, p. 111.

13 Ideas of imperial authority as bureaucratic service predated the reign of Franz I. See for example the discussions on Joseph II (1741–1790) in Robertson and Timms 1991. The Emperor is described as 'the chief administrator of a secular and, so far as possible, homogeneous state', p. xiii. Joseph's rejection of the Baroque ostentation of his parents is discussed pp. 1–21.

14 The term panopticon is associated with the British philosopher and social reformer Jeremy Bentham (1748–1832), who conceived plans for institutional buildings designed to allow surveillance of the residents from a central vantage point.

15 See the essay on Jakob and Rudolf von Alt in Vienna (Albertina) 2010. The urban and landscape views were indicative of the period's vogue for *vedute*, realistic topographical depictions of specific places as opposed to the more classical, idealised landscapes promoted by the Academy.

16 The peepbox (or perspective box) dates back to the Renaissance. Peepboxes were especially popular in seventeenth-century Holland as a means of depicting domestic interiors. The Samuel Hoogstraten in the National Gallery is one example.

17 Boddy 2012.

18 Charles Baudelaire's *The Painter of Modern Life* was published in 1863. See Baudelaire 1863 (1995) and Benjamin 1938 (1973).

19 Jacob Alt's *View from the Artist's Studio* is discussed in the context of the *Fensterbild* in New York 2011, pp. 140–1.

20 Nebehay 1975.

21 R. Rosenblum and H.W. Janson quoted in Wilkie 1987, p. 197.

22 This forms the main theme of Schorske's *Fin-de-Siècle Vienna*. I reassess Schorske's arguments in Gronberg 2007.

23 Edith died on 28 October 1918 from Spanish influenza, a few days before Schiele himself. The male figure is clearly a portrait of Schiele, but despite the allusions to parenthood, the original title of the work was apparently not 'Family' but 'Crouching Couple'. See Whitford 1981, pp. 145–6.

PORTRAYING VIENNESE BEAUTY: MAKART AND KLIMT

1 The Polish nobleman and landowner Alfred Potocki (1817/22–1889) was an Austrian and Galician politician.

2 At present there is no study of this field.

3 See Frodl 1974, pp. 43–5. It would be profitable to build on and further refine Frodl's classification.

4 See Kiel 2009, pp. 219, 244–5 and Frodl 1974, p. 43.

5 Frodl 1974, p. 44.

6 Frodl 1974, p. 44 and N. Schaffer in Salzburg 2007, p. 254.

7 As a reason for the negative verdict on Makart's portraits, Elke Doppler points to the moral authority of the character portrait, which was not matched by these works, which glitter with optical effects and decorative surfaces. E. Doppler in Vienna (Historisches Museum) 2000, pp. 134–8.

8 N.N., 'The International Exhibition' *The Athenæum*, 15 June 1878, pp. 770–1.

9 See Vienna (Wien Museum im Künstlerhaus) 2011, pp. 50–7, 208–14.

10 The painting was acquired for the Berlin National Gallery in 1877 and now belongs to the Belvedere, Vienna. After it was first exhibited in Vienna in 1873, it toured to Berlin, Cologne, Düsseldorf, London and Philadelphia.

11 D. Lehmann in Vienna, Ibid., pp. 176–7, pp. 241–59. After being shown in Vienna and Paris in 1878, the painting was exhibited at the Hamburg Kunsthalle, which bought the work in 1881. In 1879 the painting travelled to Berlin, Leipzig, Dresden and Munich. In 1880 it was exhibited in Amsterdam, Rotterdam and London. In 1881 it was shown in Basel and Stuttgart.

12 V. Champier, *L'année artistique 1878. Les beaux arts en France et à l'Étranger*, Paris 1879, p. 184. Vienna (Wien Museum im Künstlerhaus) 2011, p. 251. On the back of the painting is a note saying the portrait was completed in 1878.

13 H. Gautier and A. Desprez, *Les Curiosités de l'exposition de 1878. Guide du visiteur*, Paris 1878, p. 64. After Makart's death his *Bianca Baroness Teschenberg* was still exhibited as representative of his portraits. H. Bahr, 'Die Jubelausstellung im Wiener Künstlerhaus. V. ' in *Deutsche Wochenschrift*, 1888, 6, 17, pp. 2–4.

14 See K.E. Edler, 'Prinz zu Hohenlohe-Schillingsfürst, Constantin' in *Biographisches Jahrbuch und Deutscher Nekrolog*, ed. A. Bettelheim, vol. 1, Berlin 1897, pp. 176–91.

15 Makart's last portrait of Hanna was painted before the annulment of her marriage in 1884. She did not claim it when the painter died the same year, although it was thought to be one of his best pictures in this style.

16 There are numerous photographs in the collections of the Wien Museum and the Austrian National Library.

17 Whereas his former fellow pupil Franz von Lenbach saved working time by painting from photographs, either by tracing them or projecting them, for Makart photos were more likely just aids and sources of inspiration, which he did not slavishly copy. Even those photos of Charlotte Wolter and Bianca Baroness Teschenberg which resemble his painted portraits of them are significantly different.

18 *Allgemeine Zeitung*, 19 May 1873, pp. 2127–8.

19 *Die Neue Freie Presse*, 18 January 1873, evening edition, p. 4.

20 C. Clément, 'Exposition Universelle' in *Journal des débats politiques et littéraires*, 2 May 1878, p. 2.

21 E. Ranzoni, 'Malerei' in *Neue Freie Presse*, 13 March 1878, evening edition, p. 4.

22 *Die Neue Freie Presse*, 1 April 1876, evening edition, p. 4. *Die Neue Freie Presse*, 3 November 1878, morning edition, p. 6.

23 *Local-Anzeiger der Presse*, supplement 76, 18 March 1879, p. 9.

24 Angeli had painted Berta von Schönerer in 1865 on a commission from her father. In the process the young couple had fallen in love.

25 Klimt transformed the hair ornament of the Spanish Infanta into the wall decoration behind Fritza's head. With this quotation from Velázquez, the court painter of the Habsburgs, Klimt paid homage to an Old Master and in a playful way showed his potential as Velázquez's successor – modern but conscious of tradition.

26 One continuity was that Klimt made the sitters' faces conform to the conventional rounded ideal. See M. Bisanz-Prakken in Natter 2012, p. 437. In contrast to the photography of Hermine Gallia her portrait shows her face slim and her big eyes appear brighter because Klimt lifted her eyebrows with a high forehead and a lift of the head.

27 See Blackshaw and Wieber, 2012, pp. 90–108.

28 L. Hevesi, 'Das erste Mal seit Makart. 1903' in Breicha 1978, pp. 93–5.

29 A portrait by Klimt cost around 5000 Gulden. See P. Vergo, 'Fritz Waerndorfer as Collector' in *Alte und moderne Kunst*, Wien 1981, pp. 33–8. Inflation drove the prices higher. Vienna (Belvedere) 2000, p. 63.

30 Hevesi in Breicha 1978, pp. 93–95.

31 Quoted in Natter 2012, p. 194.

32 Zaunschirm 1987, p. 9.

33 S. Partsch in Natter 2012, p. 191.

34 D. Lehmann, Historienmalerei 2011, ill. no. 73–5. Likewise, in his satire *Die Feldherrenhügel* Roda Roda remodelled this image for Teresa Ries (see her self portrait, 1902, p. 146) and her putative lovers. See J. Johnson's essay in this book.

35 S. Wieber in London and Vienna 2009, pp. 121–35.

36 Novotny and Dobai 1967, pp. 35–52; Vienna (Belvedere) 2000.

37 We do not know for sure what overpainting Klimt did after the initial exhibition. There is no evidence as to whether the 'astral chair' was subsequently given firmer contours. See Ludwig Hevesi, 'Ausstellung der Sezession', 1 February 1902 in *Acht Jahre Secession*, Vienna 1906, p. 63.

38 *Das Interieur*, IV, 1903, pp. 138–9. Neither Klimt nor his painting are named in this text.

39 Susanna Partsch speaks of the female body being reduced to an ornament. See Natter 2012, p. 201.

40 Zaunschirm 1987, p. 37.

41 Bisanz-Prakken 2009.

42 This commission was brokered for Klimt by the sister-in-law of the sitter, Berta Zuckerkandl. The completion was hindered by the First World War and was finally prevented by the death of the artist. Vienna (Belvedere) 2000, p. 146.

43 See S. Wieber's essay in this book for further details.

44 In the Christian language of images, roses stand for love, but also for death. In Western art, tulips stand for transience. In the Chinese tradition, in which white peonies were reserved for the upper classes and the well-to-do, they are a sign for a beautiful young maiden, while chrysanthemums symbolise a long and fulfilled life. The pumpkin plant signifies fertility and, like cinerarias, the wish for a lengthy continuation of the family. See Strobl, 1980–9 (German edition), vol. 3, 1984, p. 114 and Bisanz-Prakken 2009, pp. 54–5. For the romantic reception of the hyacinth, representing the desire for faithfulness until death, see also J. Paul, 'Hesperus' (1795) in *Jean Pauls Sämmtliche Werke in vier Bänden*, vol. 1, Paris 1843, p. 607.

45 *Des Mönches Aegydius Lebrecht großes illustrirtes Egyptisches Traumbuch*, New York 1870, p. 13.

46 See Vienna (Belvedere) 2000, pp. 58–9, Natter 2003, pp. 12–139, and Natter 2012.

47 This becomes obvious by looking at the Galerie Miethke managed by Carl Moll (1904–12). The exhibitions included contemporary works by the *Klimt-Gruppe*, Kokoschka, Schiele, Faistauer, Gütersloh and Broncia Koller as well as Viennese portraiture of the first half of the nineteenth century, Romako and Makart. See Schweiger 1998 and Vienna (Jüdisches Museum) 2003.

48 Like Kokoschka, Schiele and Gütersloh exhibited with Edvard Munch, Paul Gauguin and Vincent van Gogh.

49 Vienna (Pisko) 1909.

50 Hutter 1987, pp. 40–5. See essays by J. Johnson and G. Blackshaw in this book.

51 The first essential information about the sitters was published by T.G. Natter in Vienna (Belvedere) 2000.

52 Von Miller 2004.

53 The extensive catalogue of the drawings produced by A. Strobl and M. Bisanz-Prakken offers information about a variety of working methods. Strobl 1980–9 (German edition). Bisanz-Prakken is preparing the second, supplementary volume with some further drawings.

54 Vienna (Belvedere) 2000, p. 59. Vienna (Albertina) and Los Angeles 2012 (German edition), pp. 134–43, 148–53.

55 Strobl 1980–9 (German edition), vol. 1 (1878–1903), no. 1017–1027 and vol. 4 (1878–1918), no. 3516–3519a.

56 See Zaunschirm 1987, pp. 11–12.

57 If Makart was hoping to recommend himself to the royal household as a portraitist with his gift of the *Portrait of Crown Princess Stephanie*,

then this plan proved to be a failure. He received no corresponding commission.

58 Vienna (Belvedere) 2000, pp. 62–4.

59 Many of the men and women who placed commissions with Klimt were of Jewish origin, but were converts and/or assimilated Christians. See Vienna (Belvedere) 2000, pp. 66–70. Whether or to what extent the Jewish origins of his models played any part in Klimt's aesthetic choices is a subject of controversy. On this point, see E. Shapira's essay in this book.

60 Frodl 1974, p. 44.

61 On Klimt's female portraits, see Novotny and Dobai 1967, pp. 35–52. On Klimt's use of ornament within these portraits see ibid. pp. 40–5.

KLIMT, SCHIELE AND SCHÖNBERG: SELF PORTRAITS

1 Gustav Klimt, undated typescript, Wien Bibliothek im Rathaus, Vienna. Quoted and translated in Vienna (Leopold) 2012, p. 177.

2 'Where earlier painters had presented themselves as witnesses in the Christian drama of religion, Klimt historicizes himself as communicant in the Viennese religion of drama'. Schorske 1981, p. 211.

3 It is interesting to consider the path of Klimt's fellow artist Franz Matsch in this context. Unlike Klimt, who went on to draw his clients from the Bürgertum, Matsch broke into the market of the Austrian aristocracy, painting the portraits of the Emperor Franz Joseph and members of the imperial family. In recognition of his service, he was ennobled by the Emperor in 1912, becoming Franz von Matsch.

4 Letter from Schönberg to Kandinsky, 24 January 1911. Lenbachhaus, Munich (Gabriele Münter- and Johannes Eichner-Stiftung). Translated in Meyer and Muxeneder 2005, pp. 70–1.

5 See R. Jensen, 'A Matter of Professionalism: Marketing Identity in Fin-de-Siècle Vienna' in Beller 2001, pp. 195–219.

6 See Jensen 1994.

7 The experience of the artist Max Oppenheimer is pertinent here. Oppenheimer was supported by a circle of modernists in Vienna, which included the architect Adolf Loos and the writer Karl Kraus. In 1911 these two men very publicly switched their allegiance to another emerging artist, Oskar Kokoschka, who had a similar painting style. This circle accused Oppenheimer of plagiarism, effectively ending his career in Vienna as one of the city's most successful new portrait painters. For more information

on this see G. Blackshaw, 'Mad Modernists: Imaging Mental Illness in Viennese Portraits' in London and Vienna 2009–10, pp. 47–65.

8 For a thought-provoking case study on the impact of Vienna's anti-Semitism on the taste and identity of a Jewish patron see Shapira 2006.

9 For a discussion of this entanglement in the case of the writer Peter Altenberg see G. Blackshaw, 'Peter Altenberg: Authoring Madness in Vienna circa 1900', in Blackshaw and Wieber 2012, pp. 109–29.

10 Arthur Roessler, 'Kollektivausstellung Egon Schiele', Arbeiter-Zeitung, 14 January 1915. Schiele's exhibition ran from 31 December 1914 to 31 January 1915. It included 16 paintings and approximately 60 watercolours and drawings.

11 Berman 1993, pp. 627–46.

12 For an overview of how these questions were posed across Europe see West 1994. For a discussion of the specifically Viennese response see Le Rider 1993 and Luft 2003.

13 Like many Jewish-born intellectuals at the turn of the century, Weininger had a problematic relationship with his religious heritage. Responding to Vienna's anti-Semitism, which equated Jewishness with moral and physical weakness, Weininger argued that Jewish men could not be considered in terms of 'absolute masculinity'.

14 For a discussion of this see Showalter 1990.

15 See for example Richard von Krafft-Ebing's catalogue of sexual perversions, Psychopathia-Sexualis: A Clinical-Forensic Study, which was first published in 1886 and ran to a subsequent 12 editions.

16 See for example Robert Jensen's discussion of the circulation of Schiele's erotic drawings of women in 'A Matter of Professionalism: Marketing Identity in Fin-de-Siècle Vienna', in Beller 2001, pp. 195–219, and J. Lloyd, 'Egon Schiele and his Women', in London 2011.

17 Schiele's patrons included Heinrich Benesch, Erwin von Graff, Koloman Moser, Oskar Reichel, Arthur Roessler and Alfred Spitzer.

18 For a discussion of this see Blackshaw 2007.

19 Letter from Schiele to Reichel, September 1911. Translated in Comini 1974, p. 94.

20 For a selection of Schiele's writings including reproductions of the original, hand-written pages see Leopold 2008. Interestingly, many of his poems were entitled 'Self Portrait'.

21 As Abigail Soloman-Godeau has argued in her feminist engagement with the male nude in post-revolutionary French painting: 'The appearance of weakness may be another ruse of power'. Soloman-Godeau 1997, p. 135.

22 Egon Wellesz, 'Schönberg and Beyond', The Music Quarterly, vol. 2, no. 1 (January 1916), pp. 76–95, 81–2.

23 Amerling, who, like Gustav Klimt, was the son of a Mittelstand (lower-middle-class) gold and silversmith, completed self portraits throughout his life. They chart the changing status of the artist as he rose up through the ranks of Viennese society; Amerling was ennobled by Franz I's successor, Franz Joseph, in 1878.

24 Rudolf von Alt was described as 'confessor of the moderns' in a review of an exhibition devoted to Biedermeier portraiture at the Galerie Miethke, Vienna in 1905. Hohe Warte 1905 pp. 295–8.

25 For an assessment of Van Gogh's influence on Viennese modernism see A. Krapf-Weiler, 'The Response of Early Viennese Expressionism to Vincent van Gogh', in Werkner 1994, pp. 31–50.

26 Berta Zuckerkandl, Wiener Allgemeine Zeitung, 6 January 1906.

27 Die Neue Freie Presse, 14 October 1910. The other two works listed as sold were Schönberg's portraits of his wife Mathilde (two of which were in the exhibition) and the doctor and writer Marie Pappenheim.

28 Letter from Webern to Schönberg, published in Stuckenschmidt, 1978, p. 143.

29 For more information on the exhibition see Meyer and Muxeneder 2005, pp. 100–4.

30 Albert Paris von Gütersloh, 'Schönberg the Painter', reproduced and translated in Meyer and Muxeneder 2005, pp. 57–60.

31 Ibid., p. 60.

32 Letter from Schönberg to Hertzka, 7 March 1910. Reproduced and translated in Meyer and Muxeneder 2005, p. 68.

33 As Carl E. Schorske first proposed: 'The new culture-makers in the city of Freud repeatedly defined themselves in terms of a kind of collective oedipal revolt.' Schorske 1981, xxvi.

34 T.G. Natter, 'On the Limits of the Exhibitable: The Naked Body and Public Space in Viennese Art around 1900', in Vienna (Leopold) and Frankfurt 2005, pp. 17–42.

WOMEN ARTISTS AND PORTRAITURE IN VIENNA 1900

1 See Doser, 1988, p. 71. In France, Diderot also distinguished between portraits that merely captured a likeness and those that were works of art. As Mary Sheriff explains: 'the brush becomes a metonymy for the great painter whose presence in the work far outlives that of the sitter and who is set against the dauber, who can only copy appearances.' Sheriff 1990, p. 174.

2 This misconception is discussed in Johnson 2012.

3 For a list of alternative art schools for women, see Schweiger 2008.

4 Koller and Schröder shared a two-person exhibition at the Galerie Miethke in 1911. For definitions of 'Biedermeier' and the friendship portrait, see T. Gronberg's essay in this book.

5 Silvia, now a decade older, recorded related events in her diary, reprinted in Vienna (Jüdisches Museum) 1993.

6 Cernuschi 1999.

7 Nordau 1895, pp. 413–4.

8 Weininger 1906, p. 65.

9 Ibid., p. 67.

10 Ibid., p. 68.

11 Mayreder 1905 (1913), p. 33.

12 Ibid., p. 34.

13 Conrat's Brahms memorial can be seen at Vienna's Central Cemetery.

14 R.R. 'Die Kunst der Frau,' *Illustriertes Wiener Extrablatt*, 5 November 1910, p. 11; see also the foreword to Vienna (Secession) 1910.

15 Manuscript memoir, 23 March 1939, Ilse Twardowski-Conrat Papers, Munich City Archives.

16 P. Zifferer, 'Im Atelier der Frau', *Die Neue Freie Presse,* morning edition, 13 November 1910, pp. 1–3.

17 Ibid.

18 J. Strzygowski, '"Die Kunst der Frau" Feuilleton', Twardowski-Conrat Papers.

19 E. Tietze-Conrat, 'Die Kunst der Frau: ein Nachwort zur Ausstellung in der Wiener Sezession', *Zeitschrift für bildende Kunst,* N.F. 20, no. 6 (1910), pp. 146–8.

20 Los Angeles 1976.

21 See Johnson 2003.

22 The *Neukunstgruppe* included 12 women artists in its 1909 exhibition at Pisko's.

23 Ries 1928, p. 26.

24 R. Roda, *Der Feldherrnhügel,* Berlin 1911. The play was published but not staged, banned for depicting the military unflatteringly.

25 Hevesi 1906, p. 321.

26 Chadzis 2000.

27 H. Uhl 'Fin-de-siècle Vienna and the Ambivalence of Modernism', in Vienna (Belvedere) 2000, pp. 14–17.

IMAGING THE JEW:
A CLASH OF CIVILISATIONS

1 See Bilski and Braun 2005, p. 35.

2 The coverage of the Dreyfus Affair in France in the Austrian media (1894–1906), the election of the anti-Semitic Lueger as Mayor of Vienna (1897), growing criticism of the active involvement of Jews in Austrian public life and a lack of respect for religious East European Jewish migrants, all contributed to a strong sense of crisis and a growing need to rethink Jewish integration into society.

3 Vienna (Jüdisches Museum) 1995, p. 350.

4 Paul Wilhelm (pseudonym Wilhelm Dworaczek), 'Kunstlerhaus', in *Wiener Rundschau,* vol. 1, 1 April 1897, p. 394.

5 Tobias Natter noted the importance of beautiful garments in Kaufmann's portraits: 'For to this day, there has been no Jewish genre painter more naturalistic and at the same time more idealistic than Isidor Kaufmann, who divested his meticulously observed models of all everyday worries and robed them in beautifully rendered garments'. Vienna (Jüdisches Museum) 1995, p. 33.

6 R. Lothar, 'Von der Secession,' in *Die Wage,* 3 December 1898, p. 813. Translated into English in Felderer 1997, p. 74. Lothar and his journal *Die Wage* served as a model for Karl Kraus to further fashion a critical Viennese 'culture of debate' in his journal *Die Fackel.* Kraus's contribution to the debate about abortion, feminism and gender roles influenced the art of Kokoschka.

7 Beller 1993, p. 177. I disagree with Beller's question formulation since even if Gentile artists reacted to the problematic of members of the Jewish bourgeois, the production of Viennese modernism was based on close co-operation and creative dialogues.

8 In 1900, Kraus quoted the 'Parisians' mocking the success of Klimt and the Secession at the Paris Exposition Universelle by dismissing it as 'Jewish Taste' (*Die Fackel,* no. 41, mid-May 1900, p. 22). Less than a year later Kraus repeated this argument when he wanted to question the identification of the Secession style as an 'Austrian' style (*Die Fackel,* no. 73, early April 1901, p. 9.)

9 Berta Zuckerkandl, 'Kunst und Kultur, Das Kabarett 'Fledermaus',' in *Wiener Allgemeine Zeitung* November 1907, p. 3.

10 Kelley 2012 p. 113.

11 There are a few striking early portraits by Klimt documenting his fascination with the exotic physiognomy of the 'Jewess,' and at least two were published in the Secessionist journal *Ver Sacrum.* See Klimt, 'Portraitskizze' in *Ver Sacrum,* 1898, no. 3, on p. 7 Klimt, *Portrait of a Lady* (1897), a pastel now in Allen Memorial Art Museum, Oberlin College, Ohio; and on p. 17, Klimt, *Portrait of a Lady* (1897) which could show the same sitter as *Judith I* (1901).

12 The hand gesture is similar to that of the couple in Klimt's *Fulfilment* (part of the dining room frieze in Stoclet Palais in Brussels), from the same time.

13 Kokoschka 1974, p. 35.

14 Cernuschi 2002, p. 140.

15 Herzl's play concerns the failed integration attempts of a young Jewish lawyer in Viennese society. Hermann Bahr, 'Das neue Ghetto (Schauspiel in vier Acten von Theodor Herzl),' in *Die Zeit,* 8 January, 1898, p. 28. The term 'assimilation' was used by contemporaries to refer to the process of Jewish acculturation at the beginning of the twentieth century, yet it also means Jewish integration through conversion to Christianity.

16 Kokoschka painted Altenberg in a coffee house, and the intense physical experience depicted in his portrait was the result of Altenberg's anger after being asked to produce a text on the spot by a guest who was supposed to buy him a drink. Perhaps Altenberg was already drunk, or perhaps the request took him by surprise and he was further enraged because of his dependency on the goodwill of others. See Kokoschka 1974, p. 40 ff. and L.A. Lensing 'Scribbling Squids and the Giant Octopus: Oskar Kokoschka's Unpublished Portrait of Peter Altenberg' in Berlin, Johns and Lawson 1993, p. 196ff.

17 K. Hiller, 'Oskar Kokoschka,' in *Der Sturm,* vol. 1, no. 19, July 7, 1910, p. 150. J. Reich, Die Jungen Künstler Plastik und Malerei,' in *Reichpost,* 7 February, 1911, morning edition. See Lensing in Berlin, Johns and Lawson 1993, p. 207.

18 Hoffmann 1947, p. 92: 'And if he was somewhat pretentious in acting the poet, who sees and experiences things differently from other people, it was perhaps his defence against a public which ridiculed him. For he was an unusual, somewhat ridiculous figure: bald, with an enormous moustache, always untidily dressed, and too poor to appear dignified.'

19 P. Altenberg, 'Brief aus Wien' (Letter from Vienna) published in *Das Theater,* vol. 1, no. 1, 1 September 1909, p. 20.

20 Ibid.

21 See Spielmann 1975, p. 85.

22 Kokoschka's sitter Lotte *née* Rapp married Emil Franzos, who came from a prominent Jewish Viennese family.

23 Helga Malmberg, who worked in the Galerie Miethke in Vienna and later in the Wiener Werkstätte shop, befriended Lotte and her husband. Malmberg refers in her memoirs to the 'dark colour' of Emil Franzos, and to his admiration of his well-dressed, intelligent and modest wife Lotte (Malmberg, 1961 p. 41.) Moreover, Lotte appears to have attracted a group of admirers through her daring modern looks (Ibid, p. 137.)

24 Hoffmann's quotation appears in Gombrich 1991, p. 154. Gombrich asked his mother, who knew Lotte, to describe her. She replied that she was *precious* and that 'she could not let herself go but she considered herself free'.

25 K. Schreder, 'Kunstuntergang im Hagenbund' in *Deutsches Volksblatt,* 9 February, 1911.

26 Besant and Leadbeater 1908. Kokoschka used theosophy in a free manner to disclose how his subjects' inner thoughts influenced their physical experience.

27 Goldscheider 1963, p. 14.

28 In his answer to Oskar Reichel about his son Hans's future occupation, Kokoschka answered: 'A cardinal' and added: 'In a family of assimilated Jews this would have been something of an event'. Kokoschka 1974, p. 44.

29 This question is raised in Soussloff 2002, p. 113.

30 Ibid, p. 145. I would further argue that this 'Jewish identity' was also projected in the 'shared identity' of sitter and artist. Soussloff's conclusion relies on the possibility of regarding Kokoschka's portraits of Jews painted in his early period, based on their hand gestures and gazes, as an imaginary 'group portrait' (Ibid, p. 142.) I pick up on Soussloff's idea of Kokoschka creating an imaginary 'group portrait,' but offer an alternative interpretation of this specific double portrait as a 'group portrait' of the sitters and the artist.

31 Kokoschka 1974, p. 35.

32 Two articles published in Kraus's Die Fackel were direct provocation against Catholic sexual morality. The first, by Fritz Wittels (signed with a pseudonym), argued in favour of the legalisation of abortion (22 February 1907, pp. 1–22). The second, by Stanislaw Przybyszewski, encouraged the worship of the sexual act (31 December, 1907, pp. 1–11).

33 Kokoschka described it to the curator of MoMA as a 'symbol of the married life of the two sitters and as such commissioned', Soussloff 2002, p. 129.

34 Hodin 1963, p. 70.

35 Krapf-Weiler 1999, p. 70. The author's description of the assimilation narratives of Hans and Erica is also enlightening. Ibid, pp. 71–4.

36 Ibid, p. 70.

37 Schvey 1986, p. 111. Henry Schvey explains Tietze's frozen hand gestures as 'shortly before touch'.

38 Leshko 1977, p. 113. Rembrandt's portrait was known in Vienna since it was on display in a local private collection and it also inspired one of the images in a series of 'tableaux vivants' in the Ephrussi salon on the Ring-strasse. See D. Lehmann's essay in this book.

39 Leshko 1977, p. 113.

40 Ibid.

41 Schorske 1981 p. 341. See also Soussloff 2002 p. 129.

42 Krapf-Weiler 1999, p. 70.

43 I refer to the Jewish Polish author Artur Sandauer's description of the 'trap of assimilation' quoted in Bauman 1991, p. 115.

44 Freud 1919.

45 See Hugo von Hofmannsthal's witness described in Rieckmann 1993, p. 466.

46 Vienna (Kunstforum) 1993, p. 181.

47 For an enlightening analysis of Gerstl's Jewish identification and his self-portraiture as Christ, see Blackshaw 2006, pp. 25–52. Adolf von Zemlinsky, the father of Alexander and Mathilde, converted to Judaism in order to marry Clara Semo, who came from a rich Sephardic family. Alexander renounced his Jewish religion in 1899, and his sister Mathilde renounced her religion in 1901.

48 The second commandment in Exodus 20: 4 is: 'You shall not make for yourself a carved image, or any likeness of anything that is in heaven above, or that is in the earth beneath, or that is in the water under the earth.' Yet I refer to the popular story in the Jewish tradition of Abraham smashing the idols in his father's shop in Ur as reported in the biblical commentary Midrash Bereishit 38:13.

49 Kokoschka also challenged the bourgeois myth of happy children in his portrayal of the children of Richard Stein in Children playing (see p. 143). See Shapira 2001.

A BEAUTIFUL CORPSE:
VIENNA'S FASCINATION WITH DEATH

Unless otherwise noted, all translations are by the author.

The Carnegie Trust for the Universities of Scotland and the University of Glasgow have generously supported research for this essay.

1 Two years into the First World War, Austria-Hungary's army and navy were experiencing heavy losses at the fronts while food and fuel had to be rationed at home. See Herwig 1996.

2 Kassal-Mikula 1981.

3 John Souch's Sir Thomas Aston at the Deathbed of his Wife (1635, Manchester City Art Gallery) is often cited as one of the earliest examples of this 'genre'.

4 The fashion across Europe for these 'last portraits' was explored in great depth in a 2002 exhibition at the Musée d'Orsay, Paris. See Paris 2002.

5 Pointon 1993.

6 See S. Wieber, 'Vienna's most Fashionable Neurasthenic: Empress Sisi and the Cult of Size Zero,' in Blackshaw and Wieber 2012.

7 See for example Clair 1986.

8 I purposely use the term fin-de-siècle here to underscore the perceived anxieties of a time and a way of being coming to the end rather than embracing the new implied by the term turn-of-the-last century (Jahrhundertwende).

9 The literature on these topics is vast, but see for example Wheatcroft 1996; Blackshaw 2006; Masaryk 1881; Luft 2003 and Beller 2010.

10 A. Strobl cited in Vienna (Belvedere) 2000, p. 140.

11 The painting made headlines in 2010 when it was restituted to the family by the Lento Museum in Linz. R-M. Gropp, 'Das Unglück der Ria Munk,' Frankfurter Allgemeine Zeitung, 28 May 2010.

12 Viewers might draw a link to Claude Monet's famous representation of his wife Camille on her deathbed in 1879 (Camille Monet on her Deathbed, Musée d'Orsay, Paris) but Schiele would not have been aware of this painting as Monet kept it hidden in his private bedroom at Giverny until his death in 1926. See Lewis 2012.

13 S. Mattl-Wurm has written extensively about the Wien Museum's collection of death masks. See for example Vienna (Historisches Museum) 1992.

14 Gall's large collection of death masks is now partially housed at the Musée de l'Homme in Paris, where he moved after his research came under the scrutiny of the Viennese authorities in 1807.

15 Craveri 2005 and Bilski and Braun 2005.

16 The museum acquired the mask through the estate of Franz Liszt. See S. Mattl-Wurm in Essen 2002.

17 Marbach and Kassel 1999.

18 Beethoven's cause of death remains shrouded in mystery but lead poisoning has been suggested as a likely cause.

19 Bronfen 2004

20 Heine quoted in Stefenelli 1998.

21 Buklijas 2010.

22 Ballestriero 2010.

23 See Messbarger 2012, pp. 1–21.

24 For an extensive discussion of waxworks see Panzanelli 2008.

25 Buklijas 2010, p. 75.

26 Präuscher 1875.

27 A. Yarrington, 'Under the Spell of Madame Tussaud: Aspects of 'High' and 'Low' in Blühm, 1996, pp. 83–93.

28 This approach is indebted to visual culture studies as practised by scholars such as WJT Mitchell (Mitchell 2002), although visual culture privileges the eye over other senses, which is problematic when dealing with material objects such as death masks.

Bibliography

BALLESTRIERO 2010
R. Ballestriero, 'Anatomical Models and Wax Venuses: Art Masterpieces or Scientific Craft Works?' in *Journal of Anatomy*, vol. 216 no. 2 (2010), pp. 223–34.

BAUDELAIRE 1863 (1995)
C. Baudelaire, *The Painter of Modern Life and other Essays*, trans. J. Mayne, London 1995.

BAUMAN 1991
Z. Bauman, *Modernity and Ambivalence*, Cambridge 1991.

BELLER 1989
S. Beller, *Vienna and the Jews 1867–1938: A Cultural History*, Cambridge 1989.

BELLER 1993
S. Beller, 'Who Made Vienna 1900 A Capital of Modern Culture?' in *Kreatives Milieu um 1900*, eds E. Brix and A. Janik, Munich 1993.

BELLER 2001
Rethinking Vienna 1900, ed. S. Beller, New York and Oxford 2001.

BELLER 2010
S. Beller, 'Freud's Jewish World: A Historical Perspective,' in *The Jewish World of Sigmund Freud: Essays on the Cultural Roots and the Problem of Religious Identity*, ed. A.D. Richards, Jefferson 2010, pp. 175–86.

BENJAMIN 1938 (1973)
W. Benjamin, *Charles Baudelaire: A Lyric Poet in the Era of High Capitalism* (1938), trans. H. Zohn, London 1973

BERMAN 1993
P.G. Berman, 'Edvard Munch's *Self-Portrait with Cigarette*: Smoking and the Bohemian Persona', *The Art Bulletin*, vol. 75, no. 4 (December 1993), pp. 627–46.

BERLIN, JOHNS AND LAWSON 1993
J.B. Berlin, J.B. Johns, and R.H. Lawson, *Turn-of-the-Century Vienna and its Legacy, Essays in Honor of Donald G. Daviau*, Vienna 1993.

BESANT AND LEADBEATER 1908
A. Besant and C.W. Leadbeater, *Gedankenformen*, Leipzig 1908.

BILSKI AND BRAUN 2005
Jewish Women and their Salons: The Power of Conversation, eds. E. Bilski and E. Braun, New York 2005.

BIRKE 1983
V. Birke, *Josef Danhauser (1805–1845), Gemälde und Zeichnungen*, Vienna 1983.

BISANZ-PRAKKEN 2009
M. Bisanz-Prakken, 'Ria Munk III von Gustav Klimt. Ein posthumes Bildnis neu betrachtet', in *Parnass*, vol. 3 (2009), pp. 54–9.

BLACKSHAW 2006
G. Blackshaw, 'The Jewish Christ: Problems of Self-Presentation and Socio-Cultural Assimilation in Richard Gerstl's Self-Portraiture', in *Oxford Art Journal*, vol. 29, no. 1, (2006), pp. 25–51.

BLACKSHAW 2007
G. Blackshaw, 'The Pathological Body: Modernist Strategising in Egon Schiele's Self-Portraiture', *Oxford Art Journal*, vol. 30, no. 3 (2007), pp. 377–401.

BLACKSHAW AND WIEBER 2012
Journeys into Madness: Mapping Mental Illness in the Austro-Hungarian Empire, eds G. Blackshaw and S. Wieber, New York 2012.

BLÜHM 1996
The Colour of Sculpture, 1840–1910, ed. A. Blühm, Amsterdam 1996.

BODDY 2012
K. Boddy, *Geranium*, London 2012.

BONYHADY 2011
T. Bonyhady, *Good Living Street: Portrait of a Patron Family, Vienna 1900*, New York 2011.

BOURDIEU 1987
P. Bourdieu, *Distinction: A Social Critique of the Judgment of Taste*, Cambridge, MA 1987.

BOYER 1981
J.W. Boyer, *Political Radicalism in Late Imperial Vienna: The Origins of the Christian Social Movement 1848–1918*, Chicago 1981.

BREICHA 1978
O. Breicha, *Gustav Klimt. Die Goldene Pforte. Werk, Wesen, Wirkung. Bilder und Schriften zu Leben und Werk*, Salzburg 1978.

BREICHA 1993
O. Breicha, *Richard Gerstl*, Salzburg 1993.

BRONFEN 2004
E. Bronfen, *Nur über ihre Leiche: Tod, Weiblichkeit und Ästhetik*, Würzburg 2004.

BUDAPEST 1958
Benczúr, Gyula, Exposition Mémoriale, exh. cat., Hungarian National Museum, Budapest 1958.

BUKLIJAS 2010
T. Buklijas, 'Public Anatomies in *Fin-de-Siècle* Vienna,' *Medicine Studies*, vol. 2, no. 1 (2010), pp. 73, 75.

CERNUSCHI 1999
C. Cernuschi, 'Pseudo-Science and Mythic Misogyny: Oskar Kokoschka's *Murderer, Hope of Women*', *Art Bulletin*, vol. 81, no. 1 (1999), pp. 126–48.

CERNUSCHI 2002
C. Cernuschi, *Re/Casting Kokoschka, Ethics and Aesthetics, Epistemology and Politics in Fin-de-Siècle Vienna*, Cranbury, NJ 2002.

CHADZIS 2000
A. Chadzis, *Die Malerin und Bildhauerin Elena Luksch-Makowsky (1878–1967) Biografie und Werkbeschreibung*, Ph.D. thesis, University of Hamburg 2000.

CHAMPIER 1879
V. Champier, *L'année artistique 1878. Les beaux arts en France et à l'Étranger*, Paris 1879.

CLAIR 1986
J. Clair, *Vienne 1880–1938: L'Apocalypse Joyeuse*, Paris 1986.

CLEGG 2006
E. Clegg, *Art, Design and Architecture in Central Europe 1890–1920*, New Haven and London 2006.

COFFER 2011
R. Coffer, *Richard Gerstl and Arnold Schönberg*, Ph.D. thesis, University of London 2011, http://www.richardgerstl.com, accessed 22 May 2013.

COHEN 1998
R. Cohen, *Jewish Icons: Art and Society in Modern Europe*, Berkeley CA, 1998.

COMINI 1974
A. Comini, *Egon Schiele's Portraits*, Los Angeles and London 1974.

CRAVERI 2005
B. Craveri, *The Age of Conversation*, New York 2005.

DICHAND 1985
Carl Moll: Seine Freunde – Sein Leben – Sein Werk, ed. H. Dichand, Salzburg 1985.

DOSER 1988
B. Doser, *Die Frauenkunststudium in Österreich 1870–1935*, Ph.D. thesis, University of Innsbruck 1988.

DREWES 1994
F.J. Drewes, *Hans Canon (1829–1885): Werkverzeichnis und Monographie*, 2 vols, Hildesheim 1994.

EDLER 1897
K.E. Edler, 'Prinz zu Hohenlohe-Schillingsfürst, Constantin' in *Biographisches Jahrbuch und Deutscher Nekrolog*, ed. A. Bettelheim, vol. 1, Berlin 1897, pp. 176–91.

ERICKSON 1997
Schubert's Vienna, ed. R. Erickson, New Haven and London, 1997.

ESSEN 2002
J. Gerchow, *Ebenbilder: Kopien von Körpern – Modelle des Menschen*, exh. cat., Ruhrlandmuseum Essen, Ostfildern 2002, pp. 139–46.

FELDERER 1997
B. Felderer, *Secession: The Vienna Secession From Temple of Art to Exhibition Hall*, Ostfildern 1997.

FOSTER, KRAUSS, BOIS AND BUCHLOH 2004
'The Viennese Avant-garde and Psychoanalysis', in *Art Since 1900*, eds H. Foster, R. Krauss, D. Bois and H.D. Buchloh, London 2004 (revised edn 2011).

FRANKL 1889
L.A. Frankl, *Friedrich von Amerling: Ein Lebensbild*, Vienna 1889.

FREUD 1919 (2000)
S. Freud, 'Das Unheimliche' (1919) in *Sigmund Freud Studienausgabe, Bd. IV Psychologische Schriften*, Frankfurt am Main 2000.

FRITZ 1962
M. Fritz, *Der Wiener Maler Carl Moll (1861–1945)*, Ph.D. thesis, University of Innsbruck 1962.

FRODL 1974
G. Frodl, *Hans Makart. Monographie und Werkverzeichnis*, Salzburg 1974.

FUHRMANN 1972
F. Fuhrmann, *Anton Faistauer*, Salzburg 1972.

GAUTIER AND DESPREZ 1878
H. Gautier and A. Desprez, *Les Curiosités de l'exposition de 1878. Guide du visiteur*, Paris 1878.

GAY 1998
P. Gay, *Freud: A Life for Our Time*, New York and London 1998.

GOLDSCHEIDER 1963
L. Goldscheider, *Kokoschka*, London 1963.

GOMBRICH 1991
E. Gombrich, *Topics of Our Time: Twentieth-century Issues in Learning and in Art*, Berkeley, CA 1991.

GRONBERG 2007
T. Gronberg, *Vienna, City of Modernity 1890–1914*, Oxford 2007.

HERWIG 1996
H. Herwig, *The First World War: Germany and Austria-Hungary 1914–1918*, London 1996.

HEUSINGER VON WALDEGG AND LEPPIEN 1979
J. Heusinger von Waldegg and H. Leppien, *Richard Luksch/Elena Luksch-Makowsky*, Hamburg 1979.

HEVESI 1906
L. Hevesi, *Acht Jahre Secession*, Vienna 1906.

HEVESI 1911
L. Hevesi, *Rudolf von Alt, Sein Leben und Sein Werk*, Vienna 1911.

HODIN 1963
J.P. Hodin, *Bekenntnis zu Kokoschka*, Berlin 1963.

HOFFMANN 1947
E. Hoffmann, *Kokoschka: Life and Work*, London 1947.

HOHE WARTE 1904–5
'Das Altwiener Porträt' in *Hohe Warte: Halbmonatschrift zur Pflege der Künstlerischen Bildung der Städtischen Kultur*, vol. 1, 1904–5, pp. 295–8.

HUTTER 1987
A.P. Gütersloh zum 100. Geburtstag (*Monographien zur Kunst Österreichs im 20. Jahrhundert*, vol. 4), ed. H. Hutter, Vienna, 1987.

JENSEN 1994
R. Jensen, *Marketing Modernism in Fin-de-Siècle Europe*, Princeton, NJ 1994.

JOHNSON 2003
J.M. Johnson, 'Athena Goes to the Prater: Parodying Ancients and Moderns at the Vienna Secession' in *Oxford Art Journal*, vol. 26 no. 2 (2003), pp. 47–70.

JOHNSON 2012
J.M. Johnson, *The Memory Factory: The Forgotten Women Artists of Vienna 1900*, West Lafayette 2012.

KALLIR 1974
O. Kallir, *Richard Gerstl (1883–1908): Beiträge zur Dokumentation seines Lebens und Werkes*, Vienna 1974.

KALLIR 1984
J. Kallir, *Arnold Schönberg's Vienna*, New York 1984.

KALLIR 1998
J. Kallir, *Egon Schiele: The Complete Works*, New York 1998.

KASSAL-MIKULA 1981
R. Kassal-Mikula, *Franz von Matsch: Ein Wiener Maler der Jahrhundertwende*, Vienna 1981.

KASTEL 1983
I. Kastel, *Franz Eybl 1806–1880*, Ph.D. thesis, University of Vienna 1983.

KELLEY 2012
S. Kelley, 'Perceptions of Jewish Female Bodies through Gustav Klimt and Peter Altenberg,' in *Imaginations, Journal of Cross-Cultural Image Studies*, issue 3-1, (2012).

KIEL 2009
D. Luckow, P. Thurmann and T. Wolf-Timm, *Privatissimo. Kunst aus schleswig-holsteinischem Adelsbesitz*, exh. cat., Kunsthalle Kiel, Cologne 2009.

KOKOSCHKA 1974
O. Kokoschka, *My Life*, London 1974.

KOKOSCHKA AND MARNAU 1992
Oskar Kokoschka Letters, 1905–1976, eds O. Kokoschka and A. Marnau, trans. M. Whittall, London 1992.

KOSCHATZKY 1975
W. Koschatzky, *Rudolf von Alt*, Salzburg 1975.

KRAPF-WEILER 1999
Krapf-Weiler, '"Löwe und Eule" Hans Tietze und Erica Tietze-Conrat – eine biographische Skizze', in *Belvedere*, vol. 5, no. 1, (1999) pp. 64–83.

LACHIT 1998
E. Lachit, *Ringen mit dem Engel: Anton Kolig, Franz Wiegele, Sebastian Isepp, Gerhardt Frankl*, Vienna 1998.

LEGGIO 2002
Music and Modern Art, ed. J. Leggio, New York 2002.

LEOPOLD 2008
E. Leopold, *Egon Schiele: Poems and Letters 1910–12 from the Leopold Collection*, Munich and Vienna 2008.

LE RIDER 1993
J. Le Rider, *Modernity and Crises of Identity: Culture and Society in Fin-de-Siècle Vienna*, Cambridge 1993.

LESHKO 1977
J. Leshko, *Oskar Kokoschka: Paintings, 1907–1915*, Ph.D. thesis, Columbia University 1977.

LEWIS 2012
A. Lewis, 'Death and Convention' in *Apollo* (March 2012), pp. 130–6.

LONDON AND VIENNA 2009
G. Blackshaw and L. Topp, *Madness and Modernity: Mental Illness and the Visual Arts in Vienna 1900*, exh. cat., Wellcome Collection, London and Wien Museum, Vienna, London 2009.

LONDON 2011
Egon Schiele: Women, exh. cat., Richard Nagy, London 2011.

LONG 2011
C. Long, *The Looshaus*, New Haven and London 2011.

LOS ANGELES 1976
L. Nochlin and A. Sutherland Harris, *Women Artists, 1550–1950*, exh. cat., Los Angeles County Museum of Art, New York 1976.

LUFT 2003
D.S. Luft, *Eros and Inwardness in Vienna: Weininger, Musil, Doderer*, Chicago 2003.

MAHLER-WERFEL 1998
Alma Mahler-Werfel. Diaries 1898–1902, trans. A. Beaumont, London 1998.

MALMBERG 1961
H. Malmberg, *Widerhall des Herzens, Ein Peter Altenberg-Buch*, Munich 1961.

MARBACH AND KASSEL 1999
Archiv der Gesichter: Toten- und Lebendmasken aus dem Schiller-Nationalmuseum Marbach, ed. M. Davidis, exh. cat., Museum Schloss Moyland, Alexanderkirche Marbach am Neckar and Museum fur Sepulkralkultur, Kassel, Marbach 1999, p. 45.

MAYREDER 1905 (1913)
R. Mayreder, *A Survey of the Woman Problem*, Vienna 1905, trans. H. Scheffauer, New York 1913.

MASARYK 1881 (1970)
T.G. Masaryk, *Suicide and the Meaning of Civilization*, trans. W.B. Weist and R.G. Batson, Chicago 1970.

MESSBARGER 2012
R. Messbarger, 'The Re-Birth of Venus in Florence's Royal Museum of Physics and Natural History' in *Journal of the History of Collections* vol. 24, no. 3 (2012), pp. 1–21.

MESSING 2008
S. Messing, *Schubert in the European Imagination, Volume I: The Romantic and Victorian Eras*, Rochester, NY 2008.

MEYER AND MUXENEDER 2005
C. Meyer and T. Muxeneder, *Arnold Schönberg: Catalogue Raisonné*, Vienna 2005.

MICHAEL 1911
W. Michael, *Max Oppenheimer*, Munich 1911.

MILWAUKEE, VIENNA, BERLIN AND PARIS 2006–8
H. Ottomeyer, K.A. Schröder and L. Winters, *Biedermeier: The Invention of Simplicity*, exh. cat., Milwaukee Art Museum, Vienna Albertina, Deutsches Historisches Museum, Berlin and Louvre, Paris, Ostfildern 2006.

MITCHELL 2002
W.J.T. Mitchell, 'Showing Seeing: A Critique of Visual Culture' in *Journal of Visual Culture* vol. 1, no. 2 (2002), pp. 165–81.

MUNICH 2012
S. Grabner, 'Kaiser Franz I of Austria, Study for the Official Portrait of 1832' in *Oil Sketches and Paintings 1760–1910*, exh. cat., Daxer & Marschall, Munich 2012.

NATTER 2003
T.G. Natter, *Die Welt von Klimt, Schiele und Kokoschka. Sammler und Mäzene*, Cologne 2003.

NATTER 2012
T.G. Natter, *Gustav Klimt, The Complete Paintings*, Cologne 2012 (German edn: *Gustav Klimt, Sämtliche Gemälde*, Cologne 2012.)

NEBEHAY 1969
C.M. Nebehay, *Gustav Klimt: Eine Dokumentation*, Vienna 1969.

NEBEHAY 1975
C.M. Nebehay, *Ver Sacrum*, Vienna, 1975.

NEW YORK 2002
Oskar Kokoschka: Early Portraits from Vienna and Berlin, 1909–1914, ed. T.G. Natter, exh. cat., Neue Galerie, New York 2002.

NEW YORK 2011
S. Rewald, *Rooms with a View: The Open Window in the 19th Century*, exh. cat., Metropolitan Museum of Art, New York 2011.

NORDAU 1895
M. Nordau, *Degeneration*, New York 1895.

NORMAN 1987
G. Norman, *Biedermeier Painting*, London 1987.

NOVOTNY 1954
F. Novotny, *Der Maler Anton Romako, 1832–1889*, Vienna 1954.

NOVOTNY AND DOBAI 1967
F. Novotny and J. Dobai, *Gustav Klimt*, Vienna 1967.

NYÍREGYHÁZ 1963
T. Katalin, *Benczúr*, exh. cat., Josa Andras Museum, Nyíregyház 1963.

ÖBL 1957
'Delug, Alois', in *Österreichisches Biographisches Lexikon 1815–1950 (ÖBL)*, vol. 1, Vienna, 1957, p. 176.

OLSEN 1986
D.J. Olsen, *The City as a Work of Art*, New Haven and London 1986.

PANZANELLI 2008
Ephemeral Bodies: Wax Sculpture and the Human Figure, ed. R. Panzanelli, Los Angeles 2008.

PARIS 2002
E. Héran, *Le Dernier Portrait*, exh. cat., Musée d'Orsay, Paris 2002.

POGANY 1958
G.O. Pogany, *Nineteenth-Century Hungarian Painting*, Budapest 1958.

POINTON 1993
M. Pointon, *Hanging the Head: Portraiture and Social Formation in Eighteenth-Century England*, London and New Haven 1993.

PRÄUSCHER 1875
H. Präuscher, *Neuer Führer durch das anatomische, pathologische und ethnologische Museum von H. Präuscher*, Dresden 1875.

PROBST 1927
G. Probst, *Friedrich von Amerling: Der Altermeister der Wiener Porträtmalerei*, Zurich, Leipzig and Vienna 1927.

RIECKMANN 1993
J. Rieckmann, 'Zwischen Bewußtsein und Verdrängung: Hofmannsthals jüdische Erbe', in *Deutsche Vierteljahresschrift*, vol. 67, 1993.

RIES 1928
T. Ries, *Die Sprache des Steines*, Vienna 1928.

ROBERTSON AND TIMMS 1991
The Austrian Enlightenment and its Aftermath, eds R. Robertson and E. Timms, Austrian Studies, vol. 2, Edinburgh 1991.

ROESSLER AND PISKO 1908
A. Roessler and G. Pisko, *Ferdinand Georg Waldmüller*, Vienna 1908.

ROESSLER 1911
A. Roessler, *Josef Danhauser*, Vienna 1911.

ROESSLER 1918
A. Roessler, *Kritische Fragmente. Aufsätze über österreichische Neukünstler*, Vienna 1918.

ROESSLER 1921
A. Roessler, *Rudolf von Alt*, Vienna 1921.

ROESSLER 1947
A. Roessler, *Der Maler Anton Faistauer. Beiträge zur Lebens- und Schaffensgeschichte eines österreichischen Künstlers*, Vienna 1947.

RYCHLIK 2001
O. Rychlik, *Anton Kolig: Das malerische Werk, 1886–1950*, Vienna 2001.

SALZBURG 1993
S. Grabner, *Ferdinand Georg Waldmüller (1793–1865)*, exh. cat., Salzburger Museum Carolino Augusteum, Salzburg 1993.

SALZBURG 2005
Anton Faistauer 1887–1930, exh. cat., Salzburger Museum Carolino-Augusteum, Salzburg 2005.

SALZBURG 2007
E. Marx and P. Laub, *Hans Makart. 1840–1884*, exh. cat., Salzburg Museum 2007.

SCHÖNBERG 1978
'Schönberg as Artist' in *Journal of the Arnold Schönberg Institute*, vol. 2, no. 3, 1978.

SCHORSKE 1981
C.E. Schorske, *Fin-de-Siècle Vienna: Politics and Culture*, New York 1981.

SCHVEY 1986
H.I. Schvey, 'Mit dem Auge des Dramatikers: Das visuelle Drama bei Oskar Kokoschka,' in *Oskar Kokoschka Symposium*, ed. E. Patka, Salzburg and Vienna 1986.

SCHWEIGER 1983
W.J. Schweiger, *Der Junge Kokoschka: Leben und Werk 1904–1914*, Vienna 1983.

SCHWEIGER 1998
W.J. Schweiger, 'Kunsthandel in Wien 1897 bis 1938', in *Belvedere*, vol. 4, no. 2, (1998), pp. 64–85.

SCHWEIGER 2008
W.J. Schweiger, Malschulen von und für Frauen in Österreich, '2008, online database, Austrian National Library, http://www.onb.ac.at/ariadne/vfb/bt_fk_malschulen.htm (accessed 8 January 2012).

SHAPIRA 2001
'An Early Expressionist Masterpiece: Oskar Kokoschka's *Children Playing* of 1909' in *Zeitschrift für Kunstgeschichte* vol. 64, no. 4 (2001), pp. 501–36.

SHAPIRA 2006
E. Shapira, 'Modernism and Jewish Identity in Early Twentieth-Century Vienna: Fritz Waerndorfer and His House for an Art Lover' in *Studies in the Decorative Arts*, Spring–Summer 2006, pp. 52–92.

SHERIFF 1990
M. Sheriff, *Fragonard, Art and Eroticism*, Chicago 1990.

SHOWALTER 1990
E. Showalter, *Sexual Anarchy: Gender and Culture at the Fin de Siècle*, New York 1990.

SILVERMAN 1989
D. Silverman, *Art Nouveau in Fin-de-Siècle France: Politics, Psychology and Style*, Los Angeles 1989.

SOLOMON-GODEAU 1997
A. Soloman-Godeau, *Male Trouble: A Crisis in Representation*, London 1997.

SOUSSLOFF 2002
C.M. Soussloff, 'Portraiture and Assimilation in Vienna, The Case of Hans Tietze and Erica Tietze-Conrat' in *Diasporas and Exiles: Varieties of Jewish Identity*, ed. H. Wettstein, Berkeley, CA 2002.

SPEYER 2002
Anselm Feuerbach, ed. M. Hofmann, exh. cat., Historischen Museum der Pfalz, Speyer 2002.

SPIELMANN 1975
Oskar Kokoschka, Das schriftliche Werk, ed. H. Spielmann, Hamburg, 1975.

STEFENELLI 1998
Körper ohne Leben: Begegnung und Umgang mit Toten, ed. N. Stefenelli, Vienna, 1998, p. 822.

STORCH 1989
U. Storch, *Zwischen den Worten liegen alle andern Künste*, Ph.D. thesis, University of Vienna 1989.

STROBL 1980–9
A. Strobl, *Gustav Klimt Drawings*, Vienna 1980–9. (German edition: *Gustav Klimt. Die Zeichnungen*, Salzburg 1980–9)

STUCKENSCHMIDT 1978
H. Stuckenschmidt, *Schoenberg: His Life, World and Work*, New York 1978.

TIMMS 1986
E. Timms, 'The Theatre as a Social Paradigm' in *Karl Kraus, Apocalyptic Satirist: Culture and Catastrophe in Habsburg Vienna*, New Haven and London 1986.

VERGO 1981
P. Vergo, 'Fritz Waerndorfer as Collector' in *Alte und moderne Kunst*, Vienna 1981, pp. 33–8.

VERGO 2001
P. Vergo, *Art in Vienna 1898–1918: Klimt, Kokoschka, Schiele and their Contemporaries*, London 2001.

VIENNA (Miethke) 1904
Waldmüller, exh. cat., Galerie Miethke, Vienna 1904.

VIENNA (Miethke) 1905
Das Wiener Portrait, exh. cat., Galerie Miethke, Vienna 1905.

VIENNA (Pisko) 1909
Katalog der 1. Neukunst-Ausstellung, Kunstsalon Pisko, Vienna 1909.

VIENNA (Secession) 1910
Die Kunst der Frau, exh. cat., Secession, Vienna, 1910

VIENNA (Historisches Museum) 1981
Franz von Matsch. Ein Wiener Maler der Jahrhundertwende, exh. cat., Historisches Museum der Stadt Wien, Vienna 1981.

VIENNA (Historisches Museum) 1992
Bilder vom Tod, ed. S. Mattl-Wurm, exh. cat., Historisches Museum der Stadt Wien, Vienna 1992.

VIENNA (Belvedere) 1992
G. Frodl, *Der Aussenseiter, Anton Romako 1832–1889*, exh. cat., Österreichische Galerie Belvedere, Vienna 1992.

VIENNA (Kunstforum) 1993
K.A. Schröder, *Richard Gerstl 1883–1908*, exh. cat., Kunstforum der Bank Austria, Vienna 1993.

VIENNA (Jüdisches Museum) 1993
Broncia Koller-Pinell: Eine Malerin im Glanz der Wiener Jahrhundertwende, ed. T. Natter, exh. cat., Jüdisches Museum der Stadt Wien, Vienna 1993.

VIENNA (Jüdisches Museum) 1994
T.G. Natter, *MOPP*, exh. cat., Jüdisches Museum der Stadt Wien, Vienna 1994.

VIENNA (Kunstforum) 1995
K.A. Schröder, *Neue Sachlichkeit*, exh. cat., Kunstforum der Bank Austria, Vienna 1995.

VIENNA (Jüdisches Museum) 1995
T.G. Natter, *Isidor Kaufmann 1853–1921*, exh. Jüdisches Museum der Stadt Wien, Vienna 1995.

VIENNA (Belvedere) 1998
T.G. Natter and G. Frodl, *Carl Moll (1861–1945)*, exh. cat., Österreichische Galerie Belvedere, Vienna 1998.

VIENNA (Belvedere) 2000
T. G. Natter and G. Frodl, *Klimt's Women*, exh. cat., Österreichische Galerie Belvedere, Vienna, Cologne 2000.

VIENNA (Historisches Museum) 2000
R. Kassal-Mikula and E. Doppler, *Hans Makart, Malerfurst (1840–1884)*, exh. cat., Historisches Museum der Stadt Wien, Vienna 2000.

VIENNA (Historisches Museum) 2002
G. Hajós and W. Schmidt-Dengler, *Gartenkunst. Bilder und Texte von Gärten und Parks*, exh. cat., Historisches Museum der Stadt Wien, Vienna 2002.

VIENNA (Jüdisches Museum) 2003
T.G. Natter, *Die Galerie Miethke. Eine Kunsthandlung im Zentrum Der Moderne*, exh. cat., Jüdisches Museum der Stadt Wien, Vienna 2003.

VIENNA (Leopold) AND FRANKFURT 2005
The Naked Truth: Klimt, Schiele, Kokoschka and Other Scandals, eds T.G. Natter and M. Hollein, exh. cat., Leopold Museum, Vienna and Schirn Kunsthalle Frankfurt, Munich 2005.

VIENNA (Belvedere) 2006
Die Tafelrunde, Egon Schiele und sein Kreis. Meisterwerke des österreichischen Frühexpressionismus, eds T. G. Natter and T. Trummer, exh. cat., Österreichische Galerie Belvedere, Vienna 2006, pp. 45–62.

VIENNA (Belvedere Orangery) 2007
Gartenlust. Der Garten in der Kunst, ed. A. Husslein-Arco, exh. cat., Österreichische Galerie Belvedere, Vienna 2007.

VIENNA (Belvedere) 2007
Gustav Klimt und die Künstler-Compagnie, eds A. Weidinger and A. Husslein-Arco, exh. cat., Österreichische Galerie Belvedere, Vienna 2007.

VIENNA (Leopold) 2008
Josef Maria Auchentaller (1865–1949): Ein Künstler der Wiener Secession, ed. R. Festi, exh. cat., Leopold Museum, Vienna 2008.

VIENNA (Belvedere) AND PARIS 2009
Ferdinand Georg Waldmüller 1793–1985, eds A. Husslein-Arco and S. Grabner, exh. cat., Österreichische Galerie Belvedere, Vienna and Louvre, Paris 2009.

VIENNA (Albertina) 2010
K.A. Schröder and M.L. Sternath-Schuppanz, *Jakob and Rudolf von Alt: Im Auftrag des Kaisers [At His Majesty's Service]*, exh. cat., Albertina, Vienna 2010.

VIENNA (Wien Museum im Kunstlerhaus) 2011
Makart. Ein Künstler regiert die Stadt, ed. R. Gleis, exh. cat., Wien Museum im Kunstlerhaus, Vienna 2011.

VIENNA (Albertina) AND LOS ANGELES 2012
M. Bisanz-Prakken, *Gustav Klimt: The Magic of Line*, exh. cat., Albertina Vienna and J. Paul Getty Museum, Los Angeles 2012. (German edition: *Gustav Klimt. Die Zeichnungen*, 2012.)

VIENNA (Leopold) 2012
T.G. Natter, P. Weinhäupl and F. Smola, *Klimt: Up Close and Personal*, exh. cat., Leopold Museum, Vienna 2012.

VIENNA (Wien Museum) 2012
Klimt: The Collection of the Wien Museum, exh. cat., Wien Museum, Vienna 2012.

VON MILLER 2004
M. von Miller, *Sonja Knips und die Wiener Moderne: Gustav Klimt, Josef Hoffmann und die Wiener Werkstätte gestalten eine Lebenswelt*, Vienna 2004.

WAISSENBERGER 1986
R. Waissenberger, ed., *Vienna in the Biedermeier Era 1815–1848*, New York 1986.

WEIDINGER 2007
A. Weidinger, *Klimt. Catalogue Raisonné*, New York 2007.

WEININGER 1906
O. Weininger, *Sex and Character*, New York 1906.

WERKNER 1994
Egon Schiele: Art, Sexuality and Viennese Modernism, ed. P. Werkner, Palo Alto, CA 1994.

WEST 1994
S. West, *Fin-de-Siècle: Art and Society in an Age of Uncertainty*, New York 1994.

WHEATCROFT 1996
A. Wheatcroft, *The Habsburgs: Embodying Empire*, London 1996.

WHITFORD 1981
F. Whitford, *Egon Schiele*, London 1981.

WILKIE 1987
A. Wilkie, *Biedermeier*, London 1987.

ZAUNSCHIRM 1987
T. Zaunschirm, *Gustav Klimt. Margarethe Stonborough-Wittgenstein. Ein österreichisches Schicksal*, Frankfurt 1987.

ZEMAN 1996
H. Zeman, ed., *Leopold Carl Müller 1834–1892, Briefe und Dokumente*, Vienna 1996.

ZEMEN 1998
H. Zemen, *Leopold Carl Müller im Künstlerhaus: Die Orientbilder*, Vienna 1998.

ZWEIG 1964
S. Zweig, *The World of Yesterday*, Nebraska 1964.

Biographies

MARY COSTELLO

Alt, Rudolf von (1812–1905)

Alt was trained by his father, the famous lithographer, landscape and watercolour painter Jacob Alt, and at the Academy of Fine Arts in Vienna. A prolific painter, draughtsman and printmaker, he travelled extensively, painting primarily watercolours of landscapes and interiors for aristocratic patrons. He received official commissions from Archduke Ferdinand until 1848, when political unrest in Vienna forced him to flee the city temporarily. In 1889 he was ennobled. In 1897 Alt was made Honorary President of the Vienna Secession.
Hevesi 1911, Roessler 1921, Koschatzky 1975, Vienna (Albertina) 2010.

Amerling, Friedrich von (1803–1887)

Favoured painter of Emperor Franz I and his court, Amerling was a highly respected figure in Viennese society. He trained as a history painter in Vienna and Prague, but turned to portraiture after attracting the patronage of Prince Paul Esterházy. This allowed him to spend the year 1827–8 in London, where he studied under the British portraitist Sir Thomas Lawrence. Afterwards, Amerling concentrated almost exclusively on portraiture, painting around 1,000 portraits in his lifetime. He was ennobled by Franz I's successor, Franz Joseph, in 1878.
Frankl 1889, Probst 1927.

Auchentaller, Josef Maria (1865–1949)

Auchentaller began his training at the Academy of Fine Arts in Vienna in 1890. He moved to Munich in 1892, where he contributed to the journal *Jugend*. In 1896, on his return to Vienna, he joined the nascent Secession. He was on the organising committee for five Secession exhibitions, showed his work in ten, and was a major contributor of graphic work to the Secession's journal *Ver Sacrum*. From 1901 he became increasingly detached from the group, and he moved to the Italian resort of Grado in 1903, where he devoted himself mainly to portraiture and landscape painting.
Vienna (Leopold) 2008.

Benczúr, Gyula (1844–1920)

Hungarian-born Benczúr was a well-respected academic artist and teacher. He was Professor of the Munich Academy from 1876, and of the Master's School of Painting in Prague from 1883 – a post established specifically for him. Benczúr's monumental history paintings promoted official cultural policy and gained him royal and noble patronage. He received numerous commissions for portraits of kings and aristocrats, alongside mythological and religious subjects. During his lifetime he won several prizes and medals for his art.
Budapest 1958, Pogany 1958, Nyíregyház 1963.

Canon, Hans (1829–1885)

Canon (born Johann von Puschka-Straschiripka) studied in Vienna under Ferdinand Georg Waldmüller and Carl Rahl, before serving as a cavalry officer in the Austrian army from 1848 to 1855. After that he travelled extensively in the East, France and England, lived for a while in Germany, and finally settled in Vienna as Professor at the Academy of Fine Arts. A Freemason and close friend of Crown Prince Rudolf, Canon was considered one of the finest portrait painters of his time.
Drewes 1994.

Danhauser, Josef Franz (1805–1845)

The son of a furniture maker, Danhauser studied at Vienna's Academy of Fine Arts under Johann Peter Krafft. From the late 1830s he concentrated mainly on portrait and genre painting, often blurring the line between the two. His subjects were drawn both from the peasantry and from Viennese society. Danhauser's sympathetic and often humorous portraits of children were met with hostility by critics, but with enthusiasm by the public, for whom he produced numerous copies and variants.
Roessler 1911, Birke 1983.

Delug, Alois (1859–1930)

Delug studied history at Innsbruck then art in Vienna under Leopold Carl Müller. He moved to Munich in 1888 after three years travelling through Italy, France, Germany and Holland. Returning to Vienna in 1896, Delug joined the Secession as it was being founded. In 1898 he became Professor at the Academy of Fine Arts; the future modernists Broncia Koller and Anton Kolig were among his students. Delug established an art school colony in the Viennese suburb of Grinzing and a museum in his birthtown of Bozen.
ÖBL 1957

Eybl, Franz (1806–1880)

At the age of 10, the precocious Eybl entered the Vienna Academy of Fine Arts. Like his contemporary, Josef Danhauser, he studied under Johann Peter Krafft. He had a successful career as a portraitist, and though he painted a wide section of Austrian society – from peasantry to nobility – he is most appreciated for his portraits of the middle classes. Eybl also produced lithographic portraits and incorporated portraits into his popular genre scenes. From 1853 he was Curator of the Imperial and Royal Picture Gallery, and from 1867 a teacher at the Imperial Institute of Restoration.
Kastel 1983.

Feuerbach, Anselm (1829–1880)

The son of an archaeologist at the University of Freiburg, Bavarian-born Feuerbach studied at the Academies of Fine Art in Düsseldorf, Munich and Antwerp. In the 1850s he travelled across Europe, painting in Paris, Karlsruhe, Venice and Rome. Italy was to become Feuerbach's home, but in 1873 he was appointed Professor at the Vienna Academy of Fine Arts and in the following year he started work on a public mural, *The Fall of the Titans*, for the ceiling of the Academy's Great Hall. Illness and disappointment in his critical reception in Vienna led Feuerbach to resign from his post just three years later.
Speyer 2002.

Gerstl, Richard (1883–1908)

Considered a seminal Austrian Expressionist on account of his psychologically penetrating portraits, Gerstl never exhibited or received critical acclaim in his lifetime, and shunned the company of other artists. Less than 100 of his canvases and drawings survive. He received intermittent schooling and training at the Academy of Fine Arts in Vienna and developed a great interest in music. He committed suicide at the age of 25, after a short-lived affair with the wife of Arnold Schönberg.
Kallir 1974, Breicha 1993.

Gütersloh, Albert Paris von (1887–1973)

A writer, actor and artist, Gütersloh was born in Vienna as Albert Konrad Kiehtreiber. Friends with Egon Schiele and Gustav Klimt, he first exhibited at the 1909 Kunstschau. Initially self-taught as an artist, he later studied with Maurice Denis in Paris. Gütersloh taught at Vienna's School of Applied Arts from 1930 until 1938, when he was debarred by the Nazis. After the war he took up a professorship at Vienna's Academy of Fine Arts.
Storch 1989, Vienna (Kunstforum) 1995.

Kaufmann, Isidor (1854–1921)

Born in Arad, Hungary, Kaufmann moved to Vienna in 1876 to study painting. Rejected by the Academy of Fine Arts, he became a pupil of the portrait painter Joseph Matthäus Aigner. The importance of his Jewish faith led Kaufmann to travel widely in Eastern Europe to record the lives and spirit of Galician Jews. His first-hand observational sketches are the basis for oil on mahogany portraits, the backgrounds reproduced from rooms in the Old Jewish Museum in Vienna.
Vienna (Jüdisches Museum) 1995, Cohen 1998.

Klimt, Gustav (1862–1918)

The son of a Viennese goldsmith, Klimt trained at the School of Applied Arts in Vienna, and began his artistic career producing public commissions in a historicist style. After a scandal surrounding his ceiling paintings for Vienna University, he concentrated on private commissions. He was a very popular portraitist with the Viennese upper middle classes, painting mainly the wives, sisters and children of his predominantly Jewish clients. A key player in Vienna's art scene, Klimt was one of the founding members of the Vienna Secession; in 1897 he became its first President.
Nebehay 1969, Weidinger 2007, Natter 2012.

Kokoschka, Oskar (1886–1980)

Born in Pöchlarn, Lower Austria, Kokoschka studied in Vienna at the School of Applied Arts. The works he exhibited at the 1908 and 1909 Kunstschau caused critical outrage but attracted the support of the architect Adolf Loos. From 1910 to 1914 Kokoschka concentrated mainly on portraiture for clients introduced to him by Loos, dividing his time between Vienna and Berlin. He later lived in Dresden, Prague and England, before eventually settling in Switzerland.
Kokoschka 1974, Schweiger 1983, New York 2002.

Kolig, Anton (1886–1950)

Born in Moravia, Kolig relocated to Vienna in 1904 to study first at the School of Applied Arts and then at the Academy of Fine Arts. Kolig's figure paintings and portraits were displayed in an exhibition at the Hagenbund in 1911 which included work by Kokoschka and the *Neukunstgruppe*. Kolig attracted the interest of Gustav Klimt and Carl Moll, who arranged a travel scholarship to France for him. Kolig returned to Austria from Paris in 1914, and after working as a war artist in Vienna, settled in Nötsch. Here he co-founded the Nötsch School with Franz Wiegele and other artists.
Lachit 1998, Rychlik 2001

Koller, Broncia (1863–1934)

Koller was born in Galicia to orthodox Jewish parents. She studied under Josef Raab and Alois Delug in Vienna and at the Munich Academy, before marrying and moving first to Salzburg, then Nuremberg. In 1903 the family relocated to Vienna, where Koller forged close artistic links with Gustav Klimt and his circle. The Koller residence was a vibrant meeting place for these artists, as well as philosophers and musicians. Koller exhibited in several national and international exhibitions in her lifetime.
Vienna (Jüdisches Museum) 1993, Johnson 2012.

Luksch-Makowsky, Elena (1878–1967)

Russian-born Makowsky studied first in St Petersburg, and then in Munich, where she met and married the Austrian sculptor Richard Luksch. The couple moved to Vienna in 1900 and quickly became associated with the Vienna Secession. Luksch-Makowsky claimed she was the first female member of the Secession, though her name was not included on the group's official list. She was a pioneer in the development of *Raumkunst* (the art of space). Her work, which includes applied art, graphic design, painting and sculpture, was shown in numerous Secession exhibitions.
Heusinger von Waldegg and Leppien 1979, Johnson 2012.

Makart, Hans (1840–1884)

Born in Salzburg, Makart studied at the Munich Academy under the history painter Karl von Piloty. In 1867 the Emperor Franz Joseph summoned Makart to Vienna, where he worked on large-scale theatrical paintings and decorations for the court and higher levels of society. He also established himself as a portrait painter for patrons drawn from these circles. Something of a celebrity figure in *Ringstrassenzeit* Vienna, he maintained a large, sumptuously decorated studio, which was a fashionable meeting place for Viennese society.
Frodl 1974, Vienna (Historisches Museum) 2000, Salzburg 2007, Vienna (Wien Museum im Kunstlerhaus) 2011.

Matsch, Franz von (1861–1942)

A painter and sculptor, Matsch studied at the School of Applied Arts in Vienna alongside Gustav and Ernst Klimt. After graduation, the trio formed the Artists' Company, gaining commissions throughout the Austro-Hungarian Empire and beyond. A major success was their contribution to the interior decorative schemes of Vienna's newly built Burgtheater, Kunsthistorisches Museum and University. Matsch broke with Klimt after the scandal surrounding the University paintings. He taught at the School of Applied Arts from 1893 to 1901, and was ennobled in 1912.
Vienna (Historisches Museum) 1981, Vienna (Belvedere) 2007.

Moll, Carl (1861–1945)

Moll studied at the Vienna Academy of Fine Arts and privately with the painter Emil Jakob Schindler. Moll married Schindler's widow in 1892, becoming stepfather to Alma, who would go on to marry Gustav Mahler. In 1897 Moll co-founded the Vienna Secession with Gustav Klimt. He left the Secession in 1905 along with the Klimt Group, who he continued to support in his role as Director of the Miethke Gallery until 1912. He subsequently devoted himself to painting, producing landscapes and interiors, many depicting his own house on the outskirts of Vienna, designed by Josef Hoffmann.
Fritz 1962, Dichand 1985, Vienna (Belvedere) 1998.

Müller, Leopold Carl (1834–1892)

Born in Dresden, the son of a Viennese lithographer, Müller studied at the Vienna Academy of Fine Arts, where he later taught. Between 1873 and 1886 he travelled frequently to Egypt, where he kept a studio. In 1875, the historicist painter Hans Makart joined him in Cairo. A prolific producer of Oriental subjects, Müller is regarded as the founder and most prominent member of the Austrian school of Orientalist painting.
Zemen 1996, Zemen 1998.

Oppenheimer, Max (1885–1954)

At the age of 15, Oppenheimer began his studies at the Vienna Academy of Fine Arts, followed by the Prague Academy. In 1908 he returned to Vienna, where he joined the circle around Oskar Kokoschka and Egon Schiele, painting mainly portraits of the literary and cultural elite. In 1911 he was accused of plagiarising the work of Kokoschka and this led to his exclusion from the group. From 1914 the representation of music became his key subject. He moved between Austria, Germany and Switzerland before emigrating to New York in 1938.
Michael 1911, Vienna (Jüdisches Museum) 1994.

Ries, Teresa (1874–1956)

A painter and sculptor, Ries was born in Russia to wealthy Jewish parents. She studied at the Moscow Academy before moving to Vienna in 1894, where she became a private student of the sculptor Edmund Heller. Heller helped her to find commissions and exhibiting opportunities, including showing her work at the Secession from 1899 to 1905. Ries had a studio in the Liechtenstein Palace, which she was forced to leave when it was taken over by the Nazis in 1938, and she emigrated to Switzerland in 1942.
Johnson 2012.

Romako, Anton (1832–1889)

Romako studied at the Vienna Academy of Fine Arts, the Munich Academy, and privately in Vienna under Carl Rahl. In 1854 he left Vienna and travelled in Italy and Spain before settling in Rome in 1857, where he found success as a painter of genre scenes, landscape and portraits. He failed to re-establish himself on his return to Vienna in 1876, and his later life was spent between Paris, Geneva and Bad Gastein. He died in poverty in Baden.
Novotny 1954, Vienna (Belvedere) 1992.

Schiele, Egon (1890–1918)

Schiele showed a precocious talent for drawing from an early age, and entered the Vienna Academy of Fine Arts at 15 years old. A protégé of Gustav Klimt, he took part in numerous Austrian and international exhibitions, which brought him into contact with critics and collectors who became his patrons. His oeuvre consists of portraits, self portraits and nudes, as well as landscapes, and he was prolific in his output until his death from Spanish influenza at the age of 28.
Comini 1974, Whitford 1981, Werkner 1994, Kallir 1998.

Schönberg, Arnold (1874–1951)

The son of a Viennese tradesman, Schönberg is best known as a composer and the originator of the twelve-tone technique for musical composition. He began to explore painting around 1907. In painting, as well as in music, he was largely self-taught, but took some lessons from Richard Gerstl. Schönberg produced around 60 paintings and 200 drawings in the period up to 1912, when he largely abandoned visual art.
Schönberg 1978, Kallir 1984.

Waldmüller, Ferdinand Georg (1793–1865)

Trained at the Vienna Academy of Fine Arts, Waldmüller began by painting miniatures before establishing a successful and lucrative portrait practice among Vienna's middle classes, aristocracy and royalty. He also painted contemporary genre scenes, flower pieces and landscapes. Waldmüller was a staunch advocate of Realism in art, and of artistic reform, which created problems in his relationship with the Academy, where he was Professor from 1829.
Roessler and Pisko 1908, Salzburg 1993, Vienna (Belvedere) and Paris 2009.

Photographic Credits

All exhibition works are denoted by numbers in brackets.

AMSTERDAM © Rijksmuseum, Amsterdam: fig. 43; **BASEL** © Kunstmuseum Basel, photo Martin P. Bühler: (4); **BONN** © Beethoven-Haus, Bonn: (72); **BUDAPEST** © Magyar Nemzeti Múzeum, Budapest: (61); **DUISBERG** © courtesy of Lehmbruck Museum, Duisberg/photographer: Bernd Kirtz/Fondation Oskar Kokoschka/DACS 2013: (47); **ŁAŃCUT, POLAND** © Łańcut Castle Museum, photo Maria Szewczuk and Marek Kosior: fig. 23; **LONDON** © akg-images: figs 3, 15, 16, 32; © akg-images/Interfoto: fig. 4; © akg-images/ullstein bild: fig. 47; © The National Gallery, London: (1); © Tate, London 2013: (52), & detail; **MADRID** © Museo Thyssen-Bornemisza, Madrid/Fondation Oskar Kokoschka/DACS 2013: (6), (7); **MARBACH** Schiller-Nationalmuseum, Deutsches Literaturarchiv: fig. 48; **MINNEAPOLIS, MINNESOTA** © The Minneapolis Institute of Arts, Minnesota: (37); **MORITZBURG** Stiftung Moritzburg – Kunstmuseum des Landes: fig. 30; **MUNICH** © Kunstkammer Georg Laue: fig. 53; **NEW YORK** Photo © The Museum of Modern Art, New York/Scala, Florence/Fondation Oskar Kokoschka/DACS 2013: (55); Neue Galerie New York © Neue Galerie New York/Art Resource/Scala, Florence: fig. 45; © akg-images / Erich Lessing: fig. 40; **NUREMBERG** © Germanisches Nationalmuseum Nuremberg. Photo Jürgen Musolf: (51); **OLDENBURG** Landesmuseum für Kunst und Kulturgeschichte,

Oldenburg © akg-images: fig. 22; **SALZBURG** Residenzgalerie, Salzburg © Copyright Photo Austrian Archives/Scala Florence: fig. 25; © Salzburg Museum: (29); **STUTTGART** © Photo: Staatsgalerie Stuttgart: (35); **VIENNA** Albertina, Vienna © Albertina, Vienna: (31), (42); © akg-images: fig. 21; Arnold Schönberg Center, Vienna © Arnold Schönberg Center, Vienna/DACS 2013: (18), & detail, (39), & detail, (43), (44); © Arnold Schönberg Center, Vienna/Copyright 1912 by Universal Edition A.G., Wien./UE 34134: fig. 44; Belvedere, Vienna © Belvedere, Vienna: (3), (23), (24), (25), (27), (30), (33), & detail, (50), (58), (59); fig. 11; © akg-images: fig. 18; © akg-images/Erich Lessing: figs 12, 14, 35; Burgtheater, Vienna © akg-images/Erich Lessing: fig. 33; © Gemäldegalerie der Akademie der bildenden Künste Wien, Vienna: (10), & detail, (11), (12), (13), (38), (40); Gesellschaft der Musikfreunde, Vienna © akg-images/Erich Lessing: fig. 17; Kunsthistorisches Museum, Vienna © Bridgeman Art Library, London: fig. 28; Leopold Museum Private Foundation, Vienna © Leopold Museum Private Foundation, Vienna: (15), (16), (17), (21), & detail, (36), (49), (64), (65), (66); © Leopold Museum Private Foundation, Vienna/DACS 2013: (26), (34); © akg/Imagno: fig. 46; © Liechtenstein. The Princely Collections, Vaduz-Vienna: (9); fig. 24; © Österreichische Nationalbibliothek, Vienna: figs 2, 8, 9, 31, 36, 37, 39, 52; Sammlung der Medizinischen Universität Wien, Josephinum, Vienna © akg-images: fig. 51; Wien Museum, Vienna © Wien Museum,

Vienna: (14), (20), (41), (48), (60), (67), (68), (69), (70), (71); figs 7, 19, 20; © akg-images: figs 1, 6, 10, 26; © The Art Archive: fig. 41; **WASHINGTON, DC** © The Phillips Collection, Washington, DC/Fondation Oskar Kokoschka/ DACS 2013: (2); **ZUG** © Kunsthaus Zug, Stiftung Sammlung Kamm: (56), (57).

PRIVATE COLLECTIONS

Archivio Auchentaller, Italy © Photo courtesy of the owner. Photo by Luca Pedrotti: (19), (22); Austrian Collection © courtesy the owner. Photo Fotostudio Ghezzi: (28); Cartin Collection, courtesy Daxer & Marschall, Munich © courtesy the owner: (8); Edmund de Waal © Edmund de Waal: figs 27, 29; Eisenberger Collection, Vienna © Eisenberger Collection, Vienna: (45), & detail, (46); Private Collection, Hong Kong © photo courtesy Richard Nagy/Fondation Oskar Kokoschka/DACS 2013: (53); Property of The Lewis Collection © Property of The Lewis Collection: (63); Wienerroither & Kohlbacher, Vienna © Photo courtesy of the owner: (32); © Photo courtesy of the owners: (62), & detail; fig. 38; © Photo courtesy of the owners/Fondation Oskar Kokoschka/DACS 2013: (5), (54); © Private Collection, courtesy Österreichische National-bibliothek, Vienna: fig. 34; © Private Collection/Archives Charmet/The Bridgeman Art Library: fig. 5.

List of Lenders

BASEL
Kunstmuseum Basel

BONN
Beethoven-Haus

BUDAPEST
Hungarian National Museum
(Magyar Nemzeti Múzeum)

DUISBURG
LehmbruckMuseum

HERTFORD, CONNECTICUT
The Cartin Collection

LONDON
Richard Nagy Ltd
The National Gallery
Tate
Edmund de Waal

MADRID
Carmen Thyssen-Bornemisza Collection
Museo Thyssen-Bornemisza

MINNEAPOLIS
Minneapolis Institute of Arts

MUNICH
Daxer & Marschall

NEW YORK
MoMA. The Museum of Modern Art
Neue Galerie

NUREMBERG
Germanisches Nationalmuseum

PACIFIC PALISADES, CALIFORNIA
Belmont Music Publishers

SALZBURG
Salzburg Museum

STUTTGART
Staatsgalerie Stuttgart

VIENNA
Albertina
Arnold Schönberg Center
Belvedere
Eisenberger Collection
Gemäldegalerie der Akademie der bildenden
 Künste Wien
Diethard Leopold Collection
Leopold Collection II
Leopold Museum Private Foundation
Liechtenstein. The Princely Collections,
 Vaduz-Vienna
W & K – Wienerroither & Kohlbacher
Wien Museum

WASHINGTON, DC
The Phillips Collection

ZUG
Kunsthaus Zug
Stiftung Sammlung Kamm

And the Archivio Auchentaller; Federal
Republic of Germany; The Lewis Collection;
and all those lenders and private collectors
who wish to remain anonymous.

List of Exhibited Works

Measurements are given height before width

1
Gustav Klimt (1862–1918)
Portrait of Hermine Gallia, 1904
Oil on canvas, 170.5 × 96.5 cm
The National Gallery, London (NG 6434)

2
Oskar Kokoschka (1886–1980)
Portrait of Lotte Franzos, 1909
Oil on canvas, 114.9 × 79.4 cm
The Phillips Collection,
Washington, DC (1062)

3
Hans Canon (1829–1885)
Girl with Parrot, 1876
Oil on canvas, 126 × 84.6 cm
Belvedere, Vienna (5943)

4
Egon Schiele (1890–1918)
Portrait of Erich Lederer, 1912
Oil and gouache on canvas,
140 × 55.4 cm
Kunstmuseum Basel
Gift of Frau Erich Lederer-von Jacobs, in
memory of her late husband (G 1986.16)

5
Oskar Kokoschka (1886–1980)
Portrait of Hugo Schmidt, 1911
Oil on canvas, 72.5 × 54 cm
Private collection

6
Oskar Kokoschka (1886–1980)
Portrait of Max Schmidt, 1914
Oil on canvas, 90 × 57.7 cm
Museo Thyssen-Bornemisza, Madrid
(1982.29 (629))

7
Oskar Kokoschka (1886–1980)
Portrait of Carl Leo Schmidt, 1911
Oil on canvas, 97.2 × 67.8 cm
Carmen Thyssen-Bornemisza Collection,
on loan at the Museo Thyssen-
Bornemisza, Madrid (CTB.1998.27)

8
Friedrich von Amerling (1803–1887)
*Emperor Franz I of Austria, Study for
the Official Portrait of 1832*, 1832
Oil on canvas, 29.9 × 21.8 cm
Cartin Collection, USA, courtesy
of Daxer & Marschall, Munich

9
Friedrich von Amerling (1803–1887)
Portrait of Franz Xaver Stöber, 1837
Oil on canvas, 41 × 33 cm
Liechtenstein. The Princely Collections,
Vaduz-Vienna (GE 2147)

10
Carl Moll (1861–1945)
Self Portrait in his Study, 1906
Oil on canvas, 100 × 100 cm
Gemäldegalerie der Akademie der
bildenden Künste Wien, Vienna
(GG-1338)

11
Ferdinand Georg Waldmüller (1793–1865)
*Portrait of Militia Company Commander
Schaumberg and his Child*, 1846
Oil on oak, 31.8 × 26.2 cm
Gemäldegalerie der Akademie der
bildenden Künste Wien, Vienna (GG-1155)

12
Ferdinand Georg Waldmüller (1793–1865)
Portrait of Schaumberg's Wife, 1846
Oil on oak, 31 × 25.6 cm
Gemäldegalerie der Akademie der
bildenden Künste Wien, Vienna
(GG-1156)

13
Leopold Carl Müller (1834–1892)
Portrait of Victor Tilgner, about 1899
Oil on canvas, 95 × 68 cm
Gemäldegalerie der Akademie der
bildenden Künste Wien, Vienna
(GG-1223)

14
Max Oppenheimer (1885–1954)
Portrait of Heinrich Mann, 1910
Oil on canvas, 91 × 81 cm
Wien Museum, Vienna (78913)

15
Anton Romako (1832–1889)
Portrait of Isabella Reisser, 1885
Oil on canvas, 130.5 × 90 cm
Leopold Museum Private Foundation,
Vienna (LM 2116)

16
Anton Romako (1832–1889)
Portrait of Christoph Reisser, 1885
Oil on canvas, 130.5 × 90.5 cm
Leopold Museum Private Foundation,
Vienna (LM 2117)

17
Richard Gerstl (1883–1908)
Portrait of Lieutenant Alois Gerstl, 1907
Oil on canvas, 153 × 130.2 cm
Leopold Museum Private Foundation,
Vienna (LM 639)

18
Arnold Schönberg (1874–1951)
Portrait of Hugo Botstiber,
before October 1910
Oil on cardboard, 73 × 50 cm
Private Collection, Vienna. Courtesy
Arnold Schönberg Center, Vienna (CR 85)

19
Josef Maria Auchentaller (1865–1949)
'Bunte Bände' (Portrait of Maria), 1912
Oil on canvas, 120 × 110.5 cm
Archivio Auchentaller, Italy

20
Ferdinand Georg Waldmüller (1793–1865)
*Portrait of an Unidentified Seated Girl
in a White Satin Dress*, 1839
Oil on canvas, 32 × 26.5 cm
Wien Museum, Vienna (9666)

21
Gustav Klimt (1862–1918)
Young Girl, Seated, 1894
Oil on wood, 14 × 9.6 cm
Leopold Museum Private
Foundation,Vienna (LM 4146)

22
Josef Maria Auchentaller (1865–1949)
Portrait of Maria, 1896
Oil on canvas, 30.5 × 25.5 cm
Archivio Auchentaller, Italy

23
Anton Romako (1832–1889)
The Artist's Nieces, Elisabeth and Maja,
1873
Oil on canvas, 93.2 × 79.6 cm
Belvedere, Vienna
Donated by Dr. Imre von Satzger,
grandson of Elisabeth von Satzger,
née Romako (8557)

24
Richard Gerstl (1883–1908)
The Sisters Karoline and Pauline Fey, 1905
Oil on canvas, 175 × 150 cm
Belvedere, Vienna (4430)

25
Alois Delug (1859–1930)
The Markl Family, 1907
Oil on canvas, 113.5 × 138 cm
Belvedere, Vienna (1425)

26
Anton Kolig (1886–1950)
Portrait of the Schaukal Family, 1911
Oil on canvas, 160 × 160 cm
Leopold Collection II

27
Egon Schiele (1890–1918)
The Family (Self Portrait), 1918
Oil on canvas, 150 × 160.8 cm
Belvedere, Vienna (4277)

28
Hans Makart (1840–1884)
Portrait of Hanna Klinkosch, about 1875
Oil on wood, 114 × 77 cm
Austrian Collection

29
Hans Makart (1840–1884)
Portrait of Clothilde Beer, about 1878
Oil on canvas, 135.3 × 95.6 cm
Salzburg Museum (365-42)

30
Gustav Klimt (1862–1918)
Portrait of a Lady in Black, about 1894
Oil on canvas, 155 × 75 cm
Belvedere, Vienna,
loan from a private collection

31
Gustav Klimt (1862–1918)
*Study for the Portrait of Amalie
Zuckerkandl*, 1913–14
Pencil on paper, 56.9 × 37.5 cm
Albertina, Vienna (30249)

32
Gustav Klimt (1862–1918)
*Study for the Portrait of Amalie
Zuckerkandl*, 1913–14
Pencil on paper, 56.9 × 37.5 cm
Courtesy W & K – Wienerroither
& Kohlbacher, Vienna

33
Gustav Klimt (1862–1918)
Portrait of Amalie Zuckerkandl, 1917–18
Oil on canvas, 128 × 128 cm
Belvedere, Vienna
Donated by Vita and Gustav Künstler
(7700)

34
Albert Paris von Gütersloh (1887–1973)
Portrait of a Woman, 1914
Oil on canvas, 54.6 × 38.5 cm
Leopold Museum Private Foundation,
Vienna (LM 81)

35
Anselm Feuerbach (1829–1880)
Self Portrait with Cigarette, 1875
Oil on canvas, 66 × 52.5 cm
Staatsgalerie Stuttgart
Lent by the Federal Republic of Germany
(L 900)

36
Egon Schiele (1890–1918)
Self Portrait with Raised Bare Shoulder,
1912
Oil on wood, 42.2 × 33.9 cm
Leopold Museum Private Foundation,
Vienna (LM 653)

37
Egon Schiele (1890–1918)
Portrait of Albert Paris von Gütersloh, 1918
Oil on canvas, 140 × 110.3 cm
Lent by the Minneapolis Institute
of Arts, Minnesota
Gift of the P.D. McMillan
Land Company (54.30)

38
Friedrich von Amerling (1803–1887)
Self Portrait, 1867
Oil on oak, 82 × 62 cm
Gemäldegalerie der Akademie der
bildenden Künste Wien, Vienna (GG-945)

39
Arnold Schönberg (1874–1951)
Blue Self Portrait, 1910
Oil on three-ply panel, 31.1 × 22.9 cm
Belmont Music Publishers, Pacific
Palisades/CA. Courtesy Arnold
Schönberg Center, Vienna (CR 11)

40
Franz Eybl (1806–1880)
Self Portrait, about 1840
Oil on canvas, 70 × 55.5 cm
Gemäldegalerie der Akademie
der bildenden Künste Wien,
Vienna (GG-1149)

41
Rudolf von Alt (1812–1905)
Self Portrait, about 1835
Watercolour, 18.3 × 13.3 cm
Wien Museum, Vienna (116761/2)

42
Rudolf von Alt (1812–1905)
Self Portrait, 1883
Pencil and watercolour, 35.5 × 25.5 cm
Albertina, Vienna (30999)

43
Arnold Schönberg (1874–1951)
Portrait of Marietta Werndorff,
before October 1910
Oil on board, 99.7 × 71 cm
Belmont Music Publishers, Pacific
Palisades/Ca. Courtesy Arnold
Schönberg Center, Vienna (CR 88)

44
Arnold Schönberg (1874–1951)
Portrait of Georg Schönberg,
February 1910
Oil on three-ply panel, 50 × 47 cm
Belmont Music Publishers, Pacific
Palisades/CA. Courtesy Arnold
Schönberg Center, Vienna (CR 98)

45
Broncia Koller (1863–1934)
Nude Portrait of Marietta, 1907
Oil on canvas, 107.5 × 148.5 cm
Eisenberger Collection, Vienna

46
Broncia Koller (1863–1934)
Silvia Koller with a Birdcage, 1907–8
Oil on canvas, 100 × 100 cm
Eisenberger Collection, Vienna

47
Oskar Kokoschka (1886–1980)
Children playing, 1909
Oil on canvas, 72 × 108 cm
LehmbruckMuseum, Duisberg (573/1965)

48
Teresa Ries (1874–1956)
Self Portrait, 1902
Oil on canvas, 157 × 70.5 cm
Wien Museum, Vienna (133781)

49
Richard Gerstl (1883–1908)
Nude Self Portrait with Palette, 1908
Oil on canvas, 139.3 × 100 cm
Leopold Museum Private Foundation,
Vienna (LM 651)

50
Elena Luksch-Makowsky (1878–1967)
Self Portrait with her Son Peter, 1901
Oil on canvas, 94.5 × 52 cm
Belvedere, Vienna (7445)

51
Friedrich von Amerling (1803–1887)
Portrait of Cäcilie Freiin von Eskeles, 1832
Oil on canvas, 151.5 × 102 cm
Germanisches Nationalmuseum,
Nuremberg (GM 913)

52
Isidor Kaufmann (1854–1921)
Young Rabbi from N., about 1910
Oil on wood, 38.1 × 27.6 cm
Tate, London (N04464)
Presented by Viscount Bearstead
through the Art Fund, 1929

53
Oskar Kokoschka (1886–1980)
Count Verona, 1910
Oil on canvas, 70.6 × 58.7 cm
Private Collection, Hong Kong

54
Oskar Kokoschka (1886–1980)
Portrait of Peter Altenberg, 1909
Oil on canvas, 76.2 × 71.1 cm
Private collection,
Courtesy Neue Galerie New York

55
Oskar Kokoschka (1886–1980)
*Portrait of Hans Tietze and
Erica Tietze-Conrat*, 1909
Oil on canvas, 76.5 × 136.2 cm
The Museum of Modern Art, New York
Abby Aldrich Rockefeller Fund, 1939
(651.1939)

56
Richard Gerstl (1883–1908)
Portrait of Alexander Zemlinsky, 1908
Oil on canvas, 170.5 × 74.3 cm
(K.G. 78a)

REVERSE *Fragment of a Full-length
Self Portrait*, about 1904
Oil on canvas, 170.5 × 74.3 cm
(K.G. 78b)

Kunsthaus Zug, Stiftung Sammlung
Kamm

57
Richard Gerstl (1883–1908)
*Portrait of Mathilde Schönberg
in the Studio*, after February 1908
Oil on canvas, 171 × 60 cm
Kunsthaus Zug, Stiftung Sammlung
Kamm (K.G. 77)

58
Franz von Matsch (1861–1942)
Emperor Franz Joseph on his Deathbed,
1916
Oil on card, 51.5 × 69.5 cm
Belvedere, Vienna (3300)

59
Franz Eybl (1806–1880)
*The Artist Franz Wipplinger, looking at
a Portrait of his Late Sister*, 1833
Oil on canvas, 126 × 100 cm
Belvedere, Vienna (1869)

60
Friedrich von Amerling (1803–1887)
Antonie von Amerling on her Deathbed,
1843
Oil on canvas, 47 × 39 cm
Wien Museum, Vienna (43796)

61
Gyula Benczúr (1844–1920)
Portrait of Empress Elisabeth, 1899
Oil on canvas, 142 × 95.5 cm
Hungarian National Museum,
Budapest (1861)

62
Gustav Klimt (1862–1918)
Ria Munk on her Deathbed, 1912
Oil on canvas, 50 × 50.5 cm
Private collection,
Courtesy Richard Nagy Ltd., London

63
Gustav Klimt (1862–1918)
Posthumous Portrait of Ria Munk III,
1917–18
Oil on canvas, 180.7 × 89.9 cm
Property of The Lewis Collection

64
Egon Schiele (1890–1918)
Portrait of Edith Schiele, dying,
28 October 1918
Black chalk on paper, 44 × 29.5 cm
Leopold Museum Private Foundation,
Vienna (LM 2382)

65
Otto Zimmermann, 1902,
photographed by Studio S. Fleck
Photograph, 10.2 × 16.5 cm
Diethard Leopold Collection, Vienna

66
Gustav Klimt (1862–1918)
*Portrait of the Artist's Dead Son,
Otto Zimmermann*, 1902
Chalk on paper, 39.5 × 24.7 cm
Diethard Leopold Collection, Vienna

67
Moriz Schroth (dates unknown)
Death Mask of Gustav Klimt, 1918
Plaster, 27 × 21 × 18 cm
Wien Museum, Vienna (43945)

68
Unknown Artist
Death Mask of Egon Schiele, 1918
Plaster, 19.5 × 15.5 cm
Wien Museum, Vienna (95170)

69
Josef Humplik, (1888–1958)
Death Mask of Adolf Loos, 1933
Plaster, 24 × 18.5 × 17 cm
Wien Museum, Vienna (78988)

70
Carl Moll (1861–1945)
Death Mask of Gustav Mahler, 1911
Plaster, 35 × 29 × 16 cm
Wien Museum, Vienna (78658/b)

71
Josef Danhauser (1805–1845) and
Matthias Ranftl (1804–1854)
Death Mask of Beethoven, 1827
Plaster, 25 × 17 × 15 cm
Wien Museum, Vienna (95323)

72
Josef Danhauser (1805–1845)
Beethoven's Hands, 1827
Oil on canvas, 42 × 34 cm
Beethoven-Haus, Bonn
Collection H.C. Bodmer (B 952)

73 (fig. 29)
Unknown
Emmy von Ephrussi's
photograph album,
about 1904
Book open, 24 × 34 cm
Edmund de Waal

Index

Figures in **bold** refer to illustrations;
figures in *italics* to biographies of artists

Acknowledgements

In 2010 I participated in a workshop organised by the Association of Art Historians on exhibition collaborations between university and museum professionals. The event was memorably entitled 'Don't ask for the *Mona Lisa!*' and Chris Riopelle, Curator of Post-1800 Paintings at the National Gallery, followed it up with a note on the Austrian *Mona Lisa* – Gustav Klimt's glittering portrait of Adele Bloch-Bauer of 1907 – and a question about my latest research. I had just embarked on a book supported by the Leverhulme Trust and Chris encouraged me to develop its revisionist approach to portraiture in Vienna 1900 for an exhibition. I am immensely grateful to Chris for the opportunity. The 'Lady in Gold' was not on my wish-list, but there were many other riches that seemed equally out of reach. The wealth of work we have on display is down to his energy and diplomacy.

Chris and I could not have realised such a project without the exceptional generosity of institutions and individuals from across the globe, included in the List of Lenders. For their time and help, we would like to thank in particular from Vienna, Martina Fleischer and Andrea Domanig-Pogoreutz at the Gemäldegalerie der Akademie der bildenden Künste; Therese Muxeneder at the Arnold Schönberg Center; Agnes Husslein-Arco and Stephan Koja at the Belvedere; Tobias Natter and Franz Smola at the Leopold Museum Private Foundation; Wolfgang Kos and Ursula Storch at the Wien Museum; Alois Wienerroither and Andrea Glanninger-Leitner at W&K – Wienerroither & Kohlbacher; and Mimi Eisenberger. From London, we would like to thank Richard Nagy and Edmund de Waal, and from New York, we are extremely grateful to Renée Price, Scott Gutterman and Janis Staggs at the Neue Galerie.

The transformation of such an ambitious, international loan list into an exhibition is a daunting task. Catherine Putz, Exhibitions Curator at the National Gallery, made it less so, providing pragmatic advice at all stages of the project, from the proposal to the first drafts of this book. Jo Kent, Exhibitions Organiser, and Stephen Dunn, the Senior Registrar, kept keen eyes on the detail and handled all lines of communication with calm and care.

The exhibition is accompanied by this book, which includes contributions from art historians based at universities in Europe and the United States. I would like to thank Tag Gronberg, Julie Johnson, Doris Lehmann, Elana Shapira and Sabine Wieber for their new perspectives on Viennese portraiture, their supportive remarks on one another's texts, and their openness to editorial suggestions at testing times of the academic year. The artist and author Edmund de Waal welcomed me at his studio, talked about the exhibition in connection with his family history, and wrote the introduction to this book. Clare Willsdon read and commented on the first manuscript in exceptional detail, drawing on her scholarship to provide us all with much to ponder. Edward Neather completed translations of a chapter throughout the stages of its development, as well as research and language assistance towards the preparation of my chapters. Mary Costello compiled the Artist Biographies and read a number of my drafts.

The coordination of such a publication is a challenge, and I am forever in the debt of Rachel Giles, Project Editor at the National Gallery Company, who kept the book on an even keel no matter what the weather. Caroline Bugler offered further, expert editorial guidance and Suzanne Bosman, Senior Picture Researcher, ensured the exceptional quality of the reproductions in this book, so beautifully designed by Philip Lewis.

To be in the safe hands of staff at the National Gallery and National Gallery Company has been a pleasure, but there are other people who have also provided support and encouragement: David Bickerstaff, Paul Bonaventura, Claude Cernuschi, Raymond Coffer, Jeff Collins, Lin Holdridge, Leo Lensing, Anya Lewin, Jody Patterson, Siobhan Sexton, Lisa Silverman, Diane Silverthorne, Shearer West and Peter Vergo.

Colleagues and students at Plymouth have been hugely supportive throughout this project, and I am grateful for the financial support of the School of Humanities, Music and the Performing Arts. The Leverhulme Trust has also generously supported my research. Finally, and on a more personal note, I would like to thank my parents, Michael and Annemarie Blackshaw, and partner, Michael Lawson-Smith.

GEMMA BLACKSHAW